VIRGINIA
RAIL TRAILS
Crossing the Commonwealth

Joe Tennis

THE
History
PRESS

Published by The History Press
Charleston, SC 29403
www.historypress.net

All color photographs by Joe Tennis.

Front cover, top left: Trestle No. 46 on the Virginia Creeper Trail. *Author photo*; *top right*: Hiwassee Trestle at New River Trail State Park. *Author photo*; *center right*: Purcellville Depot in 1940. *Courtesy Virginia Tech*; *lower left*: Steam train on what is now Huckleberry Trail. *Courtesy Virginia Tech*; *lower right*: Swimming Hole on the Devils Fork Trail. *Author photo*.

Back cover, top: Looking toward North Carolina line on the Virginia Creeper Trail. *Author photo*; *center*: Merrimac engine on what is now Huckleberry Trail. *Courtesy Virginia Tech*; *bottom*: Crossing Trestle No. 12 at South Holston Lake on Virginia Creeper Trail. *Author photo*.

First published 2014
Second printing 2014

Manufactured in the United States

ISBN 978.1.62619.653.7

Library of Congress Control Number: 2014952363

For my brother, Rob, who made the town for our model trains.

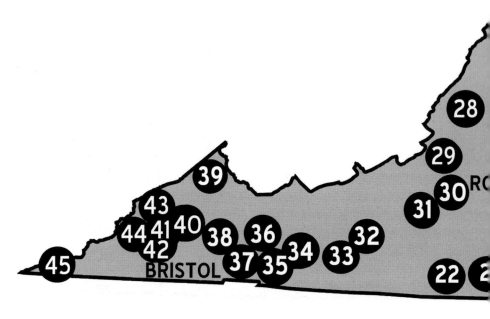

Rail trails stretch from the Eastern Shore (1) to the Cumberland Gap (45) in Virginia. Numbers on this map correspond with this book's chapters to identify the location of each trail. *Author map*.

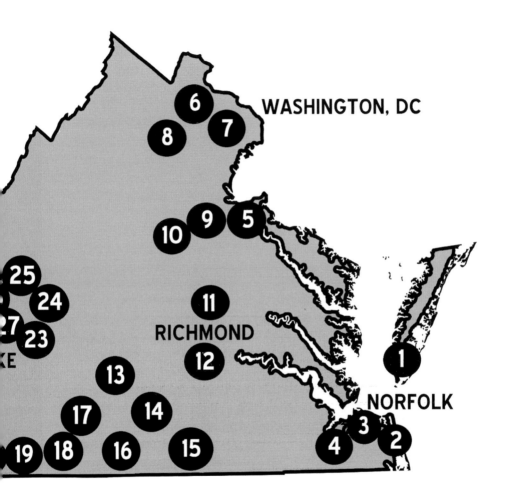

WASHINGTON, DC

RICHMOND

NORFOLK

CONTENTS

CONTENTS

ACKNOWLEDGEMENTS

Foremost, thanks goes to the crew at The History Press: J. Banks Smither, Darcy Mahan, Meredith Riddick, Hannah Cassilly, Katie Parry, Hilary Parrish, Magan Thomas and Adam Ferrell, as well as former staff members Laura All and Jessica Berzon.

I also want to thank fellow writers, editors and historians: V.N. "Bud" Phillips, David McGee, Bill McKee, Jan Patrick, Linda Hoagland, Carol Jackson, Keith Bartlett, Daniel Rodgers, Kurt Rheinheimer, Cara Ellen Modisett, Theresa Lewis, Jeff Wood, Melissa M. Stewart, Angela Blue, Bill Kovarik, Molly Moore, Erin Parkhurst, Karin O'Brien, Jennifer Bauer, James Campbell, Gary Varner, Rodney Smith, Allen de Hart, Tom Netherland, Tony Scales, Tim Cable and Tim Buchanan.

More assistance came from experts in the field, including Marc Brodsky, Jennifer Wampler, Beth Reed, Danielle Emerson, Elizabeth Saxman, Julie Buchanan, May-Lily Lee, Beth Weisbrod, Steve Galyean, Randy Rose, Catherine Fox, Jennifer Lewis, Sue Rice, Stephen Mansfield, Wayne Wilcox, Bruce Drees, Mike West, Paul Forehand, Mark Perreault, Lee Wilkins, Peggy Haile-McPhillips, Sigur Whitaker, Jeannette F. Foist, Liona Bourgeault, Helen A. Gabriel, Jim Lynch, Dave Jones, Karl Mohle, Roger Bornt, Paul McCray, Jenny Friedman, Tracy Gillespie, Julie Tahan, Alison Bremner, Niki Barwick, Jennifer Goldman, Ray Graham, Doug Fawcett, Erik Nelson, Kari Journigan, Julie Perry, Barbara J. Doniel, Douglas Graham, Dave Sadowski, Eric Hougland, Bob Flippen, Magi Van Eps, Sandra Tanner, C.J. Dean, Frank Malone, Robyn Fowler, Heather Susee, Andy Wells, Justin Kerns,

ACKNOWLEDGEMENTS

Jay McGuire, Joey Bane, Tamyra Vest, Jennifer Doss, Laura Bowles, Brian Williams, David Bowyer, John Reynolds, Tom Bishop, Ronnie Haynes, JoAnn Brown-Martin, Andrew H. Reeder, Charles Youell, Ashley Kershner, Maureen A. Kelley, Emily Harper, Steve and Popie Martin, Skip Hansberry, John Siegle, G.R. Harper, Jean Clark, Jenny deHart, Laurie Foot, Anne West, Chad Williams, Richard Flora, Doug Blount, Lon Williams, Matt Miller, Wayne G. Strickland, John Long, Emily Carter, Steve and Kim Rhodes, Leigh Anne Correll, Jim Vanhoozier, Beth Obenshain, Bill Ellenbogen, Lisa Bleakley, Ken Anderson, Joe Elton, Patrick McFall, Sam Sweeney, Amy Atwood, Nancy Lawson, Roger Peake, Ron Kime, Ken Heath, Christa Himes, Theresa Tibbs, Janice Orr, Harry Haynes, Charlie Bill Totten, Mike Pierry Jr., Hugh Belcher, Will Stein, Lisa Jett, Elizabeth Minnick, Rick Humphreys, Donnamarie Emmert, Tenille Montgomery, Wayne Miller, Link Elmore, Skip Blackburn, Gary Greer, Sidney Hal Parker, Bob McCracken, John Sauers, Sam Sauers, Lawrence Dye, Ed Morgan, Melissa Watson, Eleanor Grasselli, Beth Merz, Tom Blevins, Richard Smith, Dr. Ramsey White, Dr. French Moore Jr., Tom Taylor, Al Bradley, James Hagy, Charlie Barnette, Roscoe Osborne, Kenny Fannon, Michael R. Williams, Buzz Witt, Chuck Riedhammer, Patsy Phillips, Frank Kilgore, Jean Kilgore, Bob and Suzy Harrison, Darlene Cole, Sandy Stiltner, Brandee Brown, John Willis, Jorge Hersel, Bill Cawood, Fred Luntsford, Jack McClanahan, Pat Murphy, Rita Forrester, Rex and Lisa McCarty, Andrea Cheak, Carl Cheek, Michael Brindle, Carol Borneman and Jennifer McDaid.

I also most sincerely appreciate the help and support of family members: Maggie Caudill; James and Melissa Caudill; John Wolfe; Thomas Wolfe; Walter Wolfe; Madison Wolfe; Steve and Stephanie Talbert; Michelle Tennis; Ben Tennis; Bill Tennis; my parents, Richard and Jeanette Tennis; my daughter, Abigail; my wife, Mary; and most especially my son, John Patrick, whose love of trains and the Virginia Creeper Trail continually provided inspiration.

Long Lines, Short Tracks and Scattered Spurs

A ll over Virginia, old rails have turned to trails. Most boast gentle grades to walk, pedal a bike or ride a horse at places called Piney River and Purcellville. And each path, from Elydale to Elam, appears to have a personality: a hike with history, offering trackside tales on a wide range of long lines, short tracks and scattered spurs.

Starting at the Chesapeake Bay and stretching to the Cumberland Gap, talk turns to tying together trails from "Beaches to Bluegrass," just above Virginia's southern border. Many links in this line are rail trails along U.S. 58, like the must-ride Dick & Willie Passage of Martinsville, the priceless Ringgold Trail of Danville and the short but sweet Mayo River Trail in Stuart.

Virginia's Beaches to Bluegrass Trail ambitiously aims to create a corridor that mirrors North Carolina's Mountains-to-Sea Trail, just below the border. As planned, the five-hundred-plus miles of the Beaches to Bluegrass Trail would originate at the Southern Tip Bike & Hike Trail on the Eastern Shore, cross the Chesapeake Bay Bridge-Tunnel by passenger van and continue west, following through Virginia Beach, Norfolk and Suffolk. It's a mission—supported through a resolution passed by the Virginia General Assembly in 2014—to provide a common thread from town to town.

The Tobacco Heritage Trail would form a centerpiece across old rail beds, and a particular spotlight would shine on Southwest Virginia's success of the Virginia Creeper Trail, known for its downhill drop to Damascus. Ultimately, as planned, the Beaches to Bluegrass Trail would cruise into the Cumberland Gap National Historical Park on the Wilderness Road Trail.

At first, organizers had wanted to call this the Trans-Virginia Southern Trail. Then a state tourism official, Sandra Tanner, suggested using the main title of my book of stories along U.S. 58, *Beach to Bluegrass*, as the new name for this proposed pedestrian passageway. The trail's title soon blossomed from "Beach" to "Beaches" but remained a beacon for showing how abandoned rails can be transformed into trails for tourism.

Turning rails to trails has hardly ever been as easy as taking up tracks, scrapping iron rails and smoothing the corridor with crushed gravel. Sometimes, rail corridors have reverted to adjacent landowners, making any kind of continuous path impossible to keep together. Some neighbors, in turn, oppose having a trail built in their backyards.

Consider the Mendota Trail, long planned for Washington County. This proposed trail for Southwest Virginia would link Bristol to Mendota, a remote village on the banks of the North Fork of the Holston River near Clinch Mountain. For years, debate surfaced on whether a dozen or more miles of the old Southern Railway could be converted into a walking trail. Some landowners have disputed who actually owns the mostly visible rail bed. Yet, in 2014, a committee remained hopeful that at least part of the former path could became a trail.

In Richmond, a committee has proposed turning an abandoned CSX railroad right of way into a path called the James River Branch Rail-Trail. This route includes a two-and-a-half-mile-long section from 49th Street to Cofer Road on Richmond's Southside.

Nearby, the Virginia Capital Trail stretches for more than fifty miles across Eastern Virginia, linking Richmond to Williamsburg and Jamestown. This trail has been built largely along the scenic VA-5 corridor. One portion, about a mile, could be considered a rail trail, as it uses a former railroad corridor at Rocketts Landing in Richmond, near Dock and Ash Streets. Workers removed rails in 2013 to build this section overlooking the James River, between the Great Shiplock Park and VA-5/Old Osborne Turnpike.

In Roanoke, active rail lines along Norfolk Avenue accompany a unique "rail-with-trail" with information kiosks, railroad signals and whistles. The David R. and Susan S. Goode Railwalk parallels the railroad for about a third of a mile, running from Market Street to Warehouse Row.

Old logging lines in Virginia's national forests have also grown into new grounds for walking paths. In a remote corner of Highland County, trails called Buck Run and Locust Spring Run each span about three miles and lie on railroad tram grades used for logging in about 1900, near Laurel Fork. Not far from Pound, at another Laurel Fork, footpaths stretch across the

grades of logging tram railroads near the Laurel Fork Primitive Camping Area on the North Fork of the Pound Reservoir in Wise County.

Also near Pound, the Red Fox Trail of Wise County spans one and a half miles in the Jefferson National Forest and remembers the story of Marshall B. Taylor, who hid himself in the folds of rhododendron-bordered boulders, now known as the "Killing Rock." Taylor, best known as the "Red Fox," used a gun to stun a seven-person entourage on May 14, 1892. Today, the moderately challenging Red Fox Trail, just off VA-667, near U.S. 23, makes a trace along the historic path of the "Red Fox" and includes part of a narrow-gauge railroad grade, once used for logging by the Currier Lumber Company.

To the east, in Russell County, an annual bird and wildflower walk during April's Redbud Festival follows the Norfolk and Western Railway's Honaker Branch, locally dubbed the "Blackford Spur," a rail bed near the Clinch River. Nearby, a rail trail has been proposed for Pocahontas, a historic coal camp in Tazewell County.

Some trails stay years in the making, like the rehabilitation of the Claudius Crozet Blue Ridge Tunnel. Built by the labor of Irishmen and slaves in the 1850s, the 16-foot-tall tunnel stretches for 4,237 feet beneath the Blue Ridge. Engineering plans have been completed to outline a rail trail, using the tunnel, to link Nelson County to Augusta County, and grant money has been assigned to the project. "It's a super historic resource that needs to be restored," said Emily Harper, the director of parks and recreation in Nelson County. "The tunnel's real draw is the fact that it is a tunnel."

Blue Ridge Tunnel may stand as a portal to the past. But its future connects to a network of new life for old lines across the Old Dominion—in turning rails to trails.

Virginia Rail Trails: Crossing the Commonwealth explores these journeys—in trail towns called Lexington, Leesburg, Lawrenceville and Lynchburg—with a mix of railroads and recreation. Some lines scale high trestles and slip beside waterfalls. Many course along rivers or creeks in corridors that have been shrouded in mystery for a century, seen only by the eyes of engineers or maybe a few lucky passengers. Yet each bears some distinction—a history carved from cars once hauling lead, coal, crops, timber, salt, sand, zinc, iron ore, mail and people—on what was once the terrain of trains.

SOUTHERN TIP BIKE & HIKE TRAIL

Cape Charles

Shorebirds patrol tidal inlets, and traffic stays steady at the northern end of the Chesapeake Bay Bridge-Tunnel. In between, along U.S. 13, the Southern Tip Bike & Hike Trail threads its way past berms built as barriers for trains carrying cargo to and from Cape Charles.

The Southern Tip Bike & Hike Trail parallels U.S. 13, a busy, four-lane thoroughfare known as the Lankford Highway. From the Chesapeake Bay Bridge-Tunnel to the Maryland-Virginia border, U.S. 13 serves as the spine of the Eastern Shore's two counties, Accomack and Northampton—both blocked from the rest of Virginia by the Chesapeake Bay.

For decades, railroads paralleled U.S. 13. The stretch that is now the Southern Tip Bike & Hike Trail was once part of the Cape Charles Railroad, a line that ran from Cape Charles to Kiptopeke in the early 1900s. This line was extended—on what is now the trail—in 1941, supplying five thousand troops at an army base, Fort John Custis. That fort later became Cape Charles Air Force Station.

That station closed in 1981, and the Eastern Shore of Virginia National Wildlife Refuge was established in 1984. By then, the railroad had shut down—with the last train running in 1972—after yielding to an ever-increasing flow of truck traffic on U.S. 13. Decades later, the trail opened in 2011, lying just beyond the highway median.

Eastern Shore of Virginia National Wildlife Refuge extends more than 1,100 acres and includes a launch for boats and canoes plus remnants of military buildings and bunkers. Here, too, migrating songbirds and

Southern Tip Bike & Hike Trail spans the southernmost point of the Delmarva Peninsula as part of the Eastern Shore of Virginia National Wildlife Refuge. *Author photo.*

monarch butterflies find natural nesting places amid a maritime forest. The colorful creatures feed and rest in the marsh—at the "Southern Tip" of the Delmarva Peninsula—before taking flight across the Chesapeake Bay to Virginia Beach.

TRACKING THE TRAIL

Lined with the bright blooms of dogwoods and redbuds, the Southern Tip Bike & Hike Trail connects the Eastern Shore of Virginia National Wildlife Refuge with an entrance to Kiptopeke State Park, along VA-704, about a quarter mile from the trail's northern parking area on Cedar Grove Drive. It is well marked with mileage posts every tenth of a mile.

This asphalt trail gently glides beside farm fields and a pine forest, cutting a swath through a scenic corridor where rabbits like to run. Most

of the trail is flat and easy, except for a small dip near Milepost 0.8. About 90 percent of the 2.6-mile-long trail was built within a sixty-six-foot-wide railroad right of way. The trail affords a quick glimpse of the Chesapeake Bay (mile 1.0). A historic marker (mile 1.3) details the region's railroad history next to a park bench with a railroad spike and tie plate once used on the Cape Charles Railroad. This marker stands near Latimer Siding Road—a name that, incidentally, references a stop on the line.

ACCESS

Refuge: The southern trailhead lies along Seaside Road (VA-600), just off U.S. 13, at the entrance to the Eastern Shore of Virginia National Wildlife Refuge, immediately north of the Eastern Shore of Virginia Welcome Center.

Latimer Siding Road: A small access lies along Latimer Siding Road (VA-718), about 1.2 miles north of Seaside Road, immediately east of U.S. 13.

Cedar Grove: The trail's northern parking area lies at Cedar Grove Drive (VA-645), immediately east of U.S. 13, about 2.4 miles north of Seaside Road.

NORFOLK AVENUE TRAIL/INDEPENDENCE BOULEVARD TRAIL

Virginia Beach

Marshall B. Parks railroaded his dreams through the piney woods of Princess Anne County on tracks aimed for the Atlantic Ocean. It was the summer of 1883, and about two dozen passengers took this Norfolk businessman's inaugural steam train journey, rolling east to a site snuggled among sand dunes. There, some took a "dip in the briny," one newspaper reporter recalled—with one passenger saying this was "the best bath he ever had in his life."

Parks bestowed the name "Virginia Beach" on this untamed shore. A former Confederate naval officer, Parks had been instrumental in laying the line of narrow-gauge tracks for the Norfolk and Virginia Beach Railroad and Improvement Company, an outfit that would later promote stays at its Virginia Beach Hotel and gatherings at its oceanfront pavilion.

For that initial run in 1883, and until the following year, the Norfolk to Virginia Beach line did not quite connect, which forced a ferry to shuttle passengers along the Eastern Branch of the Elizabeth River to Broad Creek. The journey to the beach, then, began at Elizabeth Park and cut a horizontal swath of about fifteen miles across what, largely, became the city of Virginia Beach.

Along the oceanfront, the Virginia Beach Hotel eventually became the even-larger Princess Anne Hotel in 1888. But Parks and his associates would not enjoy its success. Their company folded in 1887. Their railroad, in turn, would change hands over the next several years. By the fall of 1894, the Norfolk, Albemarle & Atlantic Railroad Company had control of the tracks,

and the train made stops at Greenwich, Kempsville, Thalia, Jacksondale, Lynnhaven, London Bridge, Oceana, Seatack and Ocean Shore Park before reaching Virginia Beach.

In 1898, the narrow-gauge line was upgraded to a standard gauge. That same year, between Norfolk and Virginia Beach, the Currituck Branch veered off the main course at Euclid Junction, near what became Witch Duck Road in Kempsville. This line headed more than twenty miles south to Munden, a point on the North Landing River, where steam ferries could carry produce and passengers across the Currituck Sound, a waterway feeding into the upper reaches of the Outer Banks along the North Carolina–Virginia border.

The railroad's Currituck Branch became better known as the "Munden Point Line." It also wore informal nicknames, like the "Sportsman's Special" or "Hunter's Special" on weekends, when it brought hunters and fishermen to points near the marshy banks and forests along Back Bay. During the week, when it shuttled attorneys to the courthouse at Princess Anne, the line was dubbed the "Courthouse Special" or "Lawyer's Special." But in time, this branch would be broken. By 1955, topographic maps listed the path as simply "Old Railroad Grade." Later, this grade became the site of a power line, with a bike trail added beneath; the railroad's terminus eventually turned into Virginia Beach's Munden Point Park.

Back at the beach, electric trolleys carried passengers on the Norfolk to Virginia Beach line in the 1920s. Then came the Norfolk-Virginia Beach Railbus in 1935, running as fast as fifty miles per hour. Resembling streetcars, these gas-powered railbuses were well loved for their speed and luxury. But business slowed with the ever-increasing popularity of automobiles, freely cruising the parallel path of Virginia Beach Boulevard (U.S. 58). Finally, and despite the protests of a few riders, passenger runs from Norfolk to Virginia Beach ended in November 1947.

Freight trains still continued to roll. Princess Anne County grew into the city of Virginia Beach in 1963, and the local population grew, too. But rail traffic waned by the 1990s—an era when the city purchased about a mile of an abandoned section of rails along Norfolk Avenue, east of Birdneck Road. At this site, the Norfolk Avenue Multi-Purpose Trail opened in 2003, carrying a pricetag of nearly $525,000. Though little more than a mile long, this rail trail has become part of the city's South Beach Trail, the regional South Hampton Roads Trail and the statewide Beaches to Bluegrass Trail. At its midpoint, fittingly, the well-landscaped path crosses Parks Avenue, a namesake of the man who started it all: Marshall B. Parks.

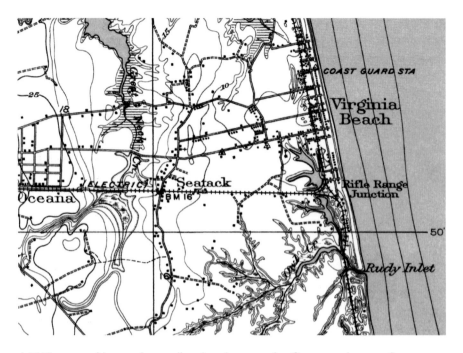

A 1919 topographic map shows railroad tracks connecting Oceana to the oceanfront at Virginia Beach. The Norfolk Avenue Trail follows part of the old railroad grade between Seatack and Rifle Range Junction. *U.S. Geological Survey map.*

TRACKING THE TRAIL

The urban sidewalk–style trails built on railroad grades in Virginia Beach are suitable for riding bikes or taking short strolls.

Norfolk Avenue Trail

The 1.3-mile-long Norfolk Avenue Trail lies largely on a raised railroad bed. Perfect for beach cruisers, the asphalt trail begins near Pacific Avenue, just west of where Ninth Street becomes Norfolk Avenue, about a block from Atlantic Avenue. Going west, the path crosses Mediterranean Avenue at 0.3 miles and grows wider. In another 0.3 miles, the trail passes a wooded area, where it is separated from Norfolk Avenue by ranch-style fencing. The rail-trail portion terminates at South Birdneck Road, but the path can be

continued by following signs for the South Beach Trail, a series of sidewalks from which you can smell the sea.

Independence Boulevard Trail

Sometimes referenced as the "Park Connector Bikeway," the smooth, concrete bike path called Independence Boulevard Trail follows about four miles of the Currituck Branch corridor, running nearly parallel to Princess Anne Road.

This fragmented trail begins along South Independence Boulevard, between Green Meadows Drive and South Plaza Trail, just below power lines. Going southeast, the trail parallels the sidewalk on South Independence for 1.5 miles and then joins the sidewalk, about 0.25 miles after crossing Dahlia Drive. To continue, use the sidewalk along South Independence Boulevard for 0.3 miles. Turn left on the sidewalk of Lynnhaven Parkway and go 0.4 miles. At Lynnhaven Parkway, the trail begins again, at right—just across from the Church of the Holy Apostles, near Windmill Point Crescent.

Between Lynnhaven Parkway and Rosemont Road, the trail runs for a quarter mile between homes. After crossing Rosemont Road, the trail parallels Rosemont for one mile, passing town homes and several city streets. Beyond Rosemont Road's busy intersection with Dam Neck Road, the trail continues as a neighborhood path through Landstown Lakes. Still near the power lines, in an area once known as "Land" and, later, "Landtown," the path cuts through a grassy area for about a half mile, ultimately ending at Winterberry Lane.

ACCESS

Norfolk Avenue Trail: The east end starts near Ninth Street's intersection with Pacific Avenue (U.S. 60), about 0.2 miles from the Virginia Beach Boardwalk. The west end lies near South Birdneck Road's junction with Norfolk Avenue, about 0.3 miles south of Virginia Beach Boulevard (U.S. 58). Look for a parking area along Norfolk Avenue, between Cypress and Mediterranean Avenues.

Independence Boulevard Trail: The north end of the trail starts along South Independence Boulevard, about 0.1 miles south of Green Meadows Drive.

Munden Point Park: The southern terminus of the Currituck Branch can be found at Munden Point Park, between Creeds and Knotts Island. From the Virginia Beach Farmers Market at the Dam Neck Road intersection, follow Princess Anne Road south for about 19.0 miles. Turn right on Munden Point Road and go 0.8 miles. Then turn right on Pefley Lane and follow to the park—with a playground, fishing area, boat ramp and ball fields—at the end of the road.

ELIZABETH RIVER TRAIL

Norfolk

With three branches, the Elizabeth River reaches into the heart of Hampton Roads and forms a natural harbor for Norfolk, where ships of all stripes can wait out the waves of the Atlantic Ocean. Once largely lined with marsh and tall pines, the Elizabeth takes its name from a princess, Elizabeth Stuart, the daughter of King James I of England. As early as 1636, ferryboats crossed this river, with men rowing skiffs. Later, horses and blind mules worked treadmills to power paddlewheelers.

Maritime traffic on the waterway helped shape Norfolk. This flat-as-a-flounder city became a port for railroad lines hauling coal from the Virginias in the late 1800s. It also evolved into a massive military headquarters, where U.S. Navy vessels shadow the shoreline. Like a tough sailor, Norfolk rolls with a rhythm, consistently reinventing its waterlogged edges. So, naturally, what happened to its Atlantic City section—and what it inspired—seems fitting.

Atlantic City was once a thriving but hard-edged community on the Elizabeth River's waterfront, supporting an icehouse, a knitting factory, cotton warehouses and lumber mills, plus a few honky-tonks. It prospered with oyster-packing houses and boat repair yards and as a place to catch crabs along the river. Founded in the 1870s, the riverside settlement was partially built on the property of John G. Colley, for whom Norfolk's Colley Avenue is named. It became part of Norfolk in 1890 and was reached on rail, by the early 1900s, as the Norfolk and Western Railway extended its Atlantic City Spur along the waterfront, near Fort Norfolk.

Overlooking the Elizabeth River, Fort Norfolk served a role in the War of 1812, when it was used to defend the city from the British. Later, the Confederacy controlled the brick stronghold to supply the CSS *Virginia* (*Merrimack*) in its duel on March 9, 1862, against the USS *Monitor* during the first battle of the ironclads, which took place not far from the fort, near the mouth of the Elizabeth River.

Atlantic City grew up around Fort Norfolk, with a line of homes surrounding its waterfront businesses. But as the decades passed, the quiet but solid fort remained standing—much like an old soldier, under the watchful eyes of the U.S. Army Corps of Engineers—while much of Atlantic City became a target for wholesale urban renewal in the 1950s. Many of its homes—some well-built, others not—were eradicated from the landscape and replaced by medical centers and an expansion of Brambleton Avenue (U.S. 58).

"The New Norfolk" arose with shiny skyscrapers flanking early twentieth-century buildings, on the east, in the dolled-up downtown. Nearby, the historic neighborhood of Ghent stood as pretty as a postcard. By then, in the 1990s, the tracks of the Atlantic City Spur stood idle.

Residents of West Ghent joined the Norfolk Historical Society in working to turn that short line into a pedestrian path. A rail trail, for one, would make Fort Norfolk more accessible for visitors. The graffiti of Civil War prisoners on the walls of the fort's dungeon had already been a draw, but so also was Fort Norfolk's sidewalk, believed to have been built on the path of a narrow-gauge rail line, possibly used by horses or mules to move powder and shells.

By 2001, the Elizabeth River Trail opened. The project converted 3,500 feet of the railroad right of way on the Atlantic City Spur into a trail, between Orapax Street and Southampton Avenue, and opened a waterfront district once virtually unknown to the general public. The rail-bed section includes a viaduct over the Midtown Tunnel. Along the way, the path passes Plum Point Park. Overlooking barges and vessels, this five-acre park was built, soon after the rail trail, on a peninsula that originated in the early 1960s from a mound of muck, scooped up during the construction of the Midtown Tunnel, linking Norfolk to Portsmouth on U.S. 58.

As the tiny trail developed, a broader vision swept Norfolk, and within a few years, the Elizabeth River Trail expanded into an urban greenway. It became part of the South Hampton Roads Trail and Virginia's Beaches to Bluegrass Trail. Fanning either way from the old rail bed at Atlantic City, the path now connects Harbor Park, near Norfolk State University, at the south and east, to Old Dominion University and beyond the Lafayette River on the north.

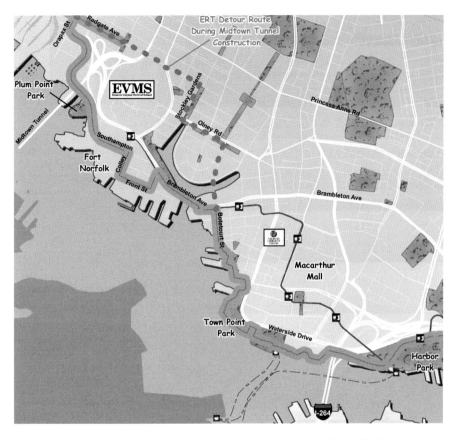

Elizabeth River Trail follows a well-marked downtown route from Harbor Park west to Plum Point Park and beyond. The original Atlantic City rails-to-trails section lies near Fort Norfolk. *Courtesy City of Norfolk.*

TRACKING THE TRAIL

Made of asphalt and concrete, the Elizabeth River Trail zips along a mix of off-road runs and city streets for about ten miles. Little of this pretty passage is a true rail trail, but the trace does stay true to its name, largely keeping the glistening waters of the Elizabeth River within sight. Direction signs are marked with pelicans along the route. Detailed maps—including detours and updates—are available through the city's parks and recreation department.

Harbor Park to Town Point Park

On the east, the trail can be accessed near Harbor Park, a baseball stadium at 150 Park Avenue, on property once covered with railroad tracks. In the early 1900s, Harbor Park and its expansive parking area was the site of the Union Passenger Station, serving both passengers and freight on the Norfolk and Western Railway. That station was torn down in 1962. Harbor Park opened in 1993.

Going one mile from Harbor Park to Town Point Park, the Elizabeth River Trail parallels the active tracks of the Tide (a light-rail connecting Eastern Virginia Medical School to Newtown Road) and initially borders Park Avenue as it continues west. It follows East Water Street for a quarter mile. Then, after passing below the Berkley Bridge, the route takes a turn to the river. It rolls past the Waterside, where passenger ferries lead to Portsmouth, then continues along the river's edge as it enters Town Point Park.

Town Point Park to Jeff Robertson Park

Just beyond Town Point Park, at the immediate left, stands Nauticus, One Waterside Drive. Continuing west, the trail remains along the river for another 0.5 miles, passing Freemason Harbor, at left. Then it joins Botetourt Street for 0.2 miles.

To reach the original rail trail in Atlantic City, turn left on York Street and follow the trail as it parallels Brambleton Avenue (U.S. 58), overlooking the Hague, a Y-shaped waterway at Ghent. Immediately, turn left on Second Street to enter Atlantic City. Follow Second Street south for one block. Turn right on Front Street and go two blocks to see Fort Norfolk, 801 Front Street, at left. Turn right on Colley Avenue and go two blocks. Then turn left on Southampton Avenue and proceed straight, going less than one mile as the trail section on the Atlantic City Spur continues to Orapax Street, passing Plum Point Park, at left.

A caveat: A construction project to widen the Midtown Tunnel, by 2014, temporarily closed the original rail trail route through Atlantic City.

To follow a detour on the trail's "Ghent Loop," simply remain straight as the trail joins Botetourt Street near Freemason Harbor. Cross Brambleton Avenue (U.S. 58) and proceed into Ghent across a footbridge over the Hague. Continue on Botetourt Street for 0.2 miles. At Olney Road, turn left and go 0.2 miles. Then turn right on Stockley Gardens and go 0.2 miles. Turn left

on Redgate Avenue and follow for 0.7 miles to reach Orapax Street, where the loop/detour end.

From the intersection of Redgate and Orapax, the trail continues north for 0.4 miles on a scenic, straight-as-an-arrow "bike path" section, locally dubbed "The Pines," as the trail passes Lamberts Point, an active railyard, at left. Turn right on Weyanoke Street and go 0.1 miles. Turn right on Graydon Place and go 0.1 miles. Turn left on Old Brandon Avenue and go 0.1 miles. Then turn left on Armistead Bridge Road and go 0.2 miles to reach Jeff Robertson Park, a greenspace with ball fields, overlooking active railroad tracks.

Beyond Jeff Robertson Park, the trail spans 0.2 miles to reach Hampton Boulevard. From here, the Elizabeth River Trail continues for about four more miles, using a mix of sidestreets and passing through Old Dominion University, eventually going north to Terminal Boulevard.

ACCESS

You can reach the Elizabeth River Trail from several sites, including at Harbor Park, at Town Point Park, along Redgate Avenue in Ghent and at Southampton Avenue at Atlantic City. Parking is available all along the route.

SUFFOLK SEABOARD COASTLINE TRAIL

Suffolk

Suffolk sits among swamps crossed by lines of railroads, some active, some abandoned. In the city, and its neighbors across Hampton Roads, sketches have swirled like locomotive breath on how to redevelop old railroad corridors. Plans, proposals and projects in the works by 2014 have designed rail trails running for miles as part of the South Hampton Roads Trail, an eastern component of Virginia's Beaches to Bluegrass Trail.

On the east, the city of Portsmouth announced an intent to build a 1.8-mile-long rail trail in Churchland on an abandoned section of the Commonwealth Railway by 2014. This route links West Norfolk Road's intersection with Old Coast Guard Boulevard to the Chesapeake city line at High Street West.

Picking up at Portsmouth, Chesapeake has proposed constructing a 3.2-mile-long trail. One phase runs from Portsmouth to I-664, near Gum Court, on the abandoned Commonwealth Railway; the second phase uses the abandoned Seaboard Coast Line Railroad from I-664 to Suffolk.

Suffolk checks in at the Chesapeake border, near Town Point Road, with a plan to roll west, crossing Quaker Neck Creek and Bennetts Creek, on the abandoned Seaboard line. Projections call for a 3.3-mile-long asphalt trail in the city, stretching southwest to the intersection of Nansemond Parkway and Kings Highway. This long-planned rail trail reaches Driver, a farming community once known as Persimmon Tree Orchard and later named for E.J. Driver, who operated a country store at the crossroads in the late 1800s. The Driver segment is part of the outline for the 11.5-mile-long Suffolk

Suffolk Seaboard Station Railroad Museum stands near the head of a rail trail called the Suffolk Seaboard Coastline Trail. *Author photo.*

Seaboard Coastline Trail. This project, as planned, could also potentially connect to a short pedestrian passage constructed years earlier in the downtown district that follows a rail bed just outside the Suffolk Seaboard Station Railroad Museum.

Built in 1885, Suffolk's Seaboard Station first serviced the Seaboard and Roanoke Railroad. In 1907, it also became a stop on the Virginian, a railroad that built tracks on the north side of the building. For decades, the train station survived railway mergers and the end of passenger service. It became a freight office. Later abandoned, a fire in 1994 nearly threatened its destruction until the Suffolk-Nansemond Historical Society's "Save Our Station" campaign proved fruitful with fundraising. The Queen Anne–style building reopened as a museum featuring an HO-scale model railroad, showcasing Suffolk as it looked in 1907.

TRACKING THE TRAIL

Downtown Suffolk's section of the Seaboard Coastline Trail provides an easy stroll spanning about a half mile. The paved trail starts just beyond a gate, immediately east of the Suffolk Seaboard Station Railroad Museum, and makes a V-shaped split near Cedar Hill Cemetery.

Turning left leads downhill on a shady path for about a quarter mile. Bordering both bamboo and a babbling brook, this rail trail reaches East Constance Road (U.S. 58) on what was a spur line, listed on topographic maps as late as 1999. The trail stops near a hotel and conference center overlooking Constant's Wharf on the Nansemond River.

Continuing straight from the split, going east, the asphalt path crosses a small bridge as it goes beneath West Pinner Street. It also parallels active railroad tracks, at right, until it reaches Moore Avenue, near East Pinner Street, in a quarter mile.

ACCESS

Suffolk Seaboard Station Railroad Museum, 326 North Main Street, lies about 0.3 miles south of U.S. 58, at the Prentis Street intersection.

DAHLGREN RAILROAD HERITAGE TRAIL

King George County

The Dahlgren Branch Line crowned the ground of King George County with ties and rails at the onset of World War II, a time when at least two other railroads in Virginia would soon face the scrap pile due to the war effort. The United States government built the Dahlgren Branch Line as 1941 became 1942, and workers were urged to camouflage construction materials after the Japanese attack at Pearl Harbor on December 7, 1941.

In all, this line spanned about twenty-nine miles, starting in Stafford County and reaching the woods and farms of Virginia's Northern Neck, a cluster of communities extending between the Potomac and Rappahannock Rivers along the Chesapeake Bay. Connected to the Richmond, Fredericksburg and Potomac Railroad near Fredericksburg, this line was used to ship munitions and war materials to the United States Naval Proving Ground, a testing site at Dahlgren.

This branch remained operating—and included passenger stops— through 1957. Six years later, the line was declared government surplus. It sat idle. Later, it was acquired by the Richmond, Fredericksburg and Potomac Railroad, eventually becoming part of CSX in the 1990s. Still, due to disuse over several years, trees grew up on one section—a skinny plat of land that spans more than two hundred acres and passes through the center of King George County for more than fifteen miles.

King George resident Joe Williams bought that overgrown property in 1997 with dreams of turning the route of the rail into a publicly accessible trail. Nearly a decade later, a volunteer group called the Friends of the

Dahlgren Railroad Heritage Trail had cleared enough trees to open the rail bed "for private use," though the trail is still open to all who register through the trail's website (friendsdrht.org).

The Dahlgren Railroad Heritage Trail is restricted to visitors who carry permits. One reason: those permits can gauge how many users are on the trail, as organizers retain hopes of convincing state and local leaders that the rail trail should be open for everyone and become part of the Virginia State Parks system. "We're not just in this to be a private trail spot forever," said trail volunteer Jim Lynch. "We really want it to be a public park."

TRACKING THE TRAIL

Lined with pines, the Dahlgren Railroad Heritage Trail runs 15.7 miles, with rock dust spread in portions to make the dirt surface smoother. It's not completely flat, but this well-cleared and quiet trail does boast an easy grade, suitable for mountain bikes or just a simple walk in the woods.

No-cost permits are required to use the privately owned trail. It has been the site of long-distance running races and scouting expeditions. It can also be a prime place to see eagles, hawks and songbirds as well as deer, rabbits, turtles and squirrels, all beneath a natural canopy that shades the sun.

Access points with limited parking are located every few miles. Passing woods and wetlands along the way, the trail crosses small streams on culverts and slips past high banks, built as shoulders for the railroad. The trail access along Indian Town Road, incidentally, lies within a half mile of Caledon State Park, a sanctuary for eagles on the Potomac River, along Caledon Road (VA-218).

The trail starts on the west end of King George County at Bloomsbury Road (VA-605) and runs about one and a half miles to Lambs Creek Church Road (VA-694). Continuing east, the next access lies about two and a half miles farther at Comorn Road (VA-609). From here, the trail spans about four more miles to reach an access at Indian Town Road (VA-610). Heading east of Indian Town Road, the trail stretches more than seven miles until it terminates just past Owens Road, near the community of Dahlgren. Like the trail, that town takes it name from John Adolphus Dahlgren, the father of the modern naval ordnance.

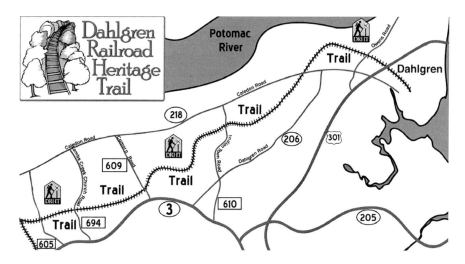

Dahlgren Railroad Heritage Trail lies between VA-3 and VA-218, passing through fields and bordered by trees. *Courtesy Dave Jones.*

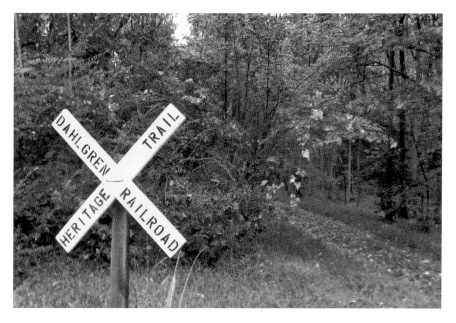

Dahlgren Railroad Heritage Trail spans more than fifteen miles in King George County. *Author photo.*

ACCESS

Parking areas are located where the trail crosses secondary state highways, all between VA-3 and VA-218, in King George County:

Near Mile 0: From VA-3, follow Bloomsbury Road (VA-605) north for 1.7 miles.

Near Mile 1.5: From VA-3, follow Lambs Creek Church Road (VA-694) north for one mile.

Near Mile 4: From VA-3, follow Comorn Road (VA-609) north for a half mile.

Near Mile 8: From VA-3, follow Indian Town Road (VA-610) north for four miles.

WASHINGTON AND OLD DOMINION TRAIL

Northern Virginia

In the beginning, when investors wanted to create a rail line to go west of Washington, D.C., the fields of Northern Virginia were vast farmlands. Endless trees covered the foothills of the Blue Ridge, and the coal-rich mountains of what is now West Virginia still lay in the arms of the Old Dominion.

This dream started in 1847. Investors secured a charter for the Alexandria and Harper's Ferry Railroad and planned to make the Potomac River port town of Alexandria—just south of Washington—an eastern terminus. But nothing really happened until 1853. That year, planners reorganized as the Alexandria, Loudoun and Hampshire Railroad Company with a renewed plot to haul loads of coal from Virginia's Hampshire County—what would later be part of West Virginia.

Construction commenced in 1855. The first trains rolled in 1859, and regular service began in 1860, reaching as far west as the Loudoun County courthouse town of Leesburg on May 17.

Then the Civil War got in the way. Union forces captured the railroad in 1861. So Confederate general Robert E. Lee ordered the railroad's destruction to stop Union troops from advancing by rail. Lee's troops tore up some tracks and burned a few bridges west of Vienna.

When the war was over, the railroad was repaired. But the initial dream of the antebellum era was greatly modified. This rail line, long bound to break through the Blue Ridge, never got any farther than Bluemont—a place earlier known as Snickersville, lying about fifty-four miles from Alexandria. And, it did not get there until 1900.

Continually plagued with financial troubles, the railroad repeatedly changed names and owners. It was called the Washington & Ohio Railroad, Washington & Western Railroad and the Washington, Ohio & Western Railroad. Trains hauled passengers and produce. Railcars carried mail. The line provided links to a string of summer resorts in the hill country of Herndon, Paeonian Springs and Purcellville. The Southern Railway acquired the line in 1894, and it was ultimately named that railroad's Bluemont Branch.

In 1911, the line became part of the Washington and Old Dominion Railway and was branded that company's Bluemont Division in 1912. Dubbed the W&OD for short, the railway was reorganized and renamed the Washington and Old Dominion Railroad in 1936. By then, this line had also collected at least a couple nicknames for operating with old or even broken-down equipment. The letters "W&OD," to some, meant "Wobbly, Old & Dilapidated." And the slow-moving train was called the "Virginia Creeper."

Train service on this line could be comical. Sometimes, the crew would jump off moving cars at road crossings to stop traffic by waving lanterns or flags. Conductors occasionally ignored regulations by stopping the train to pick up regular riders at unscheduled stops. Passenger cars became crowded. Many times, too, the train would simply not run on time.

Losing money, the railroad abandoned the westernmost section of the track from Purcellville to Bluemont in 1939. Soon after, the railroad phased

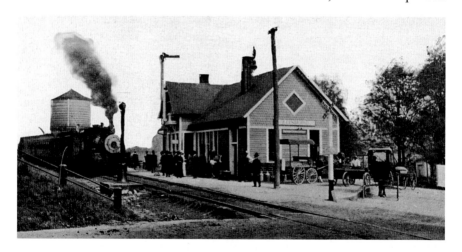

A steam train approaches the Leesburg Passenger Depot in this vintage postcard of the early 1900s. *Courtesy Northern Virginia Regional Park Authority.*

out passenger service in 1941. Later that same year, the United States entered World War II. With fuel shortages and rations, this railroad was needed to provide alternative transportation. So the W&OD's passenger line was reborn—until 1951. After that, freight trains continued to run, and the railroad hauled stones from quarries for road construction. The line also enjoyed a resurgence of business when the Dulles Airport was constructed in the late 1950s.

After great debates, however, the railroad was finally retired in 1968, and tracks along much of the line were removed. The Virginia Electric and Power Company (VEPCO) soon acquired the railroad's route. Later, piece by piece, the Northern Virginia Regional Park Authority (NVRPA) purchased a one-hundred-foot-wide right of way on the old railroad grade to build a trail.

From 1974 to 1988, the park authority constructed the Washington & Old Dominion Railroad Regional Park. Still, the power company maintained a property easement. That's why, today, electric transmission lines stand along much of the regional park's forty-five-mile-long rail trail.

The Washington and Old Dominion Trail rolls through one of the fastest-growing areas of Virginia. It also lies mainly on the old rail bed, where evidence of the past remains buried in the soft shoulders. "It's always interesting when we're putting in a sign or a mile marker," said park manager Karl Mohle. "When you dig down, you come up with a layer of dirt, and it will have a soot-charcoal substance. That's actually the burnt coal from the train."

In the era of the train, and now with the trail, a theme prevails: go west from Washington, D.C., and use this passage to find peaceful pastures. Conversely, commuters can cycle east to the subway and then return west to the subdivisions.

Washington & Old Dominion Railroad Regional Park attracts as many as three million visitors a year, ranking the W&OD Trail among the most popular rail trails in America. The paved path may also be among the country's most accessible trails, with dozens of well-marked road crossings along the way.

Countless connections to the rail trail exist, from designated routes like the Custis Trail in Arlington County to little social trails wandering into neighborhoods. Even another rail trail can be found at the Bluemont Junction Trail, which intersects the Washington and Old Dominion Trail about three miles west of the W&OD's eastern trailhead at Shirlington. The Bluemont Junction Trail follows a portion of a rail bed built in 1912 to link

Wild turkey have been spotted in the woods bordering the Washington and Old Dominion Trail near Vienna. *Author photo.*

the Washington and Old Dominion Railway's Bluemont Division with its Great Falls Division.

Farther southeast, an unconnected portion of the railroad's Bluemont Division has also turned into a trail. The Mount Jefferson Greenway—or "W&OD Greenway"—follows the railroad grade for about a half mile as it passes through Alexandria. This trail connects Commonwealth Avenue, between Ashby and Manning Streets, to the playground of Mount Jefferson Park, just off East Randolph Avenue. From there, the short span continues southeast to a point near Jefferson Davis Highway (U.S. 1).

TRACKING THE TRAIL

Washington and Old Dominion Trail's paved surface provides a smooth and universally accessible path for nearly forty-five miles of walking, bicycling and in-line skating. Stretching from Shirlington to Purcellville, numerous hills provide mild challenges as the asphalt trail conquers the contours of Virginia's piedmont.

Dashes divide the trail like a road with lanes. West of VA-123, a bridle path—with a bluestone surface—parallels the rail trail for about thirty-two miles, linking Vienna to Purcellville. Mileposts (MP) stand along the trail at half-mile increments and are used to note landmarks or attractions.

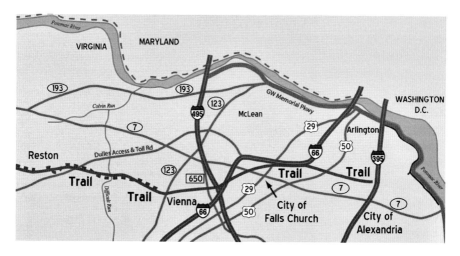

This locator map shows the eastern half of the Washington and Old Dominion Trail. Immediately west of I-395, the trail begins at Shirlington and proceeds west to Reston. *Courtesy Northern Virginia Regional Park Authority.*

Shirlington to Vienna

The eastern trailhead lies in the Nauck neighborhood near Shirlington, between Arlington and Alexandria. From here, the trail runs about twelve miles to the restored train station of Vienna.

For the initial two miles, on the east, the trail follows between businesses and residential communities. It parallels the rocky course of Four Mile Run Creek and crosses several streets. The trail passes Sparrow Pond (near MP 2) and wetlands, near the Long Branch Nature Center, that allow for observations of great blue herons and other birds. Farther west, it crosses U.S. 50 (near MP 2.5).

Look for several points of interest between mileposts 3 and 4. Less than 1.0 mile west of U.S. 50, the trail intersects the paved Bluemont Junction Trail, which runs east for about 1.5 miles to Fairfax Drive at Ballston. The intersection of these rail trails lies near Bluemont Park (near MP 3.5), which features a caboose, restrooms, water fountains, ball fields, a playground and a picnic area. In this same vicinity, the Bon Air Memorial Rose Garden blooms with bright-red flowers during summer months, just beyond the trail's intersection with Wilson Boulevard.

Continuing west, the trail parallels I-66 (MP 4) and remains alongside, or near, the interstate highway for about two miles. It crosses U.S. 29 (MP 5.5)

close to an access with the East Falls Church metro station. The trail passes through the City of Falls Church, where the first 1.5 miles of the trail was built and a grand opening was held on September 7, 1974, at Little Falls Street (near MP 6).

The W&OD goes over VA-7 (MP 7) and then crosses I-66 (near MP 8.5) and I-495 (MP 9). These routes—especially I-495, Washington's "Beltway"—have grown infamous for traffic tie-ups, making these bridges actual destinations on the trail. Some users come simply to stand high and overlook the motorized madness.

Dunn Loring borders the trail (MP 10) as the passage cuts through more open fields, where handsome homes stand amid woods with an abundance of deer and squirrel. A planned subdivision of the 1880s, Dunn Loring once had its own railroad passenger station, which served the troops of this area's Camp Alger in 1898. That camp was used to train twenty-three thousand men during the Spanish-American War.

Just west of Dunn Loring, Vienna (MP 11–12) was once called Ayr Hill for Scottish immigrant John Hunter's hometown of Ayr County, Scotland. It took its present name from Dr. William Hendrick, who had lived in Vienna, New York, and studied medicine in Vienna, Austria.

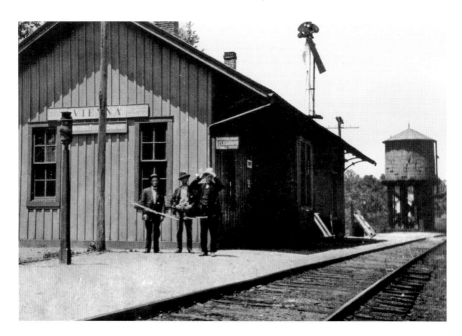

Three men stand outside the Vienna Train Station in 1909 when the depot was a stop on the Southern Railway. *Courtesy Northern Virginia Regional Park Authority.*

This Fairfax County town changed hands several times during the Civil War. It was also the site of an early tactical use of a train in a military conflict. Here, hundreds of Confederates ambushed railcars carrying Union soldiers on June 17, 1861, forcing Northern troops from Ohio to flee to the woods.

Today, Vienna is an inviting place with intriguing restaurants, shops and historic landmarks. Along the trail, look for the Vienna Centennial Park at Church Street with picnic tables, benches and a railroad caboose (between MP 11.5 and MP 12).

Within sight of the park and trail, Vienna's Freeman House Store & Museum (131 Church Street Northeast) was built circa 1859–60. The house served as a Civil War hospital for Confederates. Another time, Union officers stayed inside and kept their horses in the cellar. The town acquired the Freeman House more than a century after the Civil War and restored the structure, which now houses a gift shop and local history displays.

Nearby, Vienna's 1859 restored railroad station stands along the trail (east of MP 12) at the intersection of Dominion Drive and Ayr Hill Avenue. The depot features model trains operated by the Northern Virginia Model Railroaders.

Vienna to Herndon

Washington and Old Dominion Trail runs about eight miles from the Vienna train station to the train station at Herndon, passing both pockets of woods and urban developments. On this stretch, you may see deer jumping among trees. You also overlook the tall buildings of Reston. Along the way, the trail crosses Difficult Run (near MP 14.5), a watercourse that overflowed in 2011 and allowed kayakers a rare chance to actually navigate the trail while it was submerged with water.

Historic markers spotlight the story of the Civil War where the trail crosses Hunter Mill Road, an early transportation route. Both the Union and the Confederacy considered this junction of road and rails (near MP 15) to be strategically important.

The trail crosses the Dulles Access and Toll Road (MP 16) and rolls past the high-rise buildings of Reston, a model community built at the site of Wiehle, an 1890s town developed by Dr. Carl Adolph Max Wiehle. Near the Old Reston Parkway intersection, the trail overlooks the tiny train station at Sunset Hills (near MP 18). Just off the trail, Reston makes a great place to

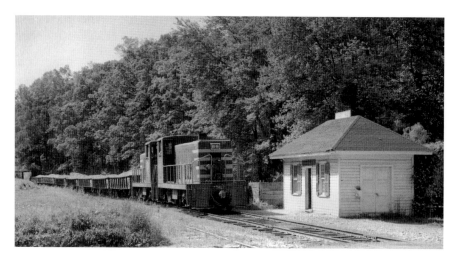

A diesel train passes the tiny Sunset Hills station, near Reston, on what is now the Washington and Old Dominion Trail. *Courtesy Northern Virginia Regional Park Authority.*

explore the vibrant culture and commerce of Northern Virginia, especially at the multifaceted Reston Town Center (MP 18).

West of Reston, the trail enters the charming town of Herndon, boasting a healthy crop of residential and commercial developments. At trailside, Herndon's restored railroad station (MP 20) serves as a museum and a visitor center, near a caboose and trail access area.

Herndon took its name when the railroad was being established in the late 1850s. According to legend, a survivor of the wreck of the SS *Central America* suggested honoring the name of that ship's commander, William Lewis Herndon. Year later, the local dairy industry helped Herndon grow. The town also became a summer cottage resort, attracting wealthy patrons to ride the rails west from Washington, D.C.

Herndon to Leesburg

Following the trail from the Herndon Train Station spans about 14.5 miles to reach the heart of Leesburg, where the railroad's freight station has been relocated, just off the trail.

West of Herndon, the trail threads through residential areas and commercial developments as it slips through Sterling (MP 23.5). Formerly

known as Guilford, Sterling was once the home of a summer house used by President James Buchanan.

Continuing west, the trail crosses VA-28 (MP 24) and Broad Run (near MP 24.5) before reaching Smiths Switch Station (near MP 26), a rest area with picnic tables, restrooms, benches, a trail shelter and a water fountain. In the early 1900s, the flag stop at Smiths Switch was known as Norman's Station while "Smiths Switch" recalls the area's railroad siding, used by a prominent farming family named Smith.

Climbing uphill, the trail approaches Ashburn (MP 27.5), a village with a variety of shops. Ashburn was first called Farmwell when the railroad was built and became one of the rail line's many summer resorts. However, "Farmwell" kept getting mixed up with Farmville, Virginia. So, at the request of the postal service, the name changed in 1896. Some say "Ashburn" comes

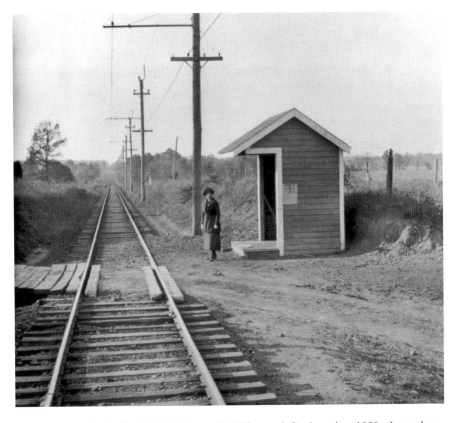

The passenger shed at Smiths Switch was called Norman's Station, circa 1920, along what is now the Washington and Old Dominion Trail, east of Ashburn. *Courtesy Northern Virginia Regional Park Authority.*

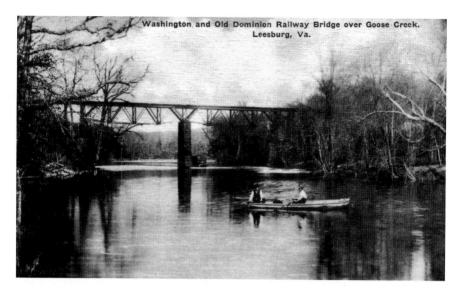

A boat floats below Goose Creek Bridge, circa 1920, on what is now the Washington and Old Dominion Trail. *Courtesy Northern Virginia Regional Park Authority.*

Washington and Old Dominion Trail's western half links Herndon to Leesburg and Purcellville. *Courtesy Northern Virginia Regional Park Authority.*

from the name of a local farm; others maintain it's a reminder of an ash tree that allegedly burned here for a week.

Beyond Ashburn, the trail works its way through woodlands. It overlooks a quarry and then crosses Goose Creek (MP 30) on a bridge that was built atop stone piers dating to the railroad's original antebellum construction. The

trail crosses Sycolin Creek (near MP 30.5) on another bridge with a great view. Between these bridges, look for the Two Creeks Trail Area, featuring a mountain biking trail and a walking path.

Tuscarora Creek crosses the trail (near MP 32.5) as the path enters Leesburg. At an incredibly blind curve, the trail zigzags beneath the U.S. 15 Bypass (MP 33). Next, it passes the antique stonework of a nineteenth-century Leesburg lime kiln (near MP 34).

Leesburg dates to 1758. The Loudoun County courthouse town contains must-see historical architecture, with representations of Georgian, Federal and Greek Revival styles. Lying just a block or two off the trail, Leesburg has also become a popular retreat with its array of boutiques, gift shops, eateries and bed-and-breakfasts.

Among the many Leesburg landmarks, look for Market Station, two blocks north of the trail at 201 Harrison Street Southeast (just west of MP 34), where the railroad's old Leesburg freight station was relocated in 1984 and has since become the site of a restaurant. Continue on the trail for another quarter mile past Harrison Street leads to South King Street, the business route of U.S. 15 (near MP 34.5), near a pleasant green space called Georgetown Park.

Leesburg to Purcellville

Following the trail from Leesburg to the Purcellville train station runs about ten miles. This westernmost section of the Washington and Old Dominion Trail may be most naturally suited for outdoor recreation, with rolling hills and a towering canopy shading the sun. Trees are thicker, businesses less frequent. Street traffic, also, appears lighter as the Northern Virginia suburbs grow less crowded.

Leaving Leesburg, the trail crosses a woodsy area as it climbs the foothills and serves as a sidewalk along Dry Mill Road (miles 37–38). The trail makes a steady but gradual incline and then slips beneath the stone arch of Clarkes Gap (near MP 38.5). This post–Civil War passage through Catoctin Mountain stands at the trail's peak elevation: about six hundred feet above sea level.

The trail passes the site of a healing springs resort, Paeonian Springs, where visitors believed bathing in spring water could produce health benefits (near MP 39). The old Paeonian Springs Station is gone, but in its place is a small flag stop shelter—one that originally stood at Clarkes (Clarks) Gap.

About a mile west of Clarkes Gap, the trail passes through what seems like a church with a high ceiling: what park officials call the "Cathedral" (mile 39.5). Here, high banks stand on the trail's shoulders, and a tunnel of tall trees frames the sky.

The privately owned Hamilton Depot (near MP 41) stands on the south side of the trail, just a few yards before crossing Hamilton Station Road. From here, the trail breezes through more of the scenic Loudoun County countryside until the final mile rolls downhill through Purcellville, where the trail ends just off Twenty-first Street at the restored Purcellville Train Depot (near MP 44.5). Built in 1904 by the Southern Railway, Purcellville's depot includes restrooms, water fountains and benches. It's a great place to take a break before exploring the town.

> **Trail tip**
> Pay attention to traffic patterns when accessing the trail, especially anywhere east of Vienna. Getting stuck in the rush-hour traffic of Northern Virginia can be completely confining.

ACCESS

Arlington/Shirlington: From I-395, use the Shirlington exit. Bear right, heading north on South Shirlington Road, and go to the second stoplight. Turn left on South Four Mile Run Drive. The access area parallels the road but is not recommended for overnight parking.

Bluemont Park: Parking is located at the corner of Manchester and Fourth Street, north of Arlington Boulevard (U.S. 50) and just west of Carlin Springs Road. Another parking area lies off Wilson Boulevard, just west of the Bon Memorial Air Rose Garden and tennis courts, on the south side of the road.

Dunn Loring: From I-495, use the Gallows Road/U.S. 50 exit and follow signs toward Gallows Road North (making a right turn on Gallows). Go past the trail, turn right on Idylwood Road and then turn right on Sandburg Street to reach gravel parking lots on both sides of the trail.

Vienna: One parking area lies outside the Vienna Community Center, 120 Cherry Street Southeast. Another lies near the restored Vienna Train Station, just off Ayr Hill Avenue, near the Dominion Road intersection.

Reston: Access points along the trail include parking areas along Old Reston Avenue and Sunset Hills Road.

Herndon: Parking is available near the Herndon Train Station at the large town municipal center parking lot, near the corner of Station Street and Elden Street.

Sterling: From VA-28, follow Waxpool Road (VA-625) westbound. Turn right onto Pacific Boulevard, pass over the W&OD bridge and turn left into the parking lot access.

Ashburn: Parking is available at a large lot (MP 27.5) near a restaurant at the site of the old Partlows Brothers Store, 20702 Ashburn Road.

Leesburg: One parking area lies behind the Douglass Community Center, 405 East Market Street. Another—available only on weekends during the school year—is at Loudoun County High School, 415 Dry Mill Road Southwest.

Purcellville: Parking is available—only on weekends during the school year—at Loudoun Valley High School, 340 North Maple Avenue. Another access lies just off the trail at Hatcher Avenue (near MP 44.5).

LAKE ACCOTINK TRAIL

Fairfax County

Tracks of the Orange and Alexandria Railroad once spanned what is now suburban Springfield in Northern Virginia. This line fostered the growth of Fairfax County in the 1850s. But in 1862, soon after the Civil War began, the Orange and Alexandria Railroad came under Union control.

The U.S. Military Railroad incorporated this line into its system, and that made it a target for Confederate major general James Ewell Brown "J.E.B." Stuart. He set his sights on a particular railroad trestle built in 1851 over Accotink Creek. Stuart ordered a dozen men to torch it, and the bridge was burned on December 28, 1862.

That trestle at Accotink Creek was soon rebuilt, and it continued to carry supplies for the Union. Years later, when the war was over, the railroad changed hands. It became part of the Southern Railway in 1894.

Today, in Fairfax County, that old trestle over Accotink Creek is gone, but the original right of way for the Orange and Alexandria Railroad has been incorporated into the main access road at Lake Accotink Park. It's also part of a trail near the lakeshore, with portions running on the old railroad grade. This park's name, like the creek, comes from a word with roots in the Algonquian language, meaning "at the end of the hill."

A modern railroad bridge stands high above the dam near the center of the park. The present dam was constructed in 1943 to replace the earlier Springfield Dam, built in 1918.

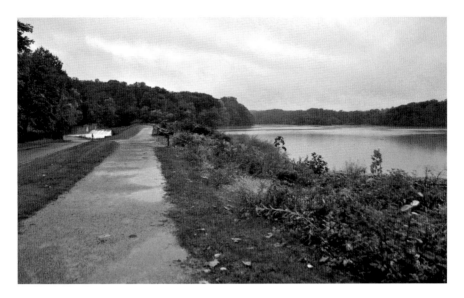

Lake Accotink Trail passes along a dam, far left, and partially follows a railroad grade in Fairfax County. *Author photo.*

TRACKING THE TRAIL

Lake Accotink Park offers a sanctuary among the suburbs. Look for picnic shelters, Lucky Duck Miniature Golf Course and an antique carousel built during the 1940s with hand-carved horses dating to 1926. The fifty-five-acre Lake Accotink is the star attraction and hosts such fun traditions as the annual Lake Accotink Cardboard Boat Regatta each spring.

Ideal for foot traffic or mountain bikes, the Lake Accotink Trail runs for about four miles on a surface that ranges from asphalt to crushed stone. Signs at the park indicate the route of the trail. Start at the main recreation area, where you'll find the marina, beach and carousel.

Going right, the trail slips over a small bridge and soon overlooks a tangle of trees at the edge of the lake. Cross another bridge in a few more yards as the trail winds around the woodsy shoreline of the lake. It's peaceful.

Going left, by returning toward the park entrance road, the trail remains at the edge of the lake. It actually runs beside the reservoir like a sidewalk as it aims for the dam. The portion that passes by the dam, however, may not always be accessible. High-water conditions sometimes shut off the passage. After this point, the trail climbs steeply and continues through the woods beyond the dam on the old rail bed.

ACCESS

Lake Accotink Park lies in the Springfield area of Fairfax County, 7500 Accotink Park Road, near an intersection with Southern Drive. From Ox Road (VA-123) near University Mall and the campus of George Mason University in Fairfax, follow Braddock Road (VA-620) east for 3.8 miles. Turn right on Rolling Road and go 2.5 miles. Turn left on Old Keene Mill Road and go 2.3 miles. Turn left on Hanover Avenue and go 1.0 mile. Turn left on Highland Street and go 0.2 miles. Bear right on Accotink Park Road and go 0.4 miles then turn left into Lake Accotink Park and proceed for about 0.5 miles to the parking for the main recreation area.

WARRENTON BRANCH GREENWAY

Warrenton

John Singleton Mosby came to be called the "Gray Ghost"—and for good reason. The Confederate colonel possessed an uncanny gift for slipping in and out of situations like a thief in the night. That caused the Union to waste time worrying where Mosby and his "Rangers" might strike next—even if Mosby was nowhere around.

Why, merely mentioning that the man was in the neighborhood during the Civil War might spark hysteria, like it did one Sunday night at Warrenton in April 1863. Somebody said Mosby would soon be charging up Winchester Street, and a small Union force prepared a defense by piling logs and other objects—including a fake cannon—to make a barricade. But as it turned out, only the Union cavalry's imaginations saw Mosby and his Rangers cutting through the night.

Mosby did actually get to Warrenton—more than once. He also had a special attachment to the counties surrounding the Fauquier County courthouse town, where his exploits wreaked such havoc on the Union that the Federals called the region "Mosby's Confederacy."

Troops traveled by rail during the Civil War—a time when Mosby, a young attorney, left his law practice at Bristol and joined the Washington Mounted Rifles in Southwest Virginia. He eventually befriended Major General James Ewell Brown "J.E.B." Stuart, a Confederate cavalry leader who encouraged Mosby's hit-and-run charges against the Federal troops.

Mosby—a wartime guerrilla—spent a lot of time disrupting trains. Still, not everything went as planned. Mosby suffered a setback after a raid went

wrong on May 3, 1863, leaving several men dead, wounded or captured at Warrenton Junction—the place where the Warrenton Branch begins, at what was later called Calverton.

As early as 1852, the Warrenton Branch connected Warrenton to the Orange and Alexandria Railroad. This nearly nine-mile-long railroad extension became a supply line for both the Confederacy and the Union during the Civil War.

Rail traffic remained steady on the Warrenton Branch through the early 1900s, when the Southern Railway operated the line. Freight service continued past World War II. But passenger service did not, due to wartime cutbacks and an increased reliance on cars and buses. Ten years later, in 1951, the Southern switched to diesel locomotives that could run either forward or reverse, and that switch made the turntable at Warrenton obsolete.

In 1976, the Warrenton depot was sold; it later became a restaurant called Claire's. A dozen years after that, freight service stopped at Warrenton in 1988. The town's railroad tracks were removed. Part of the railroad right of way became the Warrenton Branch Greenway in 1998. Along the way, the concrete foundation of the old Warrenton turntable was uncovered and restored after being buried near the end of the line.

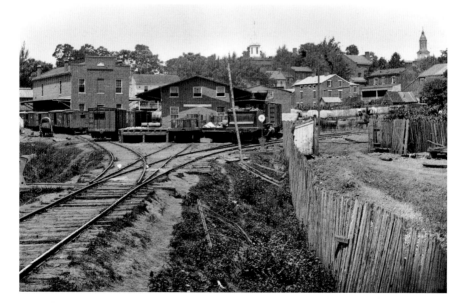

Photographer Timothy H. O'Sullivan captured this Civil War–era scene of the railyard on the Warrenton Branch in August 1862. *Library of Congress.*

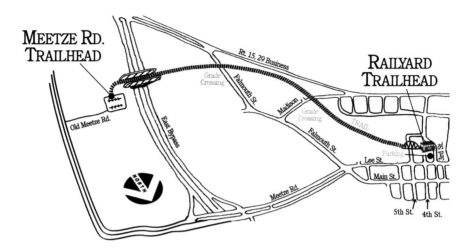

Warrenton Branch Greenway links Meetze Road to the downtown trailhead, just off Third Street. *Courtesy Fauquier County Parks and Recreation.*

As for Mosby, he reached the end of his line in 1916 and was buried at Warrenton. He had come to town to practice law after the Civil War and, perhaps ironically, befriended Union general Ulysses S. Grant. That association did not sit well with Mosby's fellow Southerners—and once, as Mosby got off a train at Warrenton, somebody tried to shoot him.

The "Gray Ghost" survived that skirmish. Years later, Mosby's funeral on June 1, 1916, attracted a crowd of three thousand—after his body was carried to the train station on the Warrenton Branch.

Today, Mosby's home at Warrenton has become a historical museum, and a portion of the railroad that he traveled—in life and death—has become a peaceful path to walk, jog or ride a bike, never straying far from Warrenton's intriguing attractions: the Old Jail Museum, Liberty Heritage Museum, Lincoln and Washington Museum and the Mosby Museum, which honors the Confederate colonel.

TRACKING THE TRAIL

Warrenton Branch Greenway spans nearly one and a half miles of the old Warrenton Branch. Overseen by the Fauquier County Department of Parks and Recreation, it's the scene of many races, runs and rides.

The asphalt surface is also easy enough—and flat enough, with few grade changes—that a child could learn to ride a bike. All along, vintage railroad signs provide a definite track-to-trail ambiance on this greenway, bordered by rhododendron and redbuds.

The trail begins in the downtown corridor and immediately arrives at the old railyard. This yard consists of a restored Norfolk and Western Railway caboose, sitting on a short section of rail line, next to a small passenger shed with the town's name in large letters.

Just past the railyard, the trail makes a crossing on its signature curved bridge, arching high above Fifth Street. About a quarter mile beyond that bridge, look right for the remains of the branch's old turntable, used to turn engines in the opposite direction.

The path crosses Madison Road (at a half mile from the trailhead). From here to the next road crossing at Falmouth Street (about a third of a mile), the trail comes close to paralleling East Shirley Avenue (U.S. 15/U.S. 29 Business).

Beyond Falmouth Street, the greenway moves increasingly away from town, and trees arch overhead, nearly touching at the trail's center. The path

Railroad markers like this one highlight the paved path of the one-and-a-half-mile-long Warrenton Branch Greenway. *Author photo.*

passes a pond in a wooded area at left. Finally, 1.3 miles from the start, the rail trail passes over U.S. 29 on a giant bridge, guarded by a chain-link fence. Then it takes a left turn and scurries to a finish, within 0.25 miles, at Old Meetze Road.

ACCESS

Railyard: The trailhead in downtown Warrenton lies at the end of South Fourth Street, near the East Lee Street intersection. It is just behind Claire's at the Depot, a restaurant housed in Warrenton's old train station on South Third Street.

Old Meetze Road: From the downtown trailhead near the corner of South Fourth Street and East Lee Street, follow Lee Street southeast for about 0.5 miles and then continue on Meetze Road for another 0.5 miles. Turn right on Old Meetze Road and go 0.3 miles to the trailhead.

VIRGINIA CENTRAL RAILWAY TRAIL

Fredericksburg

It's been one name—or nickname—after another for the railroad heading west of Fredericksburg. As early as 1853, this line was known as the Fredericksburg & Gordonsville Railroad. But no cars rolled down any tracks. The company ran out of money after buying land, grading the ground and building bridges—all prior to the Civil War, a time when the trackless terrain of the "Unfinished Railroad" was used for troop movements.

From 1871 to 1873, this line adopted a lengthy moniker: the Fredericksburg, Orange and Charlottesville Railroad Company. Then it reverted to its original name—until 1876. After that, the line was finally completed in 1877, and until 1925, it was known as the Potomac, Fredericksburg & Piedmont Railroad Company, though the initials "PF&P," to many, comically became the "Poor Folks & Preachers" railroad.

Again, the name changed. Starting in 1925, the line spent one year as the "Orange & Fredericksburg Railroad." Then, in 1926, the name became the Virginia Central Railway, which dubbed itself the "Battlefield Route," a nickname recognizing the rail bed's ties to Civil War history, especially around Fredericksburg.

The story of the Civil War defines much of Fredericksburg. Mass tombs shoulder the city and haunt home after home in the tree-lined town with tales of bullets, cannonballs and caskets. Chartered in 1728, this port on the Rappahannock River changed hands multiple times during the war between North and South but became known for the Confederate victory at the Battle of Fredericksburg on December 11–15, 1862—a decisive win for General Robert E. Lee.

As for the Virginia Central Railway, its story changed considerably in the 1930s when train traffic dwindled. Most of the route shut down in 1938. But one mile stayed open in downtown Fredericksburg until finally closing in 1983, ending more a century of railroad history. Decades later, portions of the old railroad grade in the Fredericksburg area became rail-to-trail projects.

TRACKING THE TRAIL

Sections of the Virginia Central Railway grade have morphed into the Virginia Central Railway Trail in Spotsylvania County and nearby Fredericksburg; the Spotsylvania section has also been called the "Virginia Central Bicycle Trail." Each path spans slightly more than two miles, and as of 2014, they do not connect. Yet long-range plans have called for a united line that will eventually link Fredericksburg to Orange.

Virginia Central Railway Trail borders Alum Spring Park, at right, as it approaches Jefferson Davis Highway in Fredericksburg. *Author photo.*

Virginia Central Railway Trail: Fredericksburg

East of I-95, the Virginia Central Railway Trail hit the fast track of construction in 2014. This 2.7-mile-long trail links a warehouse and residential district with the intriguing Alum Spring Park.

Near downtown Fredericksburg, the paved trail begins at a small brick plaza just off Essex Street, immediately southwest of the intersection of Jackson Street and Lafayette Boulevard. For nearly a half mile, the urban trail doubles as a sidewalk for the Cobblestone residential development; it follows the path of the railroad grade while paralleling Cobblestone Boulevard.

The path crosses Willis Street (near mile 0.4) and makes its way beside businesses. Then it takes a turn beneath Lafayette Boulevard, makes a loop and follows along Lafayette to its busy intersection with the Blue & Gray Parkway (VA-3). The trail turns right and makes yet another change for 0.5 miles. The trail parallels a lane called Alum Spring Road and then becomes a shaded path as it follows the southern border of the city's Alum Spring Park to Jefferson Davis Highway (U.S. 1).

Alum Spring Park serves as a central gathering ground along the trail. The park's footbridges and footpaths lead past a playground, picnic tables, sandstone cliffs and points along Hazel Run, including Fat Annie's Old Swimming Hole. Local lore says this wide spot on the creek was once a hangout for local boys going skinny-dipping. But a rather large woman did not enjoy their company, and the swimming hole—where swimming is no longer allowed—became known for her name, Annie, sometime after the 1920s.

Just west of Alum Spring Park, construction continued in 2014 on another section of the Virginia Central Railway Trail. That portion, shaded by trees, spans about a mile beyond Jefferson Davis Highway as it reaches the Idlewild neighborhood and stops near I-95.

Virginia Central Railway (Bicycle) Trail: Spotsylvania County

West of I-95, the Virginia Central Railway Trail of Spotsylvania County runs 2.1 miles in a forest-like setting, bordering backyards. Paved with asphalt, the trail links Salem Church Road with Gordon Road. The main access lies at a park with ball fields off Harrison Road (VA-620). From here, you can reach the trail access lane at the far end of the parking lot near the back of the ball fields.

┌─ ─ ─ ─ ─ ─ ┐

| **Trail tip** |
| The return is easy. Your |
| uphill journey has now |
| become a coast-is-clear, |
| downhill slide to Harrison |
| Road Park. |

└─ ─ ─ ─ ─ ─ ┘

Turning right at the trail reaches the east end of the trail at Salem Church Road in 0.1 miles.

Going left from the trail access runs mildly uphill for 1.1 miles. Then the trail intersects with Harrison Road. At this point, turn right and go a few yards down the sidewalk. At the traffic signal, use the crosswalk and return to the remainder of the trail on the opposite side of Harrison Road, near Green Arbor Drive. This next portion spans a little more than 0.5 miles; it cuts through a more narrow space but stays under shade trees while offering plenty of company, including dog-walkers, bicycle riders and joggers.

The trail stops at Gordon Road, though a connecting path—just a few yards before the end—takes a left and winds up at a cul-de-sac on Doryl Drive, near Merridith Lane, where limited parking may be available.

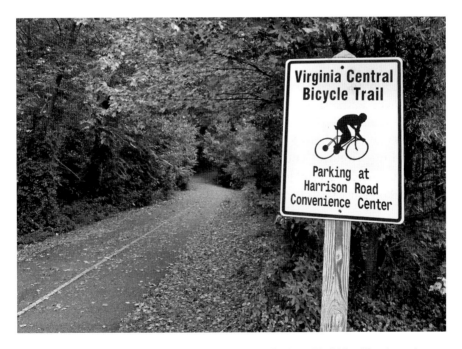

Spotsylvania County's section of the Virginia Central Railway Trail identifies the path as "Virginia Central Bicycle Trail" as it weaves its way through woods near Harrison Road. *Author photo.*

ACCESS

Fredericksburg: From I-95 Exit 130, follow VA-3 (Plank Road) east for 1.3 miles. Turn right on Greenbrier Drive and go 0.4 miles to enter Alum Spring Park. Beware: all vehicles entering the park must drive over a concrete ford of Hazel Run. This entrance is closed during high-water periods.

The rail trail borders the southern boundary of the park, just beyond the parking area, where park maps are posted. Look for an access to the trail along Alum Spring Road, just behind the park office building. You can also follow a footpath for about thirty yards beyond the picnic shelter and playground. Turn left and follow between the cliffs and Hazel Run, and then bear left when the trail forks and climb a few stairs to reach the rail trail at a point about a quarter mile above the trail's crossing with Jefferson Davis Highway (U.S. 1).

Spotsylvania County: Access at Harrison Road Park, 5917 Harrison Road, in Fredericksburg, near Salem Church Road intersection.

CHAPTER 10

RAILROAD FORD TRAIL

Lake Anna State Park ·

L ong before the California gold rush, prospectors shoveled their way into the clay of what became Lake Anna State Park. Gold was discovered at this spot in Spotsylvania County as early as 1829. Yet nearly a century later, gold would not be the metal needed to win World War I. Bullets required lead, and in 1917, that's why steam trains streamed across what was once called Gold Hill.

A 17.5-mile-long narrow-gauge track crossed the North Anna River in the early 1900s. It connected the ore of the Holladay Mine, at the north, with the Allah Cooper Mine, farther south. Later, the zinc and lead extracted from the ore was transported to Mineral, a town in Louisa County. There, this spur line joined the Chesapeake and Ohio Railway, and the railroad cargo was eventually sent to factories to make shell cartridges and bullets to fight on the front lines of the Great War.

Today, a portion of this old rail route lies inside Lake Anna State Park. This summertime oasis boasts a busy beach (open Memorial Day to Labor Day), plus ten miles of waterfront, cabins, picnic areas and the site of the former Goodwin Gold Mine, where park visitors can try their luck panning for gold on Pigeon Run. The 2,810-acre park opened in 1983, about a decade after the creation of the 13,000-acre Lake Anna in 1971 to supply cooling water for the Virginia Electric and Power Company's North Anna Nuclear Power Plant.

The state park's picturesque Railroad Ford Trail follows a small section of the old rail corridor. "The park road is on the main ridge line through

the property, and, so, that's where the railroad was, too," said longtime park manager Doug Graham. "Then, when you get to the waterfront, it went to the left. And the 'Railroad Ford' would have been the bridge across the North Anna River."

TRACKING THE TRAIL

Railroad Ford Trail begins behind the Lake Anna State Park visitor center, near the end of the sidewalk. The scenic dirt path is open for foot traffic only. Look for red blazes on the trail. Maps of all park trails are available at the visitor center.

Bear right as the one-and-a-half-mile-long loop begins, and proceed toward the lakeshore, traversing tree roots along the banks. Here, tiny trails escape from the main branch and sneak to the shoreline. No wonder: Lake Anna is widely known for its crappie and largemouth bass fishing.

After most of a mile, the path climbs a hill on a peninsula, offering several vantage points. Then it leans left and joins the old rail bed. At this juncture, the trail becomes wider and more flat in the mixed hardwood and pine

Railroad Ford Trail includes a small portion with a steep grade at Lake Anna State Park. *Author photo.*

forest. Continue to follow this easier portion. Turn left on the Glenora Trail and go a few yards to finish the loop by joining the sidewalk and returning to the visitor center.

ACCESS

Lake Anna State Park is located at 6800 Lawyers Road (VA-601) at Spotsylvania, about twenty-five miles southwest of Fredericksburg. At the entrance, follow the state park road for about two and a half miles to the visitor center.

ASHLAND TROLLEY LINE

Ashland

Frank Jay Gould dreamed of a railroad that would not only run through Richmond. Gould outlined a high-speed electric run, wanting to eventually link Norfolk to the Northern Neck. But obstacles stood in the way, including a ripple in the stock market during October 1907. Money became tight. So this New York financier had to simply settle for opening a short sprint between Richmond and Ashland, using an electric trolley with luxury cars.

Spanning almost fifteen miles, Gould's Richmond and Chesapeake Bay Railway officially opened on October 28, 1907. Service began at the Richmond Depot, standing at the corner of West Broad and Laurel Streets. Then, heading north, the line ran mostly parallel to U.S. 1, crossed the Chickahominy River and entered Hanover County, the birthplace of American patriot Patrick Henry. The railway ended at a trolley station in Ashland, at the corner of Maple and England Streets.

Though popular, the line proved unprofitable. It changed hands during World War I and reopened in 1919, using less expensive cars that ran on fewer volts. But accidents—including a head-on collision between two trolleys in 1922—would strain financial resources. What was lastly known as the Richmond-Ashland Railway ran for the final time in 1938.

The Virginia Electric and Power Company purchased the railroad's right of way to run electric transmission lines. Later, a small section of the line opened as a rail trail in Hanover County at the south end of Ashland.

Today, a post office stands at the site of the old trolley depot in Ashland, a college town that takes its name from the Kentucky estate of Hanover County native Henry Clay, a famous American statesman.

Trail tip

Ashland's active rails make it the kind of town you want to duplicate with model trains. Much of the town's charming architecture owes its origin to Ashland being established as a summer retreat, built along the Richmond, Fredericksburg and Potomac Railroad in the mid-1800s. Near the center of town, Ashland's Railside Trail offers an up-close glimpse of the much-active tracks near the campus of Randolph-Macon College. This rail-with-trail follows the tracks for almost a half mile, linking the northern end of North Center Street to West Vaughan Road.

TRACKING THE TRAIL

Not far from Ashland's downtown district, the Ashland Trolley Line consists of a mostly natural surface of dirt, with some gravel. It follows along power lines and spans almost one mile of the path once used by trolleys. The trail offers little evidence of railroad history on the landscape, but you can hear the sweet tones of trains echoing on the nearby CSX tracks, passing just beyond the leafy woods. The rail trail stops at a bright-red sign, saying, "END OF ASHLAND TROLLEY LINE," just before the path meets Maple Street.

ACCESS

From I-95 Exit 92, follow England Street (VA-54) west into Ashland for about 1.2 miles. Immediately after crossing the railroad tracks, turn left on South Railroad Avenue (VA-663), which becomes South Center Street, and go 1.9 miles. Turn left on Gwathmey Church Road (VA-707) and go 0.2 miles to the trailhead for the Ashland Trolley Line on the left, just before the "END STATE MAINTENANCE" sign.

CHESTER LINEAR PARK

Chester

C hester shares its name with Chesterfield County. Both places are situated south of Richmond and take their names from British statesman Philip Dormer Stanhope, the fourth Earl of Chesterfield. In a neighborhood on the west side of Chester, a short portion of the Seaboard Air Line Railroad right of way has been converted into the twelve-acre Chester Linear Park. Chesterfield County Parks and Recreation oversees this path, meandering for most of a mile.

TRACKING THE TRAIL

Sandwiched among suburbs, Chester Linear Park partially resembles a mountain bike trail in a scattered section of woods. A few park benches stand along the trail. The narrow passage is suitable for casual walks, runs and short rides. The trail begins along the sidewalk of a commercial district of West Hundred Road (VA-10), next to a bank. Initially, the trail leads beneath shade trees before crossing over Ecoff Avenue (mile 0.3). Just beyond, the gravel path reaches a small parking area. The trail continues to Chester Village Drive (mile 0.7) and then wanders into the woods for a few more yards on a sandy-clay surface shaded by pines and oaks.

ACCESS

From I-95 Exit 61B at Chester, follow West Hundred Road (VA-10) west for 2.7 miles to Ecoff Drive. Turn right and go 0.3 miles to cross the trail near a parking area. (To reach the southern trailhead, simply continue on West Hundred Road for another 0.2 miles beyond Ecoff Drive; the trail starts at right.)

CHAPTER 13

HIGH BRIDGE TRAIL STATE PARK

Farmville

Heading for the hills was about all a Rebel soldier could do in April 1865, with the Confederate capitol of Richmond in flames. But running, of course, also meant fighting your way to the west: a grim reality for the troops commanded by Confederate general Robert E. Lee. As it turned out, these troops faced the final days of the Civil War, and for the South, rations were running low.

On April 6, Lee's men suffered a disastrous blow at the Battle of Sailor's Creek. Afterward, with so many men wounded, killed or captured, Lee surveyed the situation and wondered, "My God! Has the army been dissolved?"

Answer: almost.

Still, many believed there remained a fighting chance.

The next test came at High Bridge, a gargantuan railroad crossing that spanned more than 2,400 feet in length and stood 117 feet above the Appomattox River. The bridge was part of the South Side Rail Road. On April 6, 1865, the same day as the Battle at Sailor's Creek, Union troops tried to burn the High Bridge. But, the Confederate cavalry defeated their charge.

The next day, you might say, there was a switch at the tracks.

Within only a few hours, the westward-bound Confederate army had crossed the High Bridge. These starving men planned to find fresh supplies at Farmville. But making their retreat complete would also mean burning the High Bridge behind them and leaving the Appomattox River as a barrier

between their band—the ragtag remnants of Lee's Army of Northern Virginia—and the more well-equipped Federal forces.

On April 7, the Confederate army torched four spans at the west end of the High Bridge. The mighty structure was engulfed in flames. But that was not enough. The Union army found its way across the Appomattox River. It crossed on a tiny wagon bridge, down at the river's level. That bridge, too, had been set ablaze. But the river was so high and the lumber was so green that all a Union soldier really had to do was dip a canteen in the river and douse the flames.

The chase stayed on. In only two more days, it would all be over. Just a few more miles to the west, in a place that shares its name with the river—Appomattox Court House—Lee surrendered to Union general Ulysses S. Grant on April 9.

For a dozen years prior to the War Between the States, the High Bridge had stood, well, high above the Appomattox. It was a great feat of engineering and produced so the South Side Rail Road could connect Petersburg to Lynchburg in 1854. "There have been higher bridges not so long, and longer bridges not so high," said the railroad company's chief engineer, C.O. Sanford. "But taking the length and height together, this is, perhaps, the largest bridge in the world."

Tourists took note. Men and women came to the outskirts of Farmville to stroll the big bridge's deck, making this an antebellum rail-with-trail.

Edward Beyer provided what may be the earliest image of High Bridge: a lithograph, produced in the 1850s. *Author's collection.*

German artist Edward Beyer also stopped by while traveling the United States and made a popular portrait of the bridge—a lithograph—that was printed in 1858.

The reason this big bridge was even built can be traced to the people of Farmville in the early 1850s. An alternate route had been proposed, cutting to the south at Prince Edward Court House, at a place later known as Worsham. But Farmville's most prominent citizens rallied to have a railroad route pass *through* their town—not bypass it. They even pledged a purchase of $100,000 in railroad company stock. Even so, to fulfill that promise meant banking on building the High Bridge—and spanning a half-mile-wide valley of the Appomattox River just east of Farmville.

The High Bridge became a scene of sheer magnificence, though it was one with at least some comedic proportions. That is, to look at this big bridge—spanning roughly a half mile in length—is to see what it took to, at one time, give the people what they want. Down below, the Appomattox River measures just sixty or seventy feet wide. But here was this big bridge, built to keep the railroad grade smooth and consistent as it worked its way

This 1865 photograph of High Bridge shows temporary scaffolding put in place to repair trusses damaged by the Confederacy near the end of the Civil War. *Library of Congress.*

west and, ultimately, blaze a trail for those Rebels who would, one fateful day, follow it toward Farmville.

Soon after the Civil War ended in 1865, both Federal troops and the South Side Rail Road worked on repairing the railroad. The damaged bridge was fixed, and trains ran again that September.

As time marched on, the big bridge was rebuilt periodically with new trusses. Yet trains continued to grow heavier and longer until finally, it was time for a new High Bridge. That's the one that remains today, constructed in 1914 alongside a dozen of the original brick piers from the first bridge: ghostly reminders of one town's insistence on having a railroad running through it.

A locomotive passes over the current High Bridge in 1928. This newer bridge was built in 1914 out of necessity: Trains were getting heavier and longer, and the bridge needed a stronger superstructure. *Courtesy Virginia Tech.*

Photographer Timothy H. O'Sullivan captured this photo of himself in April 1865, leaning on the railing of the original High Bridge. *Library of Congress.*

Train traffic was diverted from the old High Bridge to the new High Bridge on June 22, 1914. Passengers of the line continued to stop at depots in Farmville, Prospect and Rice. But this route would be bypassed, after all, as rails were built to the south. The High Bridge, ultimately, factored into finally closing the route through Farmville. The Norfolk Southern Corporation—then the owners of the line—had deemed the High Bridge just too costly to maintain. The final train ran on July 15, 2005.

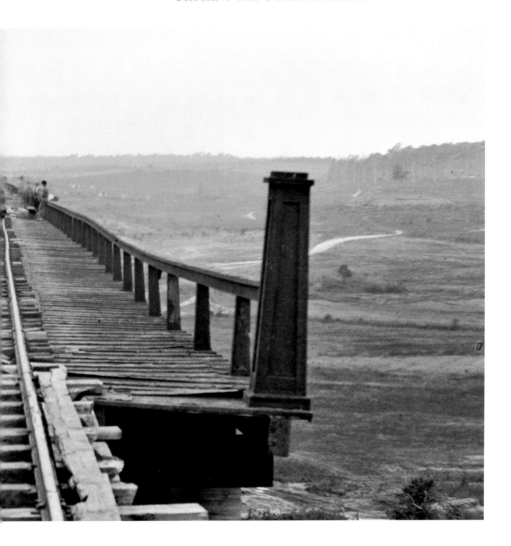

The railroad company donated the abandoned line between Burkeville and Pamplin City to the Commonwealth of Virginia: a gift that naturally lent itself to become the High Bridge Trail State Park. The first four miles of the trail opened near Farmville on August 22, 2008. After that, the trail was completed section by section until, finally, with new decking and overlooks, the historic High Bridge opened to hiking, biking and horseback riding on April 6, 2012—a date marking the 147th anniversary of the first battle for the bridge during the Civil War.

Mile markers from the railroad era—with *N*s, noting the distance to Norfolk—remain where this trail passes through the counties of Cumberland,

Nottoway and Prince Edward. The trail, in turn, has been well received, said the park's first manager, Eric Hougland. "One thing about the communities here," he said. "They have embraced this park. If something's good for one community, it's going to be good for all of us, because we're interconnected by this rail trail."

TRACKING THE TRAIL

High Bridge Trail State Park works well for short hikes, like exploring Farmville, or checking out the High Bridge, as well as longer excursions on horseback or bicycles. Walking, you don't notice much of an elevation climb, moving east or west. The thirty-one-mile-long trail's crushed limestone surface and largely flat grade is also easy on a bicycle. Come here at night, during walks conducted by park rangers, and it appears the trail's smooth, bleach-white surface practically glows in the light of a full moon.

High Bridge Trail State Park's western half mostly parallels U.S. 460, connecting the communities of Elam, Prospect and Tuggle. *Courtesy Virginia State Parks.*

Pamplin City to Farmville

West of Farmville, a quiet section of High Bridge Trail State Park stays close to and largely within sight of U.S. 460 as it stretches for almost sixteen miles starting at an access near Pamplin City, once the home of the largest clay pipe factory in the world. From the west, the trail makes a gradual downhill roll to the west side of Farmville.

Shouldered by trees, including Virginia pines, the trail runs near residences and crosses several secondary state highways, all the while offering a feast of farms, fields and forests. Wildlife sightings on this portion may include bobcats, bears, deer, red foxes and groundhogs. Look for picnic tables along the way, plus restrooms at the Pamplin City–area trailhead and in Prospect and Tuggle.

The trail runs for three miles from the parking lot near Pamplin City to the next parking access at Elam. The distance spans 3.5 miles from Elam to Prospect, where an old depot stands near the trail access. The stretch from Prospect to Tuggle runs 3.9 miles. Along the route, beware of steep drop-offs in the hardwood forests.

From Tuggle, the trail spans 5.4 miles—and crosses beneath U.S. 460—as it heads to Farmville. It passes over Farmville's Third Street (about four miles from Tuggle) as it comes into town to reach the old Farmville train station near Appomattox Street, about 0.5 miles east of the Buffalo Creek Bridge.

Passengers wait outside the Prospect Train Station, circa 1917, along the tracks that are now High Bridge Trail State Park. *Courtesy Virginia Tech.*

Farmville

Many trail users come from the student population at Farmville's Longwood University, a central landmark in this inviting small town, where residents and businesses have lovingly embraced the trail, just as their ancestors lobbied for the train to pass through Farmville generations ago. Landmarks in the downtown district reflect the region's railroad heritage. So do bricks, laid in concrete in the shape of railroad tracks.

Going east of Farmville—on a typical bike ride—follows the trail for about five miles to reach the far end of the famous High Bridge. On this journey, after leaving the restored Farmville train station at 510 West Third Street, the trail reaches the municipal parking access on Main Street (mile 0.3), River Road bridge (mile 0.5), Osborne Road access (mile 0.8), River Road access (mile 3.8), west end of High Bridge (mile 4.7) and east end of High Bridge (mile 5.2).

High Bridge

A great destination for family outings, the High Bridge is the iconic anchor attraction of the entire High Bridge Trail State Park. Stretching ten feet wide, the bridge overlooks the Appomattox River, where you may occasionally catch a glimpse of a kayak or canoe.

If you only want to see the High Bridge, you only have to walk about 1.0 mile. Start at the River Road access, which includes a restroom, and head east for 0.9 miles to the bridge's west end. From here, the High Bridge stretches 0.5 miles to its eastern end. Be sure to notice the piers of the original antebellum bridge, standing beside the current structure.

Rice

Typically, for many users on the trail, Rice serves as a gathering spot, going either east or west. The access has restrooms. It's also a place with history: both Confederate and Union troops moved through Rice on April 6, in the closing hours of the Civil War, and it was a headquarters for Confederate general Robert E. Lee.

Westbound, one typical bike ride starts at Rice and goes to Farmville— that's eight miles, one way. Immediately on this stretch, beyond the parking

A horse-drawn carriage (at left) waits outside the Farmville Train Station in this early 1900s photograph, captured along what is now High Bridge Trail State Park. *Courtesy Virginia Tech.*

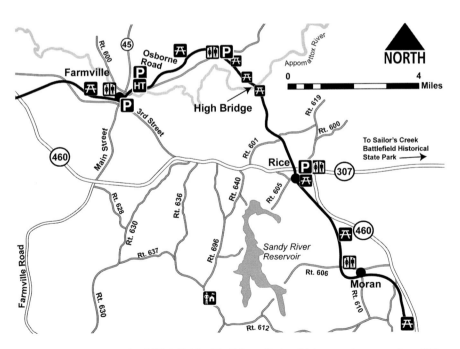

Picnic tables line the path of High Bridge Trail State Park, which meanders away from U.S. 460 between Farmville and Rice to reach the High Bridge. *Courtesy Virginia State Parks.*

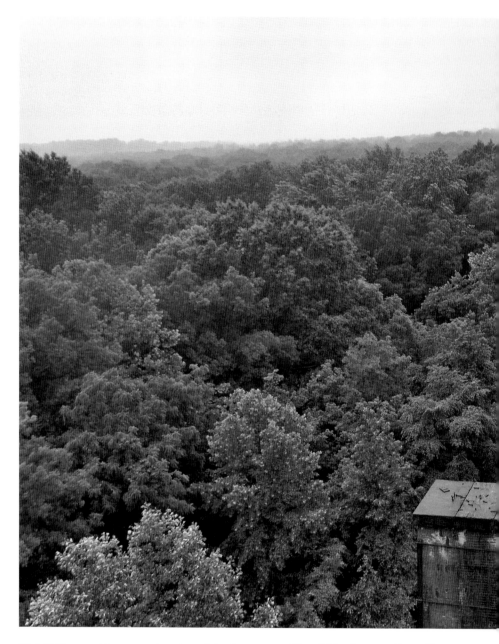

High Bridge provides a sweeping view of the Appomattox River Valley, between Farmville and Rice. *Author photo.*

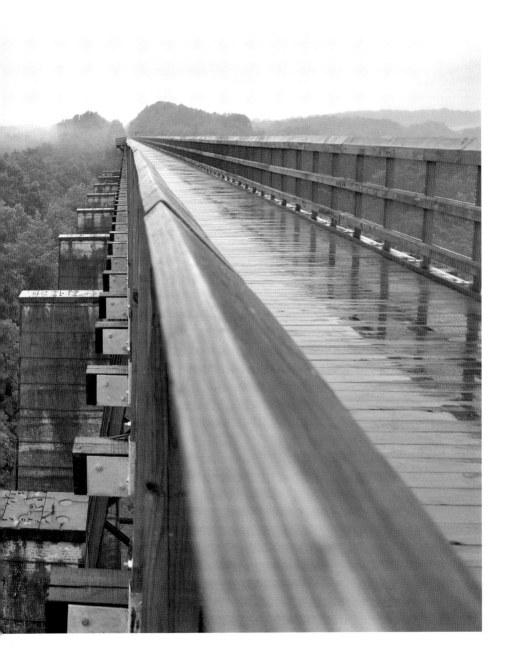

area at Rice, this trek crosses U.S. 460 (mile 0.2), Aspen Hill Road (mile 1.2), east end of High Bridge (mile 3.1), west end of High Bridge (mile 3.6), River Road access (mile 4.5), Osborne Road access (mile 7.5), River Road bridge (mile 7.8) and Farmville's Main Street (mile 8).

Going east of Rice, the remainder of the trail follows quite quietly along U.S. 460, spanning 3.8 miles from Rice to Moran Road (VA-610). From there, it's another 3.0 miles to the end of the trail near Burkeville.

> **Trail tip**
> Visit the Virginia's Heartland Regional Visitor Center and Transportation Heritage Museum at 121 East Third Street, Farmville, where scale-model exhibits and historic photographs showcase the High Bridge.

ACCESS

Pamplin: From U.S. 460, follow Pamplin Road south for 0.7 miles. Turn left on Heights School Road (VA-660) and go 0.1 miles to the trail access, near milepost 168.

Elam: Access off U.S. 460 at Sulphur Spring Road (VA-657), near milepost 164

Prospect: From U.S. 460, follow Prospect Road (VA-626) south for 0.1 miles to the access, near milepost 161.

Tuggle: From U.S. 460, follow Tuggle Road (VA-695) southeast for 0.7 miles. Turn right on Hardtimes Road (VA-648) to reach the access, near milepost 156.

Farmville: Downtown access at municipal lots where the trail intersects with Main Street, near milepost 150

Osborne Road: Access lies 0.3 miles off North Main Street in Farmville, near milepost 149

Farmville/River Road: From North Main Street in Farmville, follow River Road (VA-600) east for three miles to the access, near milepost 146.

Rice: From U.S. 460, follow Rice's Depot Road (VA-600) south for 0.2 miles to the trail access, near milepost 142.

VICTORIA RAILROAD PARK

Victoria

Victoria boasts a name literally fit for a queen. Once, this tiny town marked the halfway point between Roanoke and Norfolk on the Virginian Railway, a line built to haul coal from West Virginia to the ports of Hampton Roads. Created in 1906 and incorporated a decade later, Victoria was named by the railroad's builder, Henry H. Rogers, for Queen Victoria.

Railroad shops helped Victoria grow among the farms of Lunenburg County. Some prospectors even dreamed Victoria might blossom into a "Magic City" the size of Roanoke. But Victoria's boom ran out of steam with the passing of the steam-train era.

Passenger trains stopped coming to town in 1956; officials capped steam operations the following year. Then came further downsizing, starting in 1959, when the Virginian merged with the Norfolk and Western Railway. By then, the center of Victoria had boasted multiple lanes of rail traffic plus a turntable and a roundhouse.

Today, the outline of all that rail action has been preserved at Victoria's Railroad Park, 1403 Firehouse Road, about a half mile from the downtown district. Victoria's twenty-one-acre Railroad Park boasts two pavilions, a playground, a volleyball sand court and horseshoe pits, plus a display of Virginian railroad cars, including a C-10 Caboose, No. 342, delivered to the town in 2004.

A rail trail passes through the park. Part of Virginia's Tobacco Heritage Trail system, this path follows a portion of the Virginian line that was abandoned by the 1980s, when rail traffic was shifted to the Norfolk Southern main line that

Victoria Railroad Park includes a Virginian rail car on display. *Author photo.*

runs through nearby Crewe. Uniquely, the rail trail in Victoria follows a split between watersheds, with creeks on the west side draining to the Meherrin River and streams on the east emptying into the Nottoway River.

TRACKING THE TRAIL

Victoria's rail trail spans about two miles, going roughly one mile either north or south of the Railroad Park. Lined with pines and covered with crushed gravel, the largely flat grade makes a bike ride easy and enjoyable.

Starting at the northern access near Tenth Street, the trail turns left. It soon reaches the Victoria Railroad Park and then wraps around the park's perimeter on sidewalks that were built on what was part of Victoria's bustling railroad yard.

Southeast of the park, the trail parallels Firehouse Road (Route 1055) for several yards and then crosses Railroad Avenue. From here, the trail meanders alongside Twin Cemetery Road (Route 1009) for about one mile and borders light woods before meeting that same road at a space with limited parking.

ACCESS

Northern Access: From Fifth Street, near the Victoria Railroad Park, follow Main Street for a half mile north. Turn left on a gravel road opposite Tenth Street to reach the parking area, immediately on the left.

Firehouse Road: Victoria Railroad Park lies one block west of Main Street (VA-40), near the Fifth Street intersection, at Firehouse Road.

Twin Cemetery Road: From Main Street (VA-40), follow Twin Cemetery Road (Route 1009) southeast for 0.7 miles to a trail intersection and small parking area at the south end of the trail.

CHAPTER 15

TOBACCO HERITAGE TRAIL

Lawrenceville to South Hill

Lawrenceville grew with the tobacco trade, and the train tracks in town became like a pipeline—a virtual "Tobacco Road"—shipping big bulks of bright-leaf tobacco far beyond Brunswick County. Being near the center of the Atlantic and Danville Railway, between Norfolk and Danville, it made sense for Lawrenceville to become the site of shops and the company headquarters, with a water tank, a turntable, two depots and an eight-stall roundhouse.

Credit Benjamin Newgass for lighting the match. The Atlantic and Danville Railway began in the 1880s with this British industrialist's dream to transport cotton to the ports of Hampton Roads. Part of the route even lay on what was surveyed but never built—the Norfolk and Great Western Railroad, which had been planned in the late 1860s to connect Norfolk to Danville and Bristol.

Rail service began at Lawrenceville in 1889. From there, going about twenty rail-miles west, the Atlantic and Danville Railway virtually created what became the town of South Hill. Many of the railroad financiers invested in the Mecklenburg County community by buying fifty-six acres near South Hill's railroad depot.

In between, La Crosse was practically born on an X. It had been called Piney Pond, but building the Atlantic and Danville Railway drained the actual Piney Pond. Needing a new name, the place was dubbed La Crosse (pronounced "LAY-cross" by some) for the game lacrosse when a post office was established in 1890, though another tale says the meaning of "La

Crosse" comes from the town being at the crossing of two railroads: the Atlantic and Danville Railway, running east to west, and the Seaboard Air Line Railroad, running north to south.

The Atlantic and Danville Railway was alternately advertised as the Danville Short Line in 1891. It brought prosperity to La Crosse, including a bank, stores and the La Crosse Hotel. South Hill, too, grew into one of the largest flue-cured tobacco markets in Virginia. The rail line, in turn, gave Lawrenceville some of the best years of its life.

Passenger service continued only until July 31, 1949, but freight service got a boost in the early 1950s with the construction of the John H. Kerr Dam near Boydton. About a decade later, the line became part of the Norfolk and Western Railway. This line's name changed to the Norfolk, Franklin and Danville Railway Company for a few years. But traffic waned in the 1980s, and the last trains left South Hill in 1989—about a century after the first iron horse arrived.

Credit a nonprofit organization—Roanoke River Rails to Trails, Incorporated—for fanning new flames. This group began acquiring old rail lines from Norfolk Southern Corporation and developed a vision for the old Atlantic and Danville Railway, in particular, especially after the first four-mile section of the Tobacco Heritage Trail opened in 2005, linking La Crosse to Brodnax by following the old rail bed just south of U.S. 58.

In 2014, a long-awaited stretch that linked Lawrenceville to Brodnax opened, along with a shorter section stretching west to South Hill. That provided a seventeen-mile-long continuous trail on the historic rail bed and preserved a corridor that was once an industrial link, with rail cars running all day and night.

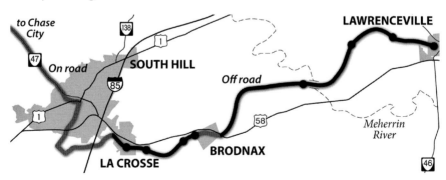

Tobacco Heritage Trail links Lawrenceville to South Hill for seventeen miles while paralleling U.S. 58 on the old Atlantic and Danville Railway. *Courtesy Tobacco Heritage Trail.*

Smoke rings of enthusiasm continue to swirl above the Tobacco Heritage Trail, which may be the most ambitious track-to-trail network in Virginia. The master plan calls for converting rails to trails—as well as marking paths on highways, like VA-47, between South Hill and Chase City—to form a route that spans more than 150 miles through Brunswick, Lunenburg, Mecklenburg, Charlotte and Halifax Counties.

South Hill's construction of U.S. 58, however, extinguishes the Tobacco Heritage Trail from being built on the original rail corridor through town. Still, a tiny portion of the Atlantic and Danville Railway does survive—with a few feet of track—outside the town's restored train station. Located on South Mecklenburg Avenue, the South Hill Depot contains a must-see model train display, depicting the tobacco towns of Southern Virginia as they appeared in the 1950s. It also shows the Atlantic and Danville Railway line that has since been made into the Tobacco Heritage Trail.

TRACKING THE TRAIL

From east to west, the Tobacco Heritage Trail generally follows uphill—on a gentle grade—from Lawrenceville to South Hill. The surface of the seventeen-mile-long stretch varies. The entire stretch is open for walking, biking and horseback riding; paved portions are available for in-line skating.

Lawrenceville to Brickyard Street

On the east, the trail originates in Lawrenceville on South Street and rolls through an industrial section of town for almost one mile on a surface of crushed gravel. At left, look for the old Lawrenceville railyard—about a quarter mile from the South Street trailhead.

Brickyard Street to Evans Creek

Going west from the Brickyard Street access, the Tobacco Heritage Trail enters a must-see stretch with a distance that spans about seven miles of solitude. Lined with crushed gravel, this section lies wholly at the heart of

Tobacco Heritage Trail crosses Great Creek on three bridges in Brunswick County, just west of Lawrenceville. *Author photo.*

Brunswick County, known for its claim as the "original home" of thick-and-rich Brunswick stew.

Over the first mile, the trail makes three crossings of Great Creek at a scenic spot once called Wesson. Plan a picnic, and you'll find a table ready near these bridges of Brunswick County. Also, look on the berm for evidence of railroad remains, with scattered, old railroad ties embedded in the embankments and lying crossways, pointing to the trail.

From Great Creek's trio of bridges, the trail continues west amid rock cuts and split-rail fencing. This journey makes a mild climb and, in about one and a half miles, slips beneath Pleasant Grove Road (VA-681). The woods recede, yielding to more open views over the next two miles. The trail crosses Totaro Creek and reaches the rail-side community called Charlie Hope, with a small parking area along VA-644. Charlie Hope was formerly the site of a tiny, one-room train station.

For two more miles, the trail passes pleasant patches of pines. At left, look for a restroom and picnic table just before the trail crosses the Meherrin River on a three-hundred-foot-long pedestrian bridge—a span built in 2013 atop a pair of C-shaped concrete piers that support the trail bridge, originally installed for rail traffic in 1939. This river takes its name from the Meherrin Indian tribe that lived along the Virginia–North Carolina border in the 1700s. An Eagle Scout project in 2014

Tobacco Heritage Trail crosses the Meherrin River on a three-hundred-foot-long bridge, supported by concrete piers constructed for railroad traffic in 1939. *Author photo.*

added a river access with steps for boaters just below one of the concrete piers that support the trail bridge.

West of the Meherrin River Bridge, the trail reaches an access with a restroom at Evans Creek Road (VA-623) in 0.7 miles.

A caveat: This section of the trail, from Evans Creek Road to the river, is closed during hunting season and gated, making the Meherrin River Bridge a dead-end on the trail from November to January.

Evans Creek to Brodnax

From the Evans Creek access, the trail spans 4.8 miles, going west to the U.S. 58 underpass at Brodnax, with a crushed-gravel surface and no road crossings. Highly recommended for horseback riding, highlights of this section include a rest area about a mile west of the Evans Creek access, a creek-crossing, split-rail fences and plantings of crepe myrtle trees. The sometimes-swampy edges of Evans Creek meander along the trail for about three miles.

Brodnax to La Crosse

Stretching into both Brunswick and Mecklenburg Counties, Brodnax grew as a shipping center along the railroad in the 1890s by exporting locally grown cotton, cucumbers, peaches and timber. The Tobacco Heritage Trail breezes through Brodnax for 1.2 miles, using the appropriately named Railroad Street on what was once the rail bed.

Starting at the U.S. 58 underpass and heading west, the trail joins street pavement and runs for 0.5 miles before passing the old Brodnax Depot, a combination freight and passenger station that stands at Railroad Street's intersection with Main Street, at left. Just beyond the depot, the paved portion gives a good view of the Brodnax water tower, at right, as it goes another 0.7 miles to reach a trail access point. It becomes a nonmotorized route again at the west end of Railroad Street.

From here, the trail continues west on asphalt for 3.1 miles until it reaches the La Crosse Caboose. The first 0.6 miles borders piney woods. The trail reaches the large parking area at Regional Airport Road. The next 2.5 miles go uphill. The trail runs through woods with a few views of open fields and fences. Then it passes the Airport Industrial Park and Mecklenburg County Airport, at left. The trail also passes businesses, churches and homes as it parallels U.S. 58.

> **Trail tip**
> Returning east toward Brodnax from the La Crosse Caboose, the asphalt trail runs mostly downhill for 2.5 miles to the airport-area access. This makes a short but fun family ride.

La Crosse to South Hill

The La Crosse Caboose provides a focal point for gatherings and groups on the Tobacco Heritage Trail. It also makes a good base for exploring the western portion of the trail. Going west, from La Crosse to South Hill, the trail's asphalt surface spans almost one mile between backwoods and backyards. The rail-trail portion terminates at Rocky Branch Road, just barely inside the South Hill town limits and almost immediately beyond a trail parking area on High Street.

ACCESS

Lawrenceville: The easternmost trailhead is on South Street, between West Fifth Avenue and New Street. From U.S. 58, follow U.S. 58 Business/VA-46 northeast for 0.7 miles into town. Turn left on New Street, and go west for 0.1 miles, then turn left on South Street and go a few yards to find the trail access, at right. Limited parking is available.

Brickyard Street: Limited roadside parking lies on the western edge of Lawrenceville, near RR Mile 95, just off Brickyard Street (VA-695), about one trail-mile west of the South Street access.

Charlie Hope: From U.S. 58, about 4.2 miles west of VA-46 in Lawrenceville, turn north on Grandy Road (VA-644) and go 2.2 miles. Then turn left at Charlie Hope Place (VA-680) and go 0.1 miles to the trail. Limited roadside parking is available.

Evans Creek: From U.S. 58, about 1.6 miles west of Grandy Road (VA-644), turn north on Evans Creek Road (VA-623) and go 1.0 mile north to the trail access area, at right. This parking area has room for horse trailers.

Brodnax: From U.S. 58, about 1.1 miles east of Regional Airport Road (VA-626), turn south on Main Street and go 0.1 miles to Railroad Street. Turn right and go 0.5 miles to the parking area, or turn left and follow Railroad Street east for 0.7 miles to the U.S. 58 underpass.

Airport: From North Main Street at La Crosse, follow U.S. 58 east for 2.4 miles. Turn right on Regional Airport Road (VA-626) and go south for 0.3 miles to the trail access area, at left.

La Crosse: From U.S. 58, turn south on North Main Street (VA-621) and go 0.4 miles to the trail access area, at left, near the La Crosse Caboose.

South Hill: An access lies along High Street (VA-618), about 0.8 miles west of the La Crosse Caboose or about 0.1 miles east of the trail's terminus at the South Hill border on Rocky Branch Road (VA-642).

CHAPTER 16

TOBACCO HERITAGE TRAIL

Boydton

Quiet and charming, Boydton contains the courthouse of Mecklenburg County and the Boyd Tavern, a multiroom structure with sections dating from 1790. The Boyd Tavern was once a gathering spot for students and professors at the original Randolph-Macon College, before that school relocated from Boydton to Ashland to be closer to a railroad in 1868.

Boydton did finally get a railroad: the Atlantic and Danville Railway arrived in the tiny town in 1890. By then, of course, it was far too late to save the school, but the Boyd Tavern enjoyed business as an overnight lodge. Here, too, passengers of the 1890s could leave Boydton and head west to Danville, arriving in three and a half hours.

By the early 1980s, the tracks through Boydton lay abandoned. But town officials sparked a new chapter in Boydton on June 9, 2014. On that day, they broke ground on a long-awaited project to turn what was once the rail into a trail with an initial phase spanning just a bit more than a mile.

TRACKING THE TRAIL

Boydton's 1.1-mile-long portion of the Tobacco Heritage Trail stretches from the downtown district on Washington Street east to Prison Road (VA-386), just south of U.S. 58. A portion of the lightly wooded trail parallels Hull Street (Route 1204).

Going east, within the first half mile, the trail overlooks Boydton's demonstration site of the Boydton-Petersburg Plank Road, at right, near Hull Street's intersection with Cemetery Street (Route 1217). In the early 1850s, stagecoach shuttles ran on this timbered turnpike, journeying seventy-three miles from Boydton to Petersburg—until the pine and oak planks rotted beyond repair, and a bridge collapsed on the Meherrin River, prior to the Civil War.

ACCESS

The trailhead parking area on Washington Street lies 0.1 miles north of the Boyd Tavern, 449 Washington Street, near the Hull Street intersection.

CHAPTER 17

BATTLEFIELD TRAIL

Staunton River Battlefield State Park

Captain Benjamin L. Farinholt played games with trains. As spring turned to summer, he ordered train after train to take a ride over the Staunton River, back and forth.

Never mind the lack of cargo: Farinholt only needed to make the Union army think that the South had a steady stream of soldiers and supplies arriving on the Richmond and Danville Railroad in 1864. So the near-empty trains rolled, almost like ghosts.

Here's why: Union general Ulysses S. Grant had put a target on the Richmond and Danville Railroad, specifically, because it turned out to be a supply line for the South. Grant wanted that route destroyed—especially the Staunton River Bridge, stretching over six hundred feet long and providing a link between Charlotte and Halifax Counties. So Grant sent two of his brigadier generals—James H. Wilson and August V. Kautz—on a mission across Virginia, leaving Petersburg that June with five thousand men.

For Grant's Union warriors, the summer days soon became unbearable. Burning railroads was exhausting work. Standing in the face of flames grew miserably hot. So was marching through smoke and fire. All of this easily wore down the men and their horses, long before they approached the Staunton River.

Setting up a base camp not far from Grant's target, the Union leaders moved into the Mulberry Plantation in Charlotte County. There, they heard word from the lady of the house, Nancy McPhail. She informed the Northerners that, yes, the Southerners did, indeed, plan to defend

that railroad bridge—and, oh, there must have been as many as ten thousand Confederates ready to stand guard. Such an account did seem plausible, especially to the Union spies who had sped ahead to check out the scene—and, of course, took note of all those trains moving back and forth, seemingly arriving with fresh recruits.

As it turned out, Farinholt's train game worked.

The South, in reality, had only a few hundred men and boys to guard that covered bridge. Many of Farinholt's forces had also come from a roundup of men who were either too old or too young to fight on the front lines. Still, this ragtag roster repulsed four charges made by the Union in the battle of the bridge on June 25, 1864. Not making any advance, and probably fearing they were outnumbered, the Union army gave up, and the bridge was left to stand.

Ironically, less than a year later, the Confederates burned the same bridge that they had so cleverly defended. In 1865, the Southern troops torched the bridge as part of their own plan to destroy the route of the Richmond and Danville Railroad—just as soon as Confederate president Jefferson Davis, the railroad's rolling stock and the rest of the Confederate government had escaped from Richmond during the final days of the Civil War.

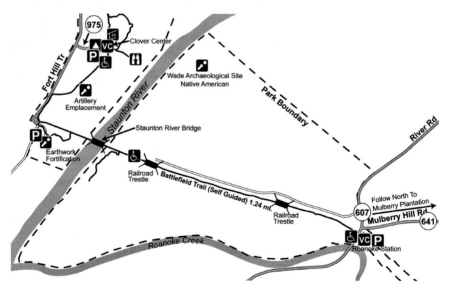

Historic markers line the path of the Battlefield Trail at the Staunton River Battlefield State Park of Randolph. *Courtesy Virginia State Parks.*

What stands today on the Staunton River is an iron structure, built in 1902 on the same piers that had been placed in the river prior to the battle of 1864. This bridge and two smaller ones are now part of a rail trail at the Staunton River Battlefield State Park.

TRACKING THE TRAIL

The Battlefield Trail runs 1.2 miles on the old Richmond and Danville Railroad, at Staunton River Battlefield State Park, 1035 Fort Hill Trail, in Randolph. It's a gem for history lovers, rated easy and open for bicycles and foot traffic.

Historic markers line the crushed-gravel path as it overlooks the river and scenic fields. The south end of the trail begins near the Clover Visitor Center, just off Fort Hill Trail, near the Confederate earthworks. The north

Battlefield Trail crosses two small trestles at Staunton River Battlefield State Park. *Author photo.*

end of the trail at Roanoke Station, featuring another visitor center, borders the intersection of River Road (VA-607) and Mulberry Hill Road (VA-641).

ACCESS

From U.S. 58 at South Boston, follow U.S. 360 north for 13.4 miles. Turn left on VA-92 and go 2.0 miles. Turn left on Black Walnut Road (VA-600) and go 3.0 miles. Turn right on Fort Hill Trail (VA-855). The Clover Visitor Center is immediately on the left.

> **Trail tip**
>
> For more, visit a satellite portion of the park, containing the Mulberry Hill Plantation and historic gardens, just off Mulberry Hill Road/VA-641.

TOBACCO HERITAGE TRAIL

South Boston

Long before any iron horse snorted along the riverbanks in South Boston, hearty troops relying on real horsepower made a brave crossing of the Dan River during the Revolutionary War. Under the command of General Nathanael Greene, these soldiers outsmarted the pursuit of the British in 1781. They rounded up ferry boats and crossed the Dan—horses and all—at what is now South Boston, thereby eluding their enemies from England, left behind on the opposite river banks.

This story became known as the "Crossing of the Dan." It marks a turning point in the American Revolution. It also happened near what has since become a start for the Tobacco Heritage Trail in South Boston.

More formally known as the Richmond & Danville Greenway & Spur Trail, South Boston's portion of the Tobacco Heritage Trail follows an abandoned portion of what ultimately became part of Norfolk Southern. The path originates not far from a giant art gallery and performance hall called the Prizery, where tobacco was once prized—or pressed, layer by layer—to fit into barrels that could be shipped by river or by rail. The Prizery features showers and lockers for trail users, plus a tobacco museum and an exhibit explaining the significance of the Crossing of the Dan.

Truly a tobacco town, South Boston includes a tobacco warehouse district listed on the National Register of Historic Places. It is also where local beauty queens once posed, au natural, to promote the National Tobacco Festival of the 1930s, wearing nothing but grins and tobacco leaves, covering shapely forms like fig leaves.

Today, though the tobacco industry has changed, it is quite natural to spot a beautiful doe along the Tobacco Heritage Trail, following the historic banks of the Dan River.

TRACKING THE TRAIL

Situated among the scenic hills of Halifax County, South Boston's picturesque portion of the Tobacco Heritage Trail originates near the site of an old cotton mill, marked by two brick towers. Mostly level and topped with finely crushed gravel, this lushly landscaped line spans 2.6 miles.

At the start, a short spur connects the Cotton Mill Park to the rail trail. Then, after several yards, take a sharp right to join the rail bed. Curving at a bend, the easy trail hits the half-mile marker beside split-rail fencing and farm fields along the river plain, at left.

Rock cuts overlook the Dan River at mile 2.6 of South Boston's Tobacco Heritage Trail. *Author photo.*

Trail tip

For more on South Boston, visit the Prizery, 700 Bruce Street, and the South Boston-Halifax County Museum of Fine Arts and History, 1540 Wilborn Avenue.

The trail reaches a scenic picnic area (mile 1.7), at left, overlooking a marshy impoundment that serves as a duck habitat. Just beyond, at right, the trail rolls past rock walls (mile 2.0) that were constructed by slaves as a border for the Berry Hill Plantation, which is now a resort that stands just over the ridge. Also on the right, above the trail, lies a slave cemetery called Diamond Hill, which takes its name from the area's quartz crystals, believed to resemble diamonds.

Edging continually closer to the Dan River, the route ends at another picnic area with an overlook of the river and a hitching post for horses (mile 2.6). Here, at right, the trail borders a cliff wall known for its "tree in the rock"—a vein of white quartz that, some say, resembles a tree.

ACCESS

From U.S. 58 at South Boston, follow VA-501 north for 1.3 miles. Turn left on Edmunds Street and go 0.6 miles. Turn left on Railroad Avenue and go 0.1 miles to reach the trailhead at the Cotton Mill Park.

RICHMOND AND DANVILLE RAIL-TRAIL

Danville

Jefferson Davis abandoned Richmond as the capital of the Confederacy crumbled. It was April 1865. The Confederate president took aim at establishing a new capital city—still thinking all was not lost for the Southern states—as he darted down to Danville on the torn-up tracks of the Richmond and Danville Railroad.

Talk about a nightmare. Davis's train trip took roughly fifteen hours to follow about 140 miles, moving at a slow pace of only 10 or 15 miles per hour. Reaching Danville, a railroad hub on Virginia's Southside, Davis set up a new command center at the home of Major William T. Sutherlin. Still, this new deal would last only a week: Confederate general Robert E. Lee surrendered to Union general Ulysses S. Grant on April 9, prompting Davis to pull up stakes—again.

Long before Davis's famous ride, the route of the Richmond and Danville Railroad began as a long-delayed dream for Whitmell P. Tunstall, a Pittsylvania County native. Tunstall, an attorney, first proposed the construction of this line in 1838. It took almost a decade before Tunstall received a charter. Later, as the railroad was under construction, Tunstall died on February 19, 1854—a victim of typhoid fever.

In 1856, the first trains steamed into Danville, after having first rolled past Ringgold, where a train station of the 1850s remains standing—a lucky survivor of the Civil War. Legend says the name Ringgold, in Pittsylvania County, comes from a nearby gold prospect that produced only enough gold to make one ring. Yet another story credits the place

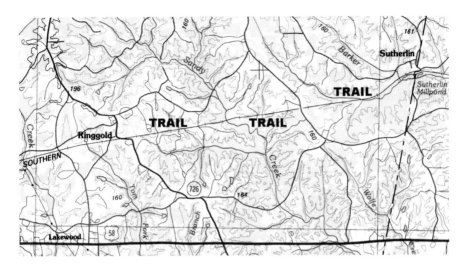

Richmond and Danville Rail-Trail links Ringgold to Sutherlin in eastern Pittsylvania County, just a few miles north of U.S. 58. *U.S. Geological Survey map.*

to being a namesake of Major Samuel Ringgold, a hero of the Mexican-American War.

Today, the Ringgold Depot marks the western gateway to the Richmond and Danville Rail-Trail—what's sometimes called the "Ringgold Trail." Open since 2001, this passage follows the fabled but long-abandoned rail bed of the "Danville train" that was immortalized in the song "The Night They Drove Ol' Dixie Down" and also the same route that was followed by Jefferson Davis, so long ago, in that retreat from Richmond.

TRACKING THE TRAIL

The five-and-a-half-mile Richmond and Danville Rail-Trail resembles a dirt road with a grassy center, bordered by lots of woods, with mileposts marking the distance every half mile. Benches line the trail, which climbs from either of its trailheads to a point near its midpoint beneath Rocksprings Road. That means whether you come from the east at Sutherlin or start out west at Ringgold, you'll enjoy at least one downhill ride on the crushed gravel surface.

Richmond and Danville Rail-Trail heads west from Sutherlin, following a railroad corridor traveled by Confederate president Jefferson Davis in 1865 near the end of the Civil War. *Author photo.*

Sutherlin to Ringgold

Starting on the east (mile 5.5) near the Halifax County line, the trail passes a large millpond, at left, in the first 0.25 miles. Then, for about 2.0 miles, the trail gradually climbs, passing the maples and pines of Pittsylvania County, as it heads toward an underpass of Rocksprings Road. From that point, the trail follows about 3.5 more miles, rolling down to Ringgold.

Ringgold to Sutherlin

The restored Ringgold Depot, used for about a century, stands at the western trailhead next to a caboose. From here, continuing east, the trail passes driveways, fields and forests, as well as a trail access along Shawnee Road (mile 1.5). The trail crosses Sandy Creek (mile 2.0), with an overlook from the bridge. The trail continually climbs uphill on a moderate grade toward Rocksprings Road (mile 3.5). From that underpass, it goes about 2.0 miles downhill to Sutherlin.

ACCESS

Sutherlin: The eastern access is about 20.0 miles west of South Boston or about 11.0 miles east of downtown Danville. From U.S. 58, follow Hackberry Road (VA-656/Kerns Church Road) north for 3.2 miles, continuing straight as it becomes Kerns Church Road. The parking access is on the left, just past the Railroad Trail (VA-943) intersection.

Ringgold: The western access is about 5.0 miles from downtown Danville. To reach the trail from Hackberry Road, near the trail's eastern end, follow U.S. 58 west for 6.2 miles. Turn north on Ringgold Road (VA-734), and go 2.1 miles north to the Ringgold Depot. (Note: Ringgold Road joins U.S. 58 about 2.8 miles east of U.S. 29.)

CHAPTER 20

RIVERWALK TRAIL

Danville

D anville's downtown rises on the banks of the Dan River, a waterway that gets its start in the shadow of the Blue Ridge and flows east along the Virginia–North Carolina border. The Dan River takes a tumble in this textiles town—a place that became known as an important railroad junction, especially during the Civil War, when its tobacco warehouses were turned into prisons.

This city lies at the terminus of both the old Richmond and Danville Railroad and the Atlantic and Danville Railway. It also once marked the start of the old Danville and Western Railway. Still, when it comes to trackside tales, Danville may be best known as the place where the Old 97 wrecked on the Southern Railway in 1903—and inspired a song that helped define the early roots of country music.

Today, an 1856 railroad bridge on the old Richmond and Danville Railroad lies just downstream from the site of the famous wreck of the Old 97. This restored landmark marks the gateway to Danville's Riverwalk Trail, a pretty and popular path that overlooks chunky rocks washed by the Dan River's ripples.

TRACKING THE TRAIL

Danville's Riverwalk hooks into an ever-growing greenway that traces the banks of the Dan River from the downtown district to Angler's Park and

beyond. It's wonderful for walking and perfect for a family bicycle ride. The trail provides access to the river for anglers and connects to the city's mountain bike trail system. Maps are posted at several spots, though you cannot get lost: the paved trail follows the river at nearly all times.

The Riverwalk begins on the south side of the river at two relics of the railroad: a circa-1904 freight station that has been revived as the Danville Community Market, and the 1899 passenger rail station that has been made

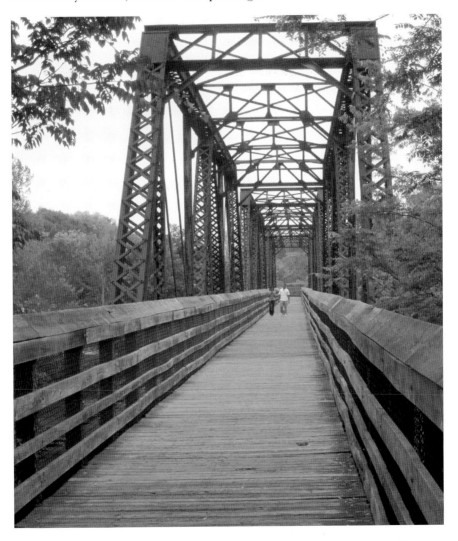

Danville's Riverwalk includes a restored railroad bridge near the Crossing at the Dan. *Author photo.*

into the Danville Science Center. Both stations are part of a municipal development called the Crossing at the Dan. From here, the rails-to-trails portion of Danville's Riverwalk spans about a quarter mile, originating on a sidewalk outside the stations and following the restored 1856 railroad bridge over the Dan River.

Next, on the river's north bank, the trail leads down a ramp and splits with a choice: go west or east. Either way, the pavement resembles a small road, broken by yellow dotted lines.

Turning left and going west, the Riverwalk winds its way between U.S. 58 Business and the Dan River, going about 1.7 miles. The trail passes beneath both Worsham Street and Main Street, almost immediately. Then, within a mile of the split, it reaches a photogenic dam, the Union Street Bridge and a scenic overlook. The trail continues along the river, terminating in a business district, just off U.S. 58 Business.

Going right, and heading east, the trail runs for about three miles until it reaches Angler's Park. It crosses Fall Creek almost immediately. All along, the riverside views are fabulous. It meanders through Dan Daniel Memorial Park, featuring ball fields, and slips beneath U.S. 29 (about 1.5 miles from the restored railroad bridge).

Curving like a horseshoe, the Riverwalk soon straightens and returns closer to the riverbanks before making a split at Ghost Tree Island, a place named because its giant sycamores, with their white bark, resemble ghosts. The trail then makes another horseshoe curve and arrives at Angler's Park.

ACCESS

From Riverside Drive (U.S. 58 Business), follow Main Street south into downtown Danville (across the Martin Luther King Jr. Bridge) for 0.3 miles. Turn left on Memorial Drive, and then continue onto Craghead Street for 0.3 miles. Turn left at the depot building, 629 Craghead Street, where the trail access lies at the restored railroad bridge, on the far side of the parking area.

DICK & WILLIE PASSAGE RAIL TRAIL

Martinsville

Pedestrians land not only in the heart of Martinsville on the Dick & Willie Passage Rail Trail but also seemingly at the center of the world. A bridge over Liberty Street comically points to places far beyond the city in Southern Virginia, showing mileage points. You can go east to Danville (27), Virginia Beach (212), Madrid (3,988) and Rome (4,698), or work your way west to Nashville (385), Las Vegas (1,949), San Francisco (2,321) and Tokyo (6,826).

Opened in 2010, the Dick & Willie Passage makes connections through Henry County and Martinsville, with endpoints at both Virginia Avenue (on the west) and an overlook of Mulberry Creek (on the east). The trail's title comes from the "Dick and Willie" nickname of the Danville and Western (D&W) Railway. That nickname, in turn, comes from a pair of brakeman on the line: Richard "Dick" Hundley and William "Willie" Martin. The route through Martinsville later became part of Norfolk Southern until it was abandoned and turned into the rail trail.

Constructed in the early 1880s with the help of convict labor, the line eventually became known as the Danville and Western Railway. It transported not only freight like locally made furniture but also passengers on runs to baseball games and family reunions. Rail passenger service through Martinsville stopped in 1949, but freight cars continued to overflow with products from textile mills well into the late twentieth century, when Martinsville was known as the "Sweatshirt Capital of the World."

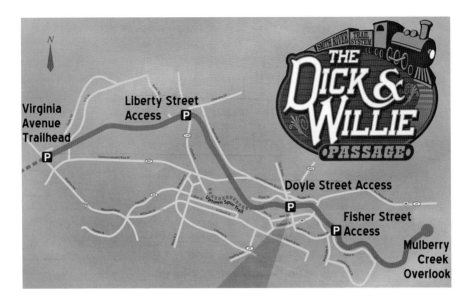

Dick & Willie Passage Rail Trail includes access points at Virginia Avenue, Liberty Street, Doyle Street and Fisher Street. *Courtesy Martinsville Tourism.*

One rail-trail section in Martinsville was once known as the "Uptown Rail Trail." Spanning 0.6 miles, the smooth-as-silk asphalt of the Uptown Rail Trail has since been identified as the "City Spur Trail" or "Uptown Spur Trail."

TRACKING THE TRAIL

On the four-and-a-half-mile-long trail dubbed "Dick & Willie," you feel like you're making a passage through wilderness. Still, even in the most remote region, you're hardly more than a quick jog from all the modern conveniences of Martinsville, a city known for its Virginia Museum of Natural History and the Martinsville Speedway. Restrooms and park benches line this path. So do interpretive signs and attractive fencing.

Trail tip

Don't have a bike? Don't worry. The Dick & Willie Passage Rail Trail features a free, bike-borrowing program—complete with helmets—at a bike shack near the Doyle Street trail access on Saturday mornings and other times.

Virginia Avenue to Liberty Street

The western trailhead at Virginia Avenue, near Villa Heights, lies along U.S. 220 Business. From here, the trail exits a commercial district to follow a young-growth forest of oaks, maples and poplar along the banks of Jones Creek. This section spans 1.4 miles, going slightly uphill, to the next access on the east at Liberty Street.

Liberty Street to Doyle Street

Bordered by large ravines and high berms, the Dick & Willie Passage contains jungle-like foliage that blooms in spring. Look for such a scene, at the center stretch, between Liberty Street (miles 1.4) and Doyle Street (mile 2.7).

From Liberty Street, the climb to Doyle is not tough. But for a real easy run, start at Doyle Street and roll back down to Liberty. You'll be pedal-free and shouting, "WHEEE!" all the way home.

In between, take a turn on the Uptown Spur Trail (near mile 2.5), which leads little more than 0.5 miles to a point close to the Martinsville–Henry County Heritage Center & Museum at the Old Henry County Courthouse, 1 East Main Street. This side path ends along Franklin Street. From the main trail, cycling this spur requires an uphill climb but, of course, an easy return.

Doyle Street to Mulberry Creek Overlook

The Dick & Willie Passage goes through an industrial stretch (near mile 3.0) between Doyle Street and Fisher Street. It also slips beneath U.S. 58 Business. Then the grade switches as it runs downhill. From Fisher Street (mile 3.2), the trail keeps going downhill for another 1.3 miles, passing a thick forest with tall pines for a runaway ride, dropping out of the city and ending at the beautiful Mulberry Creek Overlook. Of course, on a bike, you'll have to pay for that wind in your face, and here, pedaling back uphill may be a bit more difficult than it looks.

ACCESS

The parking area on Virginia Avenue (U.S. 220 Business) lies at the westernmost trailhead, at the edge of the El Parral Mexican Restaurant, 670 Commonwealth Boulevard West, between the Jones Creek Bridge and the Commonwealth Boulevard intersection. Other trail access points in Martinsville are located at Liberty Street near Clearview Drive, at Doyle Street near the Fairy Street intersection and at Fisher Street near the Brookdale Street crossing.

MAYO RIVER TRAIL

Stuart

On the last day of July in 1942, trains stopped rolling through Stuart. By then, train traffic had grown considerably slow in this courthouse town of Patrick County. But, perhaps ironic for a town named for one of the Civil War's most celebrated cavalry generals, what it took to help fight World War II overseas would signal the end of rail service.

The tracks through town became dormant about fifty-eight years after the first train arrived in 1884 at Stuart, lying about seventy-five rail-miles from Danville on what was then known as the Danville and New River Railroad. For years, trains would leave Danville at 5:00 a.m. and pass through places called Martinsville, Stella, Critz and Patrick Springs before arriving at 11:00 a.m. in Stuart, a town named for Patrick County native and Confederate major general James Ewell Brown "J.E.B." Stuart. In town, a turntable was used to turn the train around and head back to Danville.

According to plan, Stuart should not have been the end: the railroad should have crossed the Blue Ridge and continued west to reach lines along the New River. Unfortunately, the Danville and New River Railroad ran into financial hot water and had to declare bankruptcy in 1886.

Five years later, the Richmond and Danville Railroad obtained operations and changed the line's name to Danville and Western Railway. The Southern Railway took over operations in 1894. Still, the Danville and Western name was retained, using "D&W," for short.

Farmers of Stuart would once gather to sell leftover logs to help supply the wood-fueled locomotives, before the engines switched to coal. Business

also stayed steady with passengers boarding excursions alongside freight cars carrying apples, chestnuts and fertilizer.

Eventually, the Southern Railway petitioned the Interstate Commerce Commission to end the route, saying it was losing too much money. The end finally arrived in 1942 when the National War Production Board ordered the railroad closed so its scraps and steel could be used for the war effort.

Next—and not even a week after that final train left Stuart on July 31—crews set fire to the old turntable in order to obtain its scrap metal. Steel rails were also removed on the twenty-six-mile stretch between Stuart and Fieldale, reaching east toward Martinsville.

Nearly a lifetime later, the Mayo River Trail opened in 2011 on a half-mile section on the old D&W line in uptown Stuart. This short path overlooks the Mayo River, a watercourse named for Major William Mayo, a civil engineer who helped establish the boundary between Virginia and North Carolina in the 1700s.

A train crew recovers a locomotive after it overshot the turntable at Stuart, circa 1930, on the Danville and Western Railway. *Courtesy Patrick County Historical Society.*

TRACKING THE TRAIL

Stuart's Mayo River Trail stretches for 2,550 feet on asphalt, originating at a parking lot with picnic tables. The trail forms a sidewalk along Commerce Street and follows the railroad grade heading through an industrial section of town, squeezing between a factory and the bubbling waters of the Mayo River. Park benches and split-rail fencing line the path before it ends at a parking area with shade trees.

ACCESS

From U.S. 58, follow East Blue Ridge Street (VA-830) west into town for 0.5 miles. Turn left on Patrick Avenue (VA-8) and go 0.5 miles south to the trailhead, near the Patrick County Food Bank, at Patrick Avenue's intersection with Commerce Street. To reach the other parking access, continue to follow Commerce Street along the trail for 0.5 miles, then turn right on the trail access road, opposite Developmental Road, and go 0.2 miles.

CHAPTER 23

JAMES RIVER HERITAGE TRAIL

Lynchburg

John Lynch got an early start on the James River, launching a ferry service at age seventeen. That ferry of 1757 led to the production of tobacco, canals for transportation, new roads and—eventually—enough growth to bring railroads through the city that became known as Lynch's namesake: Lynchburg.

Along the James River, Lynchburg's railroads arrived almost a century after the young man's ferry service began. The South Side Rail Road came from Petersburg and reached across the piedmont to Lynchburg in 1854, at the base of the Blue Ridge Mountains. Heading west, the Virginia and Tennessee Railroad left Lynchburg to find Big Lick (now Roanoke) and Bristol (on the Tennessee border). Following the Civil War, in a merger of 1870, both the South Side Rail Road and the Virginia and Tennessee Railroad became part of the Atlantic, Mississippi and Ohio Railroad, a forerunner of the Norfolk and Western Railway.

Trains of the South Side Rail Road ran across the James River in Lynchburg to Percival's Island, named for John Percival, who lived here in the mid-1800s. This fifty-six-acre island would become a railroad hub with an engineer's bunk house, a coaling station, a machine shop and an engine house. Lynchburg's Island Yard remained active for decades. But it was abandoned by the 1970s, with its old crop of buildings either gone or falling to pieces, unrecognizable from a place where corn once grew and railroad workers lived.

A bird's-eye view of Island Yard in Lynchburg in the 1930s shows tracks and railroad cars covering what is now Percival's Island Natural Area at the center of the James River. *Courtesy Virginia Tech.*

Little more than one mile west, the Virginia and Tennessee Railroad pushed beyond downtown Lynchburg through a tunnel, spanning 508 feet—with a curve. This bore was constructed in the early 1850s by slaves and Irish immigrants, chiseling solid rock at a painstaking pace, measured by mere inches per day. What later became known as the Hollins Mill Tunnel—or simply "Hollins Tunnel"—was completed in 1852. The tunnel remained part of the primary passage of the Norfolk and Western Railway's main line until the early 1900s, when the Lynchburg Belt Line allowed freight traffic to bypass the downtown district. In later years, the tunnel remained in use to switch trains. But it had closed to all rail traffic after the 1980s.

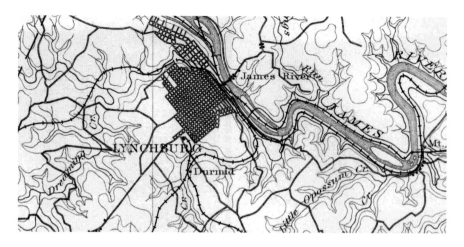

Above: An 1892 topographic map details the railroad crossing Percival's Island on the James River at Lynchburg. *U.S. Geological Survey map.*

Opposite: The Blackwater Creek Bikeway (bottom) joins the Kemper Street Station Trail near the Point of Honor Trail. Collectively known as the James River Heritage Trail, the rail-trail route passes through Hollins Tunnel and across Percival's Island near downtown Lynchburg. *Courtesy Lynchburg Parks and Recreation.*

Both unique features—the tunnel and the island—later became incorporated into a set of rail-to-trail projects collectively called the James River Heritage Trail. Linking Lynchburg to Amherst County, this complex greenway cleverly combines the downtown's urban environment with a mountainous landscape. It also offers an intimate look at the James River, a watercourse that crosses the commonwealth from mountains to marsh.

TRACKING THE TRAIL

James River Heritage Trail spans more than eight miles and unites the Blackwater Creek Bikeway with Lynchburg's RiverWalk. It also includes a path across Percival's Island, leading from the downtown district near Jefferson Street. Much of the paved passage was built on a former railroad corridor. Trail signs with maps and mileage markers are posted along the passage. Detailed brochures are also available through the town's parks and recreation department.

The main trek runs for about six and a half miles, starting just off Old Langhorne Road, and follows a northeastern path, initially, on the three-

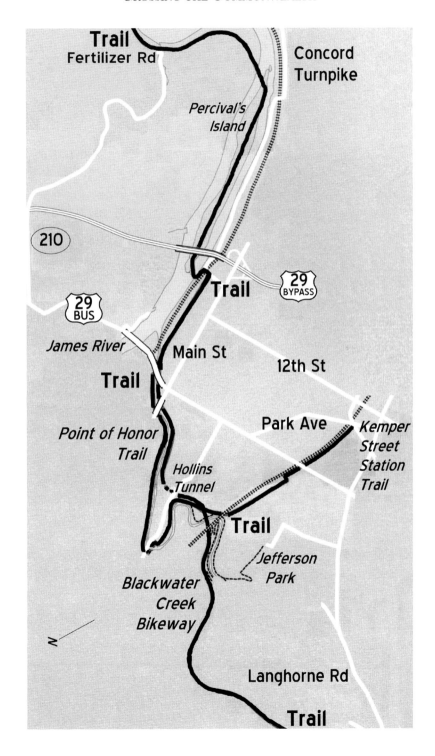

mile-long Blackwater Creek Bikeway. Beginning at the bikeway's Ed Page entrance, with its attractive Awareness Garden, the trail's first two miles provide one of the most visually delicious rail-trail corridors in Virginia, framed by a forest, benches and a few footpaths wiggling off the main line.

Blackwater Creek Bikeway reaches the East Randolph Place entrance (mile 1), cuts through rocks (mile 1.5) and crosses under active railroad tracks on a bridge (mile 2). Just beyond, the trail comes to a crossroads with a unique intersection, giving trail users many options.

Going south, by turning right, you can follow uphill on the Kemper Street Station Trail for about one mile on a passage that overlooks the same active railroad tracks also crossed under by the Blackwater Creek Bikeway. Partially built on an old railroad grade, the Kemper Street Station Trail reaches Park Avenue and then turns left to find Kemper Street at a train station with Amtrak service and a big sign that shouts, "WELCOME TO LYNCHBURG." (Starting at Kemper Station, of course, provides a fun glide on a bike, riding down to the Blackwater Creek Bikeway.)

Going northeast, and heading left, the path takes a turn on the 1.7-mile-long Point of Honor Trail, a connector that leads to the Hollins Mill Park, where water spills across a photogenic milldam. This optional loop, named for an 1815 historic home called Point of Honor at 112 Cabell Street, eventually returns to the Blackwater Creek Bikeway on a bridge near Fifth Street.

Another choice—continuing straight on the actual rail-trail portion—sends riders almost immediately through the must-see Hollins Tunnel (mile 2.2). High walls of hand-chiseled rock mark either entrance to this portal. Inside, the temperature stays cool and lights shine bright.

Beyond the tunnel, the Blackwater Creek Bikeway portion of the James River Heritage Trail ends in less than 1.0 mile, just after reconnecting with the Point of Honor Trail (mile 3.0). The route joins Jefferson Street on a ramp (mile 3.1) and follows sidewalks through the downtown corridor for almost 1.0 mile. Then the trail takes a left turn on Washington Street and crosses onto Percival's Island at a big bridge on the James River (mile 3.9).

For the next mile, the trail continues across the island, where clay and sand compose the soft shoreline, still exuding ghostly signs of railroad history, with train debris and side trails scattered in the woods at the old Island Yard. The path crosses beneath U.S. 29 (mile 4.1) and then goes across another bridge (mile 5.1) to reach Amherst County. Reaching the mainland again, the trail continues for about another mile. An access, just off Fertilizer Road, comes up on the left (mile 5.8).

The big bridge connecting downtown Lynchburg to Percival's Island once included a pedestrian passage alongside the railroad tracks. *Courtesy Virginia Tech.*

ACCESS

Ed Page Entrance: The Blackwater Creek Bikeway starts on Old Langhorne Road, a short connector just off Langhorne Road, near its intersection with Cranehill Drive.

Kemper Street Station Trail: Access is off Kemper Street, near the Park Avenue intersection.

Hollins Mill Park: Access Point of Honor Trail is at 1711 Hollins Mill Road.

Percival's Island Natural Area: Access the RiverWalk at 1600 Concord Turnpike, near Jefferson Street, in the downtown district.

Amherst County: To reach the end of the trail from Lynchburg's Main Street, follow Fifth Street (U.S. 29 Business) north for 1.0 mile (crossing the James River). Turn right on VA-210 and go 0.9 miles. Turn right on VA-334 and go 0.8 miles (passing the Central Virginia Training Center). Turn left on Route 1013 and follow for 0.3 miles. Then make a hard left turn on the narrow and curvy Fertilizer Road and follow for 0.4 miles (downhill) to the trail access area.

Chapter 24
Virginia Blue Ridge Railway Trail

Piney River

With blight on the horizon, the builders of the Virginia Blue Ridge Railway knew they had little time to waste. The year was 1915, and prospectors had saws and axes ready to grab green gold before that blight crippled any more chestnut trees. This threat had appeared in Virginia in about 1908—and soon, prospectors feared, it would eat away at the fabled tree known for chestnuts that roast oh-so-well on fires at Christmastime.

So they laid down tracks as quickly and as cheaply as possible to carry trains into the Blue Ridge Mountains of Virginia. Crews tried to make the railroad follow a most logical path. But that didn't always work. Sometimes farmers would negotiate in the sales of the land, saying, "Well, you know it might work better to go this a'way."

One construction supervisor named Howse (or Howes) would also march along and have crews build the railroad wherever *he* saw fit—without regard to engineering surveys. This man met his demise on this project, however, when he ordered the demolition of a hillside with dynamite instead of building a tunnel. A giant explosion went wrong and simply created a pile of rubble. Subsequently, this supervisor split from the scene.

The Virginia Blue Ridge Railway stretched about sixteen miles going to both Massies Mill and Woodson. It also tied into temporary tracks reaching far into the mountains to retrieve timber. Massive harvests of trees were shipped along the Piney and Tye Rivers by the end of 1915 and met the tracks of the Southern Railway at Tye River Depot.

But this timber boom ended in 1917 as the railroad was nationalized during World War I. The United States government shut down the Virginia Blue Ridge Railway during the conflict, saying the cutting of timber was not vital to the war effort.

About a year later, the war was over, and the railroad could reopen. But by that time, the dreaded blight had worsened, and the chestnut trees were just not what they used to be. Still, the little railroad limped back into operation. It tried with all its might to survive by hauling wood, apples and fertilizer. The track to Woodson was scrapped, however, after a mill closed in 1924. Floods also intermittently damaged trestles.

Surprisingly, with the railroad barely running, a new era dawned in 1931 during the grips of the Great Depression. A plant opened near the tracks at Piney River to extract titanium dioxide from ilmenite ore for the production of paint pigments.

Then, in 1935, an odd discovery was made. This logging railroad, as it turned out, had been built near one of the biggest aplite deposits in the United States. Finding this ore of quartz and feldspar—used for making glass, insulation and roofing materials—inspired another plant to come aboard by 1939 and even kept the locomotive wheels turning during World War II, when the government deemed this railroad worthy of retaining its run.

By the early 1960s, the route attracted train buffs, eager to see the rarity of steam locomotives still blowing their tops on this route. Such steam trains continued until 1963, when diesels took over.

Then came the flood.

Hurricane Camille took aim at Virginia's Blue Ridge. With little warning, the storm blasted the mountainous region on the night of August 19–20, 1969, and dumped about two feet of rain. It was a deluge so rough that birds died sitting on tree limbs. Hillsides melted, homes washed downstream and the death toll climbed to more than one hundred. That storm also forced so much water into the Tye River at its bridge on the Virginia Blue Ridge Railway that the span's girders and rails moved a foot downstream. The bridge was rebuilt, but builders were forced to leave it offset.

Camille appeared to foreshadow the end. The line was rebuilt, but another blow came in 1971 when the American Cyanamid Company closed its longtime plant. The railroad shut down a decade later—a time when it was claimed to be either "the nation's longest-operating short line" or "the longest-running, commercially successful short line in America."

With the railroad abandoned in the 1980s, grass grew high along the railroad grade. The property sat idle. But that's when local residents Steve

A freight train passes near the Tye River on the Virginia Blue Ridge Railway on January 11, 1978. This scene looks west from U.S. 29. *Courtesy Skip Hansberry.*

and Popie Martin expressed interest in the land, considering a big chunk bordered their farm. It was a skinny parcel: seventy feet wide in some sections and one hundred feet in others. "It sat there for a long time," Popie Martin said. "I mean, who wanted seventy feet wide? But we wanted to keep it."

The Martins bought the property, rounded up volunteers and began to build a rail trail. The first section of the Virginia Blue Ridge Railway Trail opened in 2003 and spanned nearly two miles, linking Piney River to Roses Mill. Steve and Popie Martin, in turn, won BikeWalk Virginia's "Community Champion" award in 2005 for their foresight in buying the railroad property and donating it to the Virginia Blue Ridge Railway Foundation, all the while continuing to build the trail. "It's just such a logical thing to have these old railroad beds and turn them into trails," Popie Martin said. "And this is such a beautiful, easy trail for families. People come every single day and walk every day."

TRACKING THE TRAIL

Easing along the Piney River, the Virginia Blue Ridge Railway Trail spans nearly seven miles through fields and river plains, where there's a good chance you'll spy wildlife, like white-tailed deer, great blue heron, red-tailed hawks and river otter. Access to the Piney River lies along the trail, making it a popular spot for anglers. But be sure to wear blaze orange during hunting season and take note: the property lies only about thirty-five to fifty feet from either side of the trail's center along the Amherst-Nelson county line.

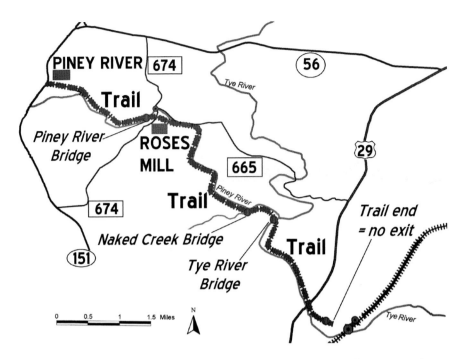

Virginia Blue Ridge Railway Trail can be accessed at Piney River, just off VA-151, and at Roses Mill, just off VA-674. The trail dead-ends about one mile after crossing beneath U.S. 29. *Courtesy Virginia Blue Ridge Railway Trail.*

Piney River to Roses Mill

Piney River Depot stands at the trail's western end and was built sometime after the railroad started operating in 1915. The restored structure contains historical artifacts related to the railroad, including the original depot sign.

Going west to east on the most easily accessible portion spans about 1.7 miles from Piney River to Roses Mill. The first 0.25 miles are paved. It also remains well groomed beyond that, with a smooth surface of white stone dust, suited for strolling, horseback riding or mountain biking. Benches can be found. So can trail markers, noting each 0.25 miles.

The trail slips past the site of the old American Cyanamid titanium plant near Piney River, at right, just beyond a split-rail fence (mile 0.2). Reach an access to the often-flat waters of the river with a picnic table (near mile 1.0). Cross the Piney River on a bridge (mile 1.6) and arrive at the trail access in Roses Mill, once a stagecoach stop and the site of a long-gone mill in a community named for an early settler, the Reverend Robert Rose (mile 1.7).

Above: Virginia Blue Ridge Railway Trail overlooks Piney River, providing a perfect place for picnics. *Author photo.*

Below: Virginia Blue Ridge Railway Trail crosses Naked Creek on a covered bridge, about two and a half miles east of Roses Mill. *Author photo.*

Beyond Roses Mill

East of Roses Mill, the trail extends another 5.0 miles through a road-less area and terminates with no exit. The Piney River comes back into view (mile 2.0) and remains in sight, at left, with its occasional small rapids, for 2.0 miles. Along the way, the trail passes through open fields. It reaches a flat area with a bench at Hunter's Bend (mile 3.4) and crosses a covered bridge at Naked Creek (mile 4.2).

The trail passes over the Tye River on a scenic, one-hundred-foot-long bridge (mile 4.5) and a second, twenty-foot-long span (mile 4.6)—both just below the confluence of the Tye and Piney Rivers. Beyond these bridges, the Tye takes over, at right, as the companion stream for the remainder of the route. Look for occasional views of rocky rapids.

A restored tip car sits on reconstructed railroad tracks at the eastern terminus of the Virginia Blue Ridge Railway Trail. *Author photo.*

Cliffs and rock cuts follow the path for more than 0.5 miles (near mile 5.5), at left, as the trail passes beside the foundation of an old water tower for steam locomotives, at left (mile 6), and slips beneath U.S. 29 (mile 6.1) near the Tye River, at right. The trail moves away from the river going east of U.S. 29 and makes an uphill climb. It crosses a cattle pass (mile 6.6) and then finally reaches another must-see point: a restored railroad tip car, push car and a rebuilt section of rails at the site of the railroad's scale house (mile 6.7) near the end of the trail.

ACCESS

Piney River: From U.S. 29 near Colleen, follow VA-56 northwest for five miles. Turn left on VA-151 and go two miles to the access, at left, at the Piney River Depot. (Alternate route: From U.S. 29, just north of Amherst, follow VA-151 north for seven miles to the trail access, at right.)

Roses Mill: From U.S. 29 near Colleen, follow VA-56 northwest for 4.0 miles. Turn left on Roses Mill Road (VA-674) and go 1.4 miles to the trail access.

YANKEE HORSE RIDGE

Blue Ridge Parkway

Of course, anyone knows you're not supposed to walk along railroad tracks. But, actually, that's what you're supposed to do along the Blue Ridge Parkway's Yankee Horse Ridge: walk on the railroad replica.

Yankee Horse Ridge ranks among Virginia's most unique rail-to-trail projects. Rails were rebuilt here in 1959 as part of a demonstration trail to show a portion of the Irish Creek Railway. This narrow-gauge railroad, dating to 1919 or earlier, once spanned more than fifty miles and carried more than one million board-feet of logs to a mill.

The rails lie on Yankee Horse Ridge amid maples and a few hemlocks, at an elevation of 3,140 feet, near the tri-county border of Nelson, Rockbridge and Amherst Counties. The ridge takes its name from a Civil War legend; it's where a hard-riding Union soldier's horse had to be shot after taking a fall.

TRACKING THE TRAIL

The reconstructed logging line at Yankee Horse Ridge spans a distance of about two hundred feet—and yes, you do actually walk on railroad tracks. Beyond the rails, the trail continues for a short distance to the south, where it becomes a dirt path, crisscrossed by snails and twigs while offering sweet solitude in the leafy woods of the Blue Ridge.

Railroad tracks were reconstructed along the Blue Ridge Parkway for a demonstration site at Yankee Horse Ridge. *Author photo.*

For a bonus, look for an easily detectable side path that leads about 0.2 miles to Wigwam Falls, a wide cascade dropping about thirty feet, with several vantage points. A smaller fall, of a few feet, makes a drop below a bridge near the parking area. Wigwam Falls takes its name from wigwams, used as shelters by Native Americans, who once used this mountain as hunting grounds.

ACCESS

Yankee Horse Ridge is located at Milepost 34.4 of the Blue Ridge Parkway, about 11.2 miles north of the parkway's U.S. 60 crossover, between Amherst on the east and Buena Vista on the west.

Dogwoods bloom along the Southern Tip Bike & Hike Trail on Virginia's Eastern Shore.

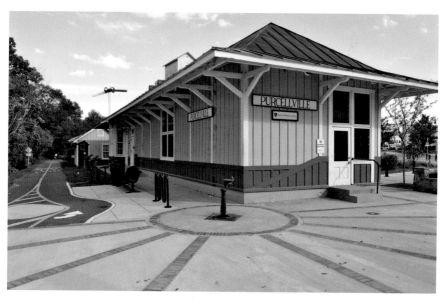

Purcellville Depot marks the western terminus of the Washington and Old Dominion Trail.

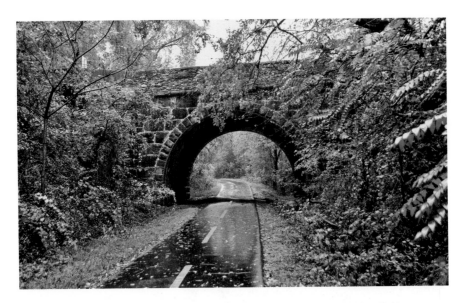

Washington and Old Dominion Trail passes beneath a stone arch at Clarkes Gap.

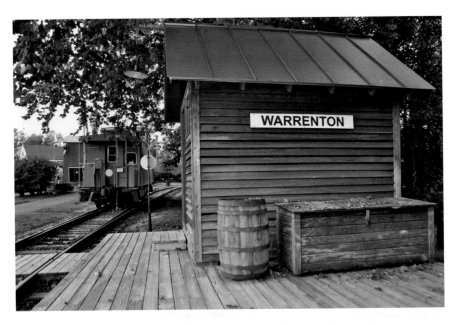

Piedmont Railroaders reconstructed the railyard on the Warrenton Branch Greenway.

Lake Anna borders the Railroad Ford Trail in Spotsylvania County.

Ashland Trolley Line
provides a short nature walk
in Hanover County.

High Bridge Trail State Park passes Farmville's Craddock-Terry building, "The Home of Lion Brand Shoes."

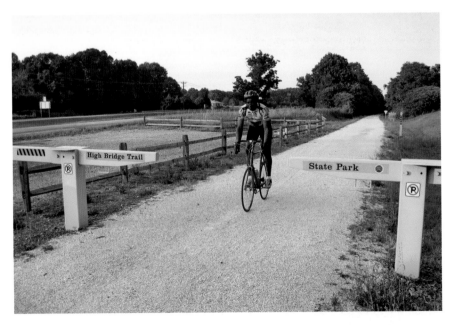

A cyclist passes the entrance to Elam along U.S. 460 at High Bridge Trail State Park.

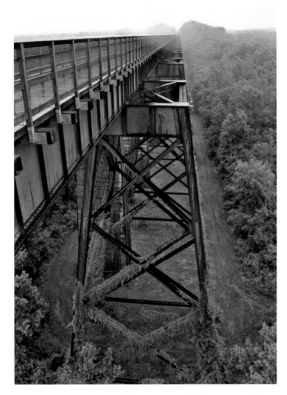

Left: High Bridge spans 2,400 feet between Farmville and Rice.

Below: High Bridge crosses the Appomattox River and the surrounding valley, where Union and Confederate soldiers fought in 1865.

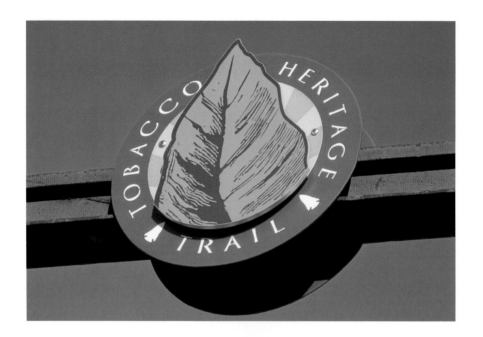

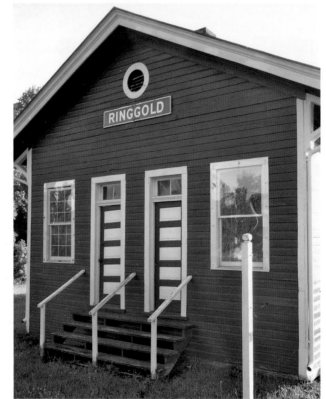

Above: Tobacco Heritage Trail includes a seventeen-mile stretch linking Lawrenceville to South Hill, plus spurs in South Boston, Boydton and Victoria.

Right: Ringgold Depot on the Richmond and Danville Rail-Trail dates to the 1850s.

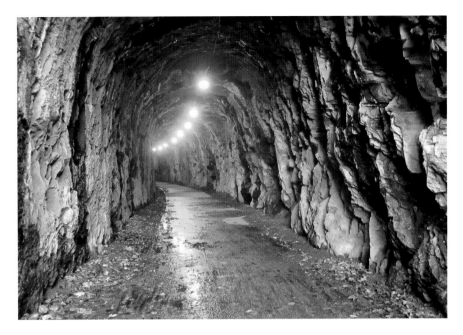

Lights illuminate the Hollins Tunnel on the James River Heritage Trail of Lynchburg.

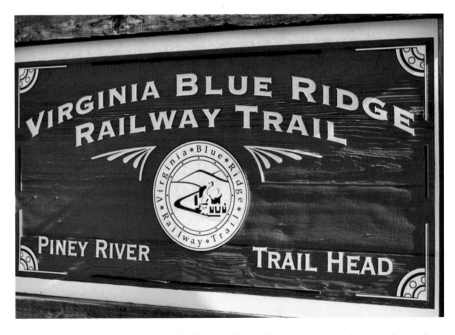

The Virginia Blue Ridge Railway Trail sign at Piney River was made using actual crossties from the Virginia Blue Ridge Railway.

Left: The Appalachian Trail's James River Foot Bridge was built on piers once used to support a bridge on the Chesapeake and Ohio Railway.

Below: Springtime means a tunnel of green trees overhanging the Blacksburg portion of the Huckleberry Trail near Virginia Tech.

New River Trail State Park spans Bridge No. 1506 at the border of Claytor Lake.

Chestnut Creek Falls drops about ten feet on the New River Trail near Chestnut Yard.

Left: The seventy-five-foot-tall shot tower stands near the New River Trail State Park between Austinville and Foster Falls.

Below: The 951-foot-long bridge at Hiwassee provides great views of Claytor Lake along the New River Trail.

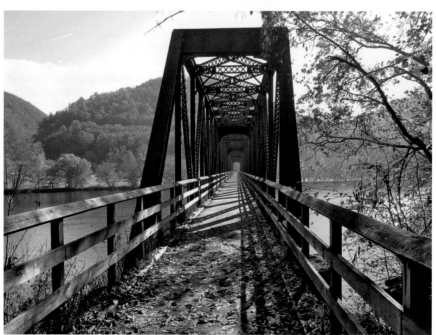

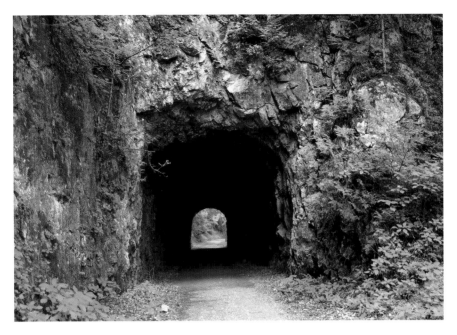

New River Trail State Park passes through a short tunnel near Austinville.

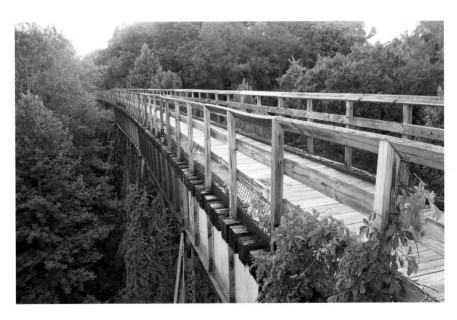

Peak Creek Trestle stands near Dora Junction along the New River Trail in Pulaski County.

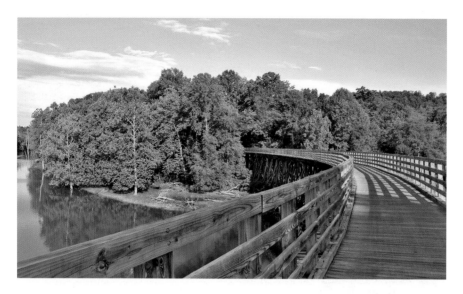

The Virginia Creeper Trail crosses South Holston Lake on a curved trestle between Watauga and Alvarado.

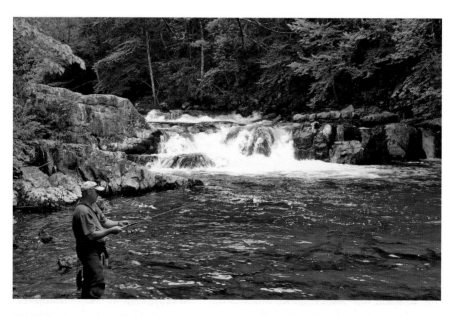

Fly-fishing is popular at Whitetop Laurel Falls, just off the Virginia Creeper Trail in Washington County.

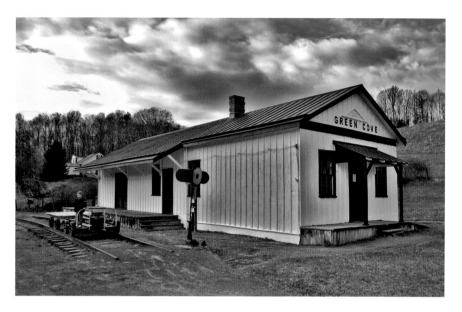

Green Cove Depot has been restored as a visitor center along the Virginia Creeper Trail.

This stone mile marker, leftover from the railroad era, notes thirty-four miles to the train stations of Abingdon ("A") along what is now the Virginia Creeper Trail.

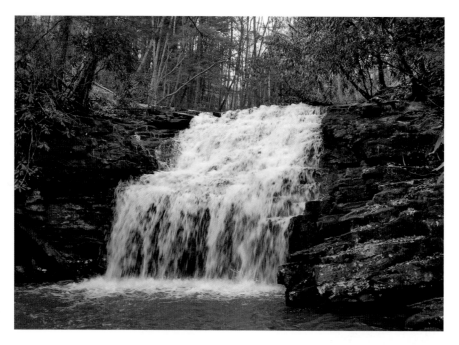

Crab Orchard Falls drops about twenty-two feet, just off the Guest River Gorge Trail.

The Lower Falls of Little Stony Creek cascades for thirty feet in the Jefferson National Forest.

Above: Little Stony
National Recreation
Trail passes over a few
footbridges in Scott
County.

Left: Devil's Bathtub is
a natural wonder in the
Jefferson National Forest
of Scott County.

Left: Phillips Creek Falls drops about fifteen feet in the Jefferson National Forest of Wise County.

Below: The sun sets on western Lee County at the easternmost trailhead of the Wilderness Road Trail.

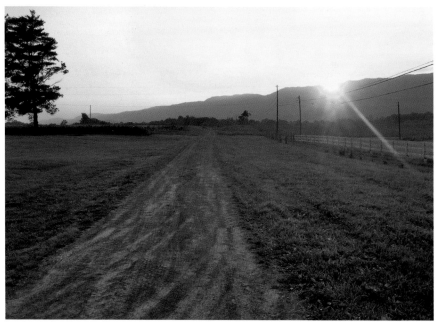

CHESSIE NATURE TRAIL

Lexington to Buena Vista

Flood after flood has ransacked the route of the Chesapeake and Ohio Railway's branch line to Lexington, washing out bridges on what was once called the North River. Perhaps fittingly, this railroad corridor for the "Chessie" originated along a controlled flood zone, where a series of locks and dams—built in the 1850s by the North River Navigation Company—enabled boats to sail upstream from the James River to Lexington, a handsome, small city established in the 1770s.

Boats were lifted in locks from one dam to the next, transporting goods and passengers. That canal system, taken over by the James River and Kanawha Company prior to the Civil War, made Lexington a port town on the sunset side of the Blue Ridge.

A boat called *Marshall* was used on the North River to carry the body of Confederate general Thomas "Stonewall" Jackson to Lexington, where he was laid to rest in 1863. Later, a flood in 1870 washed away all of a Lexington undertaker's coffins at the time of Confederate general Robert E. Lee's funeral in Lexington, but one casket was rescued on the riverbanks in time to hold the body of Lee, who was also entombed at Lexington.

The floods of 1877, however, severely damaged the canal system. Soon after, much of the company's towpath—a line of land where animals were used to pull boats—became a passage for the tracks of the Richmond and Alleghany Railroad.

This railroad faced financial difficulties, however, not long after this line was built in 1881, and the branch to Lexington became part of the

Chesapeake and Ohio Railway. In all, this branch spanned about twenty miles from Balcony Falls on the James River to its terminus in Lexington. Along the way, it threaded through Buena Vista, a small, industrial city with a name that means "beautiful view."

Within a century, the river changed names. When the railroad was built, it had been called the North River—a name that, of course, complements the South River, which joins its run, washing downstream toward the James. But in 1945, the North took the name of Matthew Fontaine Maury, an oceanographer who had once been a professor at Virginia Military Institute. (Was this fitting? Well, doing away with the name North might have seemed a good move, at least to some, considering two of the South's greatest generals—Lee and Jackson—lay at rest in Lexington.)

Still, what did not change was this waterway's tendency for flooding.

On the night of August 19–20, 1969, Hurricane Camille ransacked communities on both sides of the Blue Ridge. Flood waters picked up the railroad bridge leading into Lexington and carried it downstream. Later, when the clouds cleared, the railroad company could not justify costs to rebuild. So the train service between Buena Vista and Lexington came to an end.

About a decade later, the railroad right of way turned into a pedestrian path called the Chessie Nature Trail, using the nickname of the Chesapeake and Ohio Railway. "Chessie" was also the railway's mascot—a female feline introduced in the 1930s to promote rail travel so comfortable that you could "sleep like a kitten." Chessie the cat remained a wildly popular advertising figure through the early 1970s. She also had a couple kittens, Nip and Tuck, plus a mate named (Chessie's) Peake.

The trail's dedication in 1981 arrived one century after the railroad was built on a shelf of land above the river. But then came even more floods— from the 1980s to 2003—that ruined the path's largest footbridges. One flood destroyed a bridge to Jordan's Point, a place named for John Jordan, who had operated a mill in the 1800s on what has been commonly called "VMI Island" for Lexington's Virginia Military Institute. Today, Virginia Military Institute owns and oversees the Chessie Nature Trail, and the path is popular among college students. Lexington is also the home of Washington & Lee University, while Buena Vista, at the trail's eastern end, is home to Southern Virginia University.

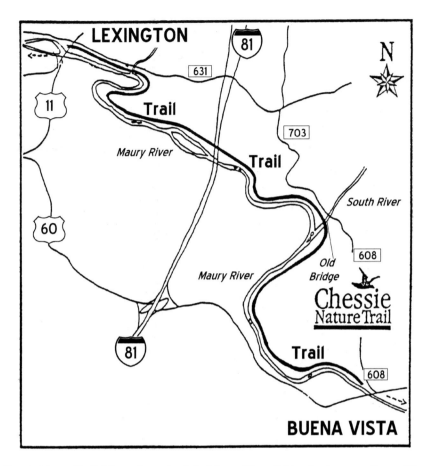

Chessie Nature Trail follows the path of the Maury River, linking Lexington to Buena Vista. Note this map's "Old Bridge" on the South River—a former crossing that must now be bypassed by an on-road detour. *Courtesy Rockbridge Area Tourism Council.*

TRACKING THE TRAIL

Like many rail trails, the Chessie Nature Trail follows a right of way open to the public while passing private land. The surface ranges from crushed stone to grass. The scenery alternates between open lands and forests, clawing its way along cliffs and among cattle. The largely level trail is open to foot traffic as well as bicycles. But remember: you will have to carry your bike over gates or around turnstiles. Traveling on two wheels is also best suited on the Lexington portion of the trail, northwest of the South River.

East Lexington

An informal entrance starts as a footpath that drops off the side of Furrs Mill Road, near its intersection with North Lee Highway (U.S. 11). From here, tracing the trail east for about a half mile, it slips beneath U.S. 11 and follows between Old Buena Vista Road (VA-631) and the Maury River until meeting an access at Mill Creek.

Mill Creek to South River

The Mill Creek access marks Lexington's most popular place to start the Chessie Nature Trail. From this point, the trail stays within sight of the Maury River for about three and a half miles before reaching the next access at South River.

Turn left and immediately cross a small bridge. Enter a wooded area near the remains of an old millrace, at right. Just beyond, the trail passes around a gate. From here, tall walls of limestone line the left side of the trail as the path makes sweeping turns with the horseshoe bends of the river.

Chessie Nature Trail follows the Maury River. This "BF-16" marker notes 16 miles on the railroad to reach Balcony Falls. *Author photo.*

At 1.3 miles from the entrance, look to the right for the remains of Reid's Lock and Dam—perhaps the best preserved site of the old navigation line used on the river during the Civil War. This structure was actually used through the early 1900s to produce electricity. But today, it is far from functional: Hurricane Camille in 1969—and a later flood—damaged the dam, which was once used to hold water to float boats.

About a half mile east of Reid's Lock and Dam, look for a unique grove of bamboo on the right. Then, within another half mile, the trail crosses Warm Run on a tiny bridge and immediately makes its way beneath I-81.

The trail crosses another gate, enters a cow pasture and—for the next mile—stays increasingly quiet, offering seclusion amid scenes characterized by blue-gray limestone cliffs and the river's chunky remains of locks and dams. Expect more gates, too, before reaching the trail access at South River.

South River

The South River access overlooks the remains of the scenic South River Bridge, a structure that was washed out by Hurricane Isabel in 2003. With the bridge gone, an on-road detour continues the trail. To follow the detour from the South River parking area, make a right on Stuartsburg Road (VA-703/608) and follow southeast for 0.4 miles. Then turn right on Old Sheppard Road (VA-839) and go 0.1 mile to continue the trail, turning left at a gate.

South River to Buena Vista

The easternmost section of the Chessie Nature Trail—spanning a bit more than two miles—follows through cattle pastures and crosses several gates. Compared to the Lexington leg, it's almost like following a different trail and probably best suited for the Chessie Nature Trail's original purpose: foot traffic only. You can, of course, follow this rural route on a bike. But that will require riding grassy fields through cattle herds, dodging cow pies and climbing over multiple gates.

This portion provides great scenery of cliffs above the river, plus a few more remains of locks and dams. Oddly, adding to this mix are railroad relics standing on grassy river plains covered with cows. One is a "W" on a four-foot-tall concrete post: a reminder for the railroad engineer to blow the

train whistle at a crossing. Another is the concrete "BF-13" marker popping out of a cow pasture: a reminder to railroad workers that this point lies 13 miles to the main line on the James River at Balcony Falls.

As the trail makes a sweeping bend to the left, overlooking sandbars on the river at right, it crosses yet another gate. Then it parallels scenic rock walls, at left, and ends in another quarter mile at a small, roadside parking area.

ACCESS

Lexington: From U.S. 11 at East Lexington, follow Old Buena Vista Road (VA-631) east for a half mile to the Mill Creek trail access, at right.

South River: From U.S. 11 at East Lexington, follow Old Buena Vista Road (VA-631) east for 2.3 miles. Turn right on Stuartsburg Road (VA-703), and go 1.2 miles to the parking area.

Buena Vista: From I-81 Exit 188A, follow U.S. 60 east for 2.8 miles. Turn left on Stuartsburg Road (VA-608) and go 0.4 miles to the access with limited parking. (From this point, it's 0.25 miles to reach the first gate on the trail.)

CHAPTER 27

James River Foot Bridge

Appalachian Trail

When it came time to name a newly built pedestrian passage on the James River, there could be no other choice than to have it honor the late William "Bill" Foot. This cancer victim had dogmatically fought for this footbridge across the river, even as he ultimately fought for his own life.

Foot thru-hiked the more than 2,100 miles of the Appalachian Trail with his wife, Laurie, in 1987—and, together, the Foots picked up a collective trail name, "Happy Feet." Later, back home in Lynchburg, Bill Foot dreamed of having hikers someday avoid using U.S. 501 to cross the James River alongside busy traffic.

As a member of the Natural Bridge Appalachian Trail Club, Foot took particular notice of some old piers standing in the James River. These were once supports for a railroad crossing at Snowden, between Amherst and Bedford Counties, about a half mile upstream from U.S. 501.

This railroad bridge remained on maps through the 1950s—a time when the tracks had long since become part of the Chesapeake and Ohio Railway. By 1966, Snowden's topographic maps no longer showed this railroad bridge but instead detailed a more diagonal crossing, just a few yards downstream. The newer railroad bridge, built in 1954, made a longer but straighter connection with the tracks on each side of the river.

With the railroad removed, the stone piers from the older bridge remained but stood silent. The railroad company no longer owned them. But Bill Foot tracked down the owner—a man who had bought the piers to tie up his houseboat—and that man agreed to sell the piers to the Appalachian Trail Conference for one dollar.

Foot's plan? Build a footbridge.

Next, Foot did the legwork to gain grant money for the project. The old stone piers were extended with ten feet of reinforced concrete, and prefabricated sections of the bridge were floated on a barge to be set in place. In all, the journey from conception to completion took close to a decade. It also cost over $1.5 million. But cancer took Foot's life just as the footbridge began to reach its final steps. He died on May 19, 2000—about five months before the bridge's dedication.

The James River Foot Bridge was intentionally named with two words, separating "Foot" and "Bridge" in the title. That distinction was made to honor the man who dreamed of using the remains of a rail to build a trail.

TRACKING THE TRAIL

The Appalachian Trail's James River Foot Bridge crosses the James River at a place where mountains rise right out of the riverbanks, and the trail provides access to the James River Face Wilderness. Here, the Appalachian Trail winds along the left edge of a parking lot on the north bank of the river. Turn right, and go south on the trail for about 350 feet, slipping through a passage beneath the active railroad tracks. Then reach a set of stairs that ascend the 624-foot-long footbridge.

This is a popular point for Appalachian Trail users, as well as bird-watchers and fishermen. The U.S. Forest Service does not allow large groups gathering on the bridge; it also prohibits pedestrians from climbing on the piers or accessing any part of the bridge other than the boarded walkway.

Beyond the bridge, the Appalachian Trail reaches the south bank of the river and follows along or near the old railroad grade for another 250 feet. Then it takes a turn at a cliff face, where water falls at a small trickle.

ACCESS

From I-81 Exit 175 at Natural Bridge, follow U.S. 11 north for 1.6 miles. Turn right on VA-130 and go east for 11.9 miles (continuing to the right as the route joins U.S. 501). The Appalachian Trail parking area lies on the right as the road borders the river.

JACKSON RIVER SCENIC TRAIL

Covington

Jack Showalter gave it all—his life's savings, time, energy. Practically everything he owned got shoveled into the Alleghany Central Scenic Railroad, like chunks of coal shoveled into the burner of a steam locomotive.

"We've lost money for seven straight years, ever since we opened. I've had to work a couple of different jobs to keep things going, but I've never regretted it for a minute—not a minute," Showalter told a newspaper in 1981. "I'm not going to say how much I've spent, but everything I've got is tied up in this railroad. Every penny goes back in."

Running this railroad was a burning passion for this businessman. Showalter had served as an apprentice machinist on the railroad in nearby Clifton Forge. But he lost his job in a mass layoff when the era of steam locomotives went up in smoke in the 1950s. Decades later, after building a successful career as a contractor, Showalter acquired a section of track and a railroad right of way from the company he once worked for—the Chesapeake and Ohio Railway.

Showalter fired up his first train excursion in Alleghany County on May 18, 1975. He took passengers on a mountainous journey along the Jackson River using closed passenger cars, special flat cars and gondolas. Showalter used steam locomotives to follow a path from Intervale, immediately north of Covington, to view remote ridges near the Bath County border.

The Alleghany Central Scenic Railroad pulled passengers during the warmest months—May to October—with excursions held on holidays and

weekends. It followed about fifteen miles of what was once called the Hot Springs Branch.

Here, as early as 1891, the rich and fabulous came to Covington to take rides on this line—what was earlier called the Warm Springs Valley Branch. This route followed S-curves along the riverbanks as it passed through Clearwater Park, Harrington, Falling Spring, Natural Well and Jenkins Ford. Then, crossing into Bath County, the line made a steep climb to Hot Springs, with a grade of more than 4 percent.

In all, the north–south railroad spanned about twenty-five miles on its journey to the Homestead Resort near the Virginia–West Virginia border. Blasted from solid rock, this branch grew from the dreams of M.E. Ingalls, the president of the Chesapeake and Ohio Railway. Ingalls had grown especially fond of Bath County's spring resorts, and he rallied to complete this line by September 7, 1891, when he took the first ride on the rails with his family.

For much of its existence, the Hot Springs Branch primarily served as a passenger line. Locomotives pulled the fanciest of Pullman sleeping cars while also pulling a car full of coal, ready to power the Homestead at the end of the line. Wealthy and famous patrons routinely came from big cities on the East Coast, making this mixed train of freight and parlor cars a most unusual sight as it cut through the narrow passage.

The end of the line—for the Chesapeake and Ohio Railway's "Hot Springs Subdivision"—came about three years before Showalter got the tracks in 1973.

Alleghany Central Scenic Railroad shut down about a decade after it began. The tracks were scrapped and sold. Later, the route was acquired by the Alleghany County Board of Supervisors. Today, while the train may be a memory, the Jackson River Scenic Trail follows the same path as the Alleghany Central Scenic Railroad.

TRACKING THE TRAIL

Jackson River Scenic Trail offers a camera-ready combination of river views, cliffs and rugged mountains plus access to a swinging bridge and a wet-weather waterfall. This rail trail in Alleghany County is open for hiking, biking and horseback riding. True to its name, the path keeps the Jackson River within sight at nearly all points.

The original railroad mile marker "8" stands along the Jackson River Scenic Trail as it heads north into the Dunbrack Circle community, between Petticoat Junction and Smith Bridge. *Author photo.*

By 2014, about half of the Jackson River Scenic Trail—more than seven miles—had been reconditioned and considered complete, stretching from Intervale to Smith Bridge. The crushed-packed gravel surface is universally accessible and suitable for strollers.

Reminders of the railroad era also remain, with concrete mile markers standing on the right-hand side of the right of way, noting the mileage to the line's original beginning at Covington.

Intervale to Petticoat Junction

The trail officially begins at Intervale, once the site of a train station used by the Alleghany Central Scenic Railroad to sell tickets in the 1980s. The station has since been torn down, and a large parking area with restrooms has been built for trail users.

From Intervale, the trail lies essentially flat as it goes north for the first two miles, stretching to Petticoat Junction—a place listed on maps as Clearwater Park. Along the way, the trail passes an original railroad marker in the first half mile. It crosses Sammy's Road (VA-731) about a half mile beyond.

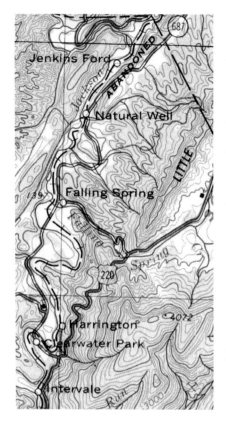

Jackson River Scenic Trail follows an abandoned railroad grade that links Intervale (on the south) to Harrington, Natural Well and Jenkins Ford. *U.S. Geological Survey map.*

Petticoat Junction to Smith Bridge

The trail makes a slight but steady climb on the 5.2-mile stretch from Petticoat Junction to the Smith Bridge access. Look for picnic tables and a few split-rail fences bordering the trail as it snakes between the river and rocks.

Sharing its name with a 1960s CBS-TV sitcom, Petticoat Junction was once known as Damron. Under the name Clearwater Park, this area was the site of a railroad flag stop through the 1960s. The current name comes from a store in the neighborhood.

Passing Petticoat Junction, the trail reenters the woods and comes to a particularly scenic section along the river's edge. It also makes a sharp curve at Harrington (near milemarker 5), where a broken rail in 1936 caused a train derailment that overturned twenty-two cars.

The trail passes a thirty-foot-high waterfall that mostly runs in wet weather, at right (2.3 miles north of Petticoat Junction), and an access to a swinging bridge, at left (2.8 miles from Petticoat Junction). Just beyond the bridge, the trail reaches the Dunbrack Circle community (mile marker 8), where the route slips in front of homes at an area once called Bruner. In another mile, the trail comes upon Smith's Bluff (near mile 9), a cliff towering five hundred feet above the trail, at right. Next, the trail reaches the Smith Bridge access, which includes a restroom (near mile 10).

Smith Bridge to Jenkins Ford

The remaining route of the Jackson River Scenic Trail—from Smith Bridge to Jenkins Ford—is composed of grass and dirt. Yet some bridges may still await reconstruction and are not passable. Trail explorers should exercise caution and not access any bridge that looks unsafe while the trail awaits improvements.

About 1 mile north of the Smith Bridge access, the trail crosses the rocky Falling Spring Creek and enters the Falling Spring community (near mile 11). This was once the site of a narrow-gauge spur that branched away from what is now the trail and headed east to Falling Spring Falls, where a fertilizer company operated in the early 1900s.

The trail passes Camp Appalachia (near mile 12). About a quarter mile beyond, the trail crosses Board Tree Run on an old bridge near Mad Ann Ridge, a place named for "Mad Ann" Bailey, a famous hunter and scout of the 1700s.

About 3 miles north of the Smith Bridge access, the corridor parallels VA-687 with limited roadside parking at Natural Well (near mile 13), a place that takes its name from an opening in limestone rocks that leads to an underground pool of water. Going north of Natural Well, the trail continues at the river's edge and reaches Jenkins Ford (near mile 15), the site of an intake pipe once used for a water tank at the river.

ACCESS

Intervale: From I-64 Exit 16A at Covington, follow U.S. 220 north for 4.2 miles. Turn left on Dressler Drive (VA-778). The trailhead is on the left.

Petticoat Junction: From I-64 Exit 16A at Covington, follow U.S. 220 north for 5.2 miles. Turn left on Jackson River Road (VA-687) and go 0.9 miles. The trail access is on the left.

Smith Bridge: From I-64 Exit 16A at Covington, follow U.S. 220 north for 5.2 miles. Turn left on Jackson River Road (VA-687) and go 4.7 miles. Turn right on North Smith Bridge Road (VA-721) and go 0.6 miles to the trail.

CHAPTER 29

FENWICK MINES RECREATION AREA/ GREENWAY TRAIL

New Castle

Easing out of Eagle Mountain in 1891, at what is now called Eagle Rock, the Chesapeake and Ohio Railway chugged across Botetourt and Craig Counties to reach iron ore deposits. The rails neared New Castle. But the tracks stopped at Craig City, about three-quarters of a mile before arriving at New Castle's Craig County Courthouse.

The Craig Company began building the Chesapeake and Ohio Railway's Craig Valley Branch in the 1880s, using convict labor. Tracks slipped along Craig Creek for much of the run, spanning about twenty-six miles—and made a stop at Oriskany before reaching Barbours Creek, where a spur track ran to Fenwick Mines, an iron ore operation.

Fenwick boomed from the 1890s through the 1920s, employing about three hundred workers. Here, the spur line from Fenwick Mines to Barbours Creek carried iron ore to a log washer, where the iron ore was washed free of silica and clay.

In its peak years, the Craig Valley Branch included passenger runs and a mixed train carrying both passengers and freight. It made a stop at Ripley Springs, between Barbours Creek and New Castle. But the railroad's days were numbered, and the Chesapeake and Ohio Railway proposed abandoning the line as early as 1933.

Passenger trains would continue to roll through the 1940s. By the 1950s, however, even freight traffic dwindled. Then, in 1961, with the railroad abandoned, the tracks were removed, and the path became the property of the Virginia Department of Transportation (VDOT).

Today, you can chase the Craig Valley Branch across the remains of the rail bed. VDOT offices now stand at the site of the old New Castle Depot. Just beyond, look for a rail trail completed in 2012; it stretches nearly one mile to a school. The spur to Fenwick Mines, meanwhile, has blossomed beyond Barbours Creek. The old company town has since become a universally accessible day-trip destination with gentle walks and a great place for a picnic.

TRACKING THE TRAIL

New Castle's Greenway Trail and the Fenwick Mines Recreation Area are the easiest places to explore the old Craig Valley Branch. Beyond New Castle, near Oriskany, much of the rail bed is a one-lane road paralleling VA-615 that is used for mountain biking or hiking as it slips through the Jefferson National Forest near the Craig-Botetourt county line. One access to this shared path can be found by following VA-615 for about nine miles northeast of the Craig County Courthouse in New Castle to a connector road, at left, near the county line.

Greenway Trail

Schoolchildren often run, walk or ride bicycles on the Craig County–New Castle Greenway. This mile-long "Greenway Trail" starts at a picnic shelter, built to look like a tiny depot and labeled NEW CASTLE, about one block off VA-615 in Craig City. From here, on the northeast side of New Castle, the trail rolls downhill, with a gentle grade, on a surface of finely crushed limestone. It passes homes and fields for the first half mile, overlooking forested mountains in the distance, at right. The trail slips through woods for about a third of a mile and then ends alongside VA-615, near the McCleary Elementary School parking lot.

Fenwick Mines Recreation Area

With swampy ponds and a waterfall, the twin trails of Fenwick Mines Recreation Area would be worth a visit even without any rail history attached.

143

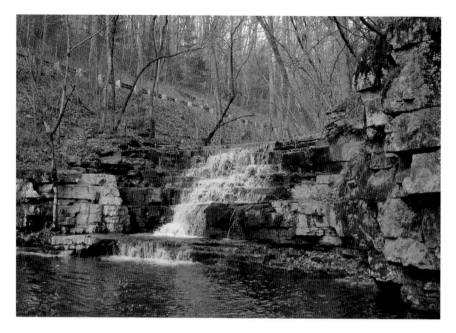

A waterfall provides a scenic highlight at the Fenwick Mines Recreation Area in Craig County. *Author photo.*

Look for an illustrated trail map posted on a kiosk at the trail entrance; both paths are universally accessible and span less than one mile through the Jefferson National Forest.

Turn left from the parking area to follow the Fenwick Wetlands Trail. Listen for the songs of frogs as this trail leads to a picnic area. It slips across scenic bridges on marsh-lined ponds that were once open-pit iron ore mines.

Go right from the parking area to find the Fenwick Nature Walk. This gravel-and-dirt trail passes through a pleasant forest on a portion of an old railroad grade for a quarter mile and then reaches a platform overlooking a twelve-foot-high waterfall on the trout-stocked Mill Creek. At this point, a lower trail descends, at right, and gives a better view of the waterfall. The railroad grade on the hill above continues a bit farther through the forest.

ACCESS

Greenway Trail: New Castle's Craig Valley Branch Greenway Trail begins at the parking area and shelter near the intersection of Commerce Avenue (VA-659) and Third Street (VA-680), near the Virginia Department of Transportation office. The trail ends at McCleary Elementary School, 25345 Craigs Creek Road, where VA-615 meets Route 9120.

Fenwick Mines Recreation Area: From the Craig County Courthouse in New Castle, follow VA-615 northeast for 5.1 miles. Turn left on Peaceful Valley Road (VA-611) and go 0.2 miles. Then turn right on VA-685 and continue straight for 1.2 miles to the trailhead, on the right, or continue another 0.5 miles to the entrance, at right, to Fenwick Mines Recreation Area on Forest Route 229, where a play area for children includes a wooden replica of a train.

HANGING ROCK BATTLEFIELD TRAIL

Salem

Seeking silica sand to send to Salem, the Catawba Valley Railway and Mining Company tracked a railroad to the base of Catawba Mountain. The year was 1907, and in two years, this 9.39-mile-long line would become known as the Catawba Branch of the Norfolk and Western Railway. Over time, too, this line would soon do more than simply ship sand to manufacture glass.

The Catawba Branch passed Hanging Rock in the valley of Mason Creek. The train made a stop at Bennett Springs Station and entered Mason Cove to reach the Catawba Sanatorium Station. For decades, this railroad line provided a vital transportation link to the state-run Catawba Sanatorium, where tuberculosis patients received treatment at the site of the old Roanoke Red Sulphur Springs resort.

Passenger service continued on the Catawba Branch until 1936. Then, north of Hanging Rock, the last half of the line was removed during World War II and scrapped for its steel as part of the war effort in 1943. Still, because the Catawba Sanatorium relied on coal, a compromise was reached. A coal trestle unloading station was built along the branch to remove coal from railroad cars so it could be sent by road.

In 1993, even more of the track was abandoned, and soon after, a rail-trail conversion called Hanging Rock Battlefield Trail was built on a portion of the Catawba Branch.

Hanging Rock shares its name with similar landmarks in Virginia. Nearby Craig County boasts a Hanging Rock on Potts Mountain. The Hanging Rock of Russell County looms over VA-63 between Dante and St. Paul.

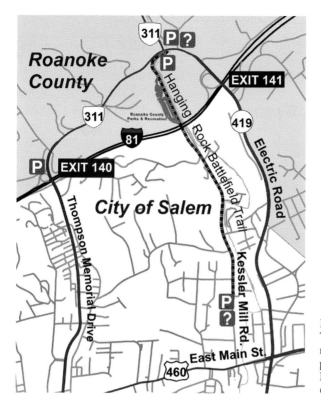

Hanging Rock Battlefield Trail spans about two miles in Salem, running parallel to Kessler Mill Road. *Courtesy Roanoke County Parks and Recreation.*

Another Hanging Rock marks the southern point of a rail trail along Little Stony Creek in Scott County.

The "Battlefield" part of this trail's name comes from a Civil War incident. Here, on June 21, 1864, Confederate general John McCausland's cavalry spotted the stalled wagons and artillery of Union general David Hunter. McCausland's Confederates set fire to those wagons, captured horses, took prisoners and confiscated guns. But Union troops soon arrived to help Hunter and forced McCausland to retreat.

TRACKING THE TRAIL

The two-mile-long Hanging Rock Battlefield Trail eases through an urban landscape on a crushed stone surface, stretching from a trailhead near downtown Salem to the Hanging Rock area along Mason Creek in Roanoke County. It's mostly a flat surface, popular for walking or casual bicycle riding.

On the south, the trail begins along Kessler Mill Road. Immediately cross that road and then follow the trail through an industrial area mixed with residences. Cross Kessler Mill Road again (mile 0.4) as the trail continues alongside homes. Cross a small bridge (mile 1.1) and slip beneath I-81 (mile 1.2).

Just beyond I-81, the route becomes woodsy. It skims past an overlook of the Hanging Rock Coal Trestle (mile 1.6), standing among trees, at left. Curving to the right, the trail crosses Kessler Mill Road (mile 1.7) again and then continues through a commercial district to reach the parking lot of a convenience store (mile 1.8). At this point, look for a bridge over Mason Creek—under construction in 2014—to make a connection to the trail's upper parking area, just off Dutch Oven Road.

ACCESS

Salem: From I-81 Exit 141, follow North Electric Road (VA-419) south for 1.9 miles. Turn right on East Main Street (U.S. 460) and go 0.2 miles. Turn right on Kessler Mill Road and go 0.4 miles to the parking area, at left.

Hanging Rock: From I-81 Exit 141, follow North Electric Road (VA-419) north for 0.3 miles. Turn right on Dutch Oven Road (VA-863) and go 0.1 miles to the parking area, at left.

A small bridge stands on the Hanging Rock Battlefield Trail near I-81 in Salem. *Author photo.*

HUCKLEBERRY TRAIL

Blacksburg to Christiansburg

O n a typical Saturday afternoon, the Huckleberry Trail blossoms with plenty of pedestrians. One woman tests a bicycle in Blacksburg and says she plans to start using this stream of asphalt to commute to work. A young mother pushes a baby stroller. Up next, a group of college-age guys laugh and tease one another as they jog near the campus of Virginia Tech.

Once the line of a coal train moving across Montgomery County, the Huckleberry Trail has grown into an ultra-popular paved path. It links the college town of Blacksburg, a place named for early settler William Black, with the courthouse town called Christiansburg, named for William Christian, a brother-in-law of Patrick Henry.

Here, in 1904, the growth of Virginia Tech (Virginia Polytechnic Institute, or "VPI") made it necessary for a passenger train to serve the Blacksburg campus. So a spur line was completed from Merrimac and celebrated with free rides for all on opening day, September 15.

At some point, the railroad was christened the "Huckleberry." One story says that name comes from a time in 1903 when residents of Blacksburg would ride carriages to the Merrimac community to watch workers build this railroad and go pick huckleberries. Others say Bill Bland came up with the "Huckleberry" name. Bland was a fruit seller, but he didn't make too many sales, he would say, because the Virginia Tech Corps of Cadets would hop off the slow-moving train, pick some huckleberries and then jump back on the railcars.

"Huckleberry" became more than a casual nickname. It actually appeared official—especially after the corps of cadets painted the name "Huckleberry"

on a small, wooden depot that once stood near the site of the present-day Blacksburg library.

The train, in turn, gained fame for going notoriously slow. One legend says a little girl boarded the train, saying she was "too young to have a ticket." But after experiencing a ride on the Huckleberry at a snail's pace, that girl would soon be huffing and puffing and saying, "Oh, now, I'm *too old* to have a ticket."

On another slow ride, one wise guy suggested the cowcatcher be taken off the front of the engine and put on the back. That way, he said, it would keep the cows from running faster than the train.

Cows did cause havoc to the Huckleberry. In one instance, during the summer of 1906, the crew put on the brakes just before hitting a cow that got in the way. The crew got off the train, and the cow apparently ran off. But by the time the crew got back on, that cow had returned and, this time, laid down on the tracks. Next, the conductor got out and approached the cow. It stood up, and he walked with it—in front of the train—until he found a fenced pasture. Then he led the animal inside and latched the gate behind.

In all, the original Huckleberry line ran almost nine miles from Christiansburg to Blacksburg. Merrimac stood near the halfway point and was the reason this line of tracks was built.

The Virginia Anthracite Coal and Railway Company constructed the railroad in 1902 as part of a coal prospecting business at Merrimac. According to legend, coal from the hand-dug mines at Merrimac was used to fuel the Confederate ironclad ship *Merrimack* (also known as *Merrimac* or *Virginia*) during its 1862 battle with the Union's *Monitor* at Hampton Roads.

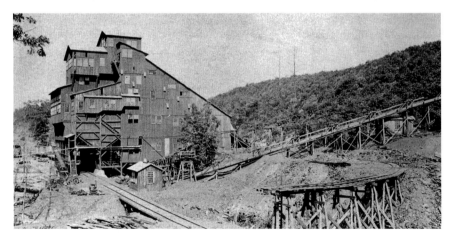

The coal tipple at Merrimac stood between Christiansburg and Blacksburg on the rail line that has since been made into the Huckleberry Trail. *Courtesy Virginia Tech.*

Years later, with the railroad running in the early 1900s, Merrimac's mining community included a two-story boardinghouse, a commissary and a one-hundred-foot-high tipple, used to load railroad cars.

In only a decade, though, the Virginia Anthracite Coal and Railway Company was acquired by the Norfolk and Western Railway. It became the railroad's Blacksburg Branch in 1912.

In its prime, the Huckleberry ran as many as four passenger trains a day between Christiansburg and Blacksburg. But in later years, it seemed like the Huckleberry was dying on the vine. The Merrimac Mines closed in 1935. And with the advancing age of the automobile, it was no longer fashionable for Virginia Tech students to ride the Huckleberry. But some did—well, at least once a year—to transport their trunks on the train.

In 1957, the little railroad attracted much fanfare. On a Labor Day excursion, four hundred members of the National Railway Historical Society boarded the Huckleberry's steam train on three open gondola cars and six coach-type cars. These rail fans came from all over America and a few foreign countries. Crowds gathered in Blacksburg, where the train stopped, and Dr. I.D. Wilson, the head of Virginia Tech's biology department, welcomed the riders as the master of ceremonies. "On board the 'Huckleberry,'" Wilson promised, "you are as safe as if you were in your own homes."

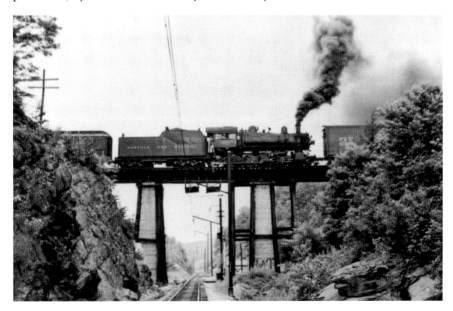

A steam locomotive uses a bridge to pass over railroad tracks on the "Huckleberry" line in Montgomery County, between Blacksburg and Christiansburg. *Courtesy Virginia Tech.*

In less than a year, however, the Huckleberry collided with a passenger car on July 2, 1958, at a crossing on U.S. 460. The driver of the car received slight bruises on his arm.

Later, on December 2, 1962, the *Blacksburg Messenger* proclaimed "'Huckleberry' Does It Again" in a headline atop a report by Mrs. W.D. Altman. "Coming to Blacksburg about 2 p.m., the N&W's historic little train jumped the tracks at the Miller Street crossing," Altman wrote. "Only a few months ago, the 'Huckleberry' left the tracks at the same location."

By then, passenger service had ended. Still, freight trains continued to run until 1966, when the Interstate Commerce Commission ordered the train service discontinued to Blacksburg because the railroad's right of way was needed for an extension of the runway at the Virginia Tech Airport.

That same year, on November 17, J.C. Garrett planted the seed for a new use of the railroad grade. Garrett, a member of Virginia Tech's horticulture department, contributed an article to the *Montgomery County News Messenger* titled "Huckleberry Bed Has Potential for Use as Local Nature Trail," writing:

> *The rails and railroad ties are gone, but many fond memories of the Huckleberry remain for former VPI students, residents and visitors. What's to happen to the railroad cinder and gravel bed? It has a wonderful potential for a nature trail and walking path. Perhaps it could be called "The Huckleberry Trail." Users would be families, elementary school classes, Cub Scouts and Scouts, and individuals. The base for an all-weather trail exists.*

Within a few years, a short trail was built on part of the railroad grade in Blacksburg. The initial mile-long path linked the town's library at Miller Street—where the train would often wreck—to the intersection of Airport Road and Country Club Drive. In 1987, the Blacksburg Town Council debated putting lights on the Huckleberry Trail but ultimately voted against it.

By 1990, new plans sprouted to extend the Huckleberry Trail to Christiansburg on the old railroad right of way, which belonged to the municipalities where it passed. But trying to turn more of the Huckleberry Train into the Huckleberry Trail would appear to take about as many plot twists as the adventures of Huckleberry Finn.

A group called PATH (People Advocating the Huckleberry) united and held fundraisers. Later, the Friends of the Huckleberry formed to raise more money and advocate building the trail. Yet there would be barriers, including people using the planned path for their driveways. One section of active railroad tracks needed to be crossed, and some of

the old railroad grade proved impossible to follow because of expansions at the airport.

Still, the great thinkers of the university community never gave up. To connect the existing Huckleberry Trail in Blacksburg with the railroad grade through Merrimac, the path was diverted beneath a farm road and through a tunnel under U.S. 460. Finally, in 1998, a longer Huckleberry Trail opened and was considered "finished" when it linked the Blacksburg library to the New River Valley Mall—a 5.76-mile journey.

The Huckleberry soon proved as popular as pie. Over the next fifteen years, the trail grew a branch to the Hethwood subdivision, a loop trail was added in Merrimac and an extension in Blacksburg headed toward the Jefferson National Forest. The trail was also stretched south to Peppers Ferry Road.

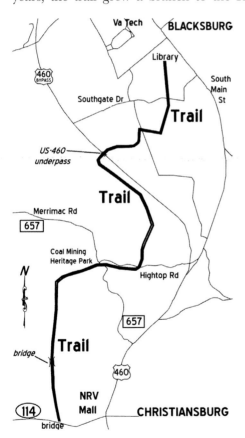

Huckleberry Trail connects the New River Valley (NRV) Mall at Christiansburg to the public library at Blacksburg. Merrimac lies near the midway point. Note the big bridge, at bottom, built in 2014 to cross VA-114 near NRV Mall. *Courtesy Friends of the Huckleberry.*

TRACKING THE TRAIL

For a cyclist, the Huckleberry Trail provides a series of fun ups-and-downs, like a roller coaster ride with lots of curves. Even so, the consistent climbing can also prove to be a bit more of a workout than you anticipate.

Fortunately, the Huckleberry Trail is blessed with a bevy of benches, usually placed at the high marks of hills. That means inexperienced riders can truly pace themselves, simply riding from bench to bench, taking a break and riding some more.

Mile markers note distances on the trail. Mileage counts are also posted on landmarks along the route.

Starting at the Blacksburg library, the rail trail drifts through a tunnel of trees on a path ready made for anyone. It's suitable for strollers, perhaps even a toddler on a tricycle. You cross over Southgate Drive (mile 0.5). Slipping past the Virginia Tech campus, the trail takes a 0.25-mile-long charge uphill (mile 1.0), makes an amazing downhill run and then winds its way up to a high point with a bench beneath a large tree (mile 1.5).

On a section that was not an old railroad grade, the trail passes through a small underpass (mile 1.6) and emerges to breathe the earthy smells of a cattle field. Next, the trail slides downhill for 0.1 miles as it narrows and passes under U.S. 460 through a tiny tunnel. Here, a spur veers right and follows for about a mile to Hethwood, a Blacksburg subdivision.

Bear left to remain on the main trail, en route to Christiansburg. For the next 0.5 miles, the route overlooks sweeping hills, at right, while shouldering the four lanes of U.S. 460 Bypass, at left. The trail reaches a small wooded area (mile 2.4). Then it crosses a small bridge (mile 2.63) that was built in 1992 as a gift by Anderson & Associates, a Blacksburg-based engineering firm.

Warm Hearth Village (mile 2.8) comes up, at right, as the trail leaves the Blacksburg town limits. It crosses Huckleberry Lane. Next, rock cuts loom twenty feet above the trail (mile 3.5) as it goes through more woods on the old railroad grade.

You cross a couple more bridges before reaching Merrimac Road (VA-657) at the Coal Mining Heritage Park (mile 4) near Hightop Road (VA-808). Merrimac's old buildings have been torn down, and the coal mine has been sealed. But the heritage park provides a sense of the past with historical markers standing at the sites or foundations of structures.

The Coal Mining Heritage Park includes restrooms and a curved boardwalk crossing wetlands. You can also step off the rail trail and follow Merrimac's coal-mining loop trail (near mile 4.3), a moderately challenging trek for bike riders, spanning 1.5 miles through a forest of pines.

South of Merrimac, the trail crosses above the active tracks of Norfolk Southern (mile 4.5) in a unique, box-shaped, wire cage that was built specifically so pedestrians cannot leap or throw things on the railroad tracks. Just beyond this bridge, look for a gazebo. This shelter had to be rebuilt after being burned by arsonists on Christmas Day of 1998, about one month after the trail opened.

One of the Huckleberry's most scenic points comes up next as the trail passes between giant rock cuts (mile 5.0) that stand several stories above both sides of the trail. Going beyond, the trail leaves the rail bed before

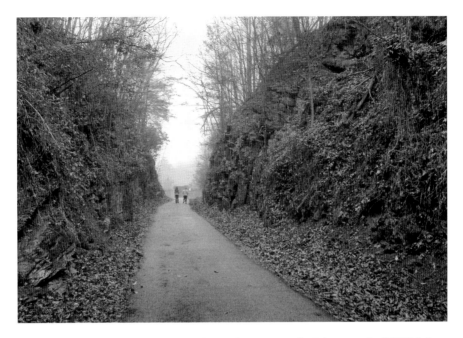

Huckleberry Trail passes through towering rock cuts near mile 5, between the NRV Mall and a box-shaped bridge passing over active railroad tracks. *Author photo.*

it reaches the New River Valley Mall (mile 5.76), where the trail was completed in 1998.

From the NRV mall, the trail has since been continued to follow a paved path that borders the railroad tracks for about a quarter mile. Then it comes to a gigantic extension, climbing over Peppers Ferry Road (VA-114) on a pedestrian bridge—under construction in 2014. Funding for this crossing comes from a $1 million donation willed by the late Renva Weeks Knowles.

ACCESS

Blacksburg: The northern trailhead lies near the Blacksburg Area Branch Library, 200 Miller Street.

Merrimac: Parking access is near the intersection of Merrimac Road (VA-657) and Hightop Road (VA-808).

Christiansburg: Park at New River Valley Mall at the corner of U.S. 460 and VA-114 (Peppers Ferry Road).

NEW RIVER TRAIL STATE PARK

Foster Falls

Colonel John Chiswell hopped in a hole in the 1750s. As legend has it, he was simply trying to hide from Native Americans. But it was in that cave that Chiswell would discover veins of lead, which became the foundation of a long-running industry in the mountains of Wythe County.

Prospectors soon moved into the vicinity of "Chiswell's Hole." The place became known as the "Lead Mines" and was renamed Austinville in 1789. For two centuries, lead mining provided an economic engine in this area along the New River. The surrounding land would also prove rich in iron and zinc, natural resources that attracted the attention of investors who—literally—wanted to get the lead out.

So, in 1882, work began on the Cripple Creek Branch of the Norfolk and Western Railroad. Alternatively known as the Cripple Creek Extension, this line originated at Martin's Tank, a town later called Pulaski. Heading south along the New River, this railroad aimed not only for Austinville; it was also designed to reach the river's confluence with Cripple Creek, the site of several iron furnaces.

Tracks connected to the iron furnace of Foster Falls in Wythe County in 1886. Edging beyond Austinville, the railroad turned southwest to Ivanhoe, the site of another iron furnace in Wythe County. Trains pulsed like a main vein through these Virginia villages, where mining—and dining on the legendary catfish of the New River—was a way of life. Mile after mile, the railroad followed the river's course on a shelf, just above the floodplain.

Originating in North Carolina, the New River runs north to West Virginia. In between, it follows a rocky course through several Virginia counties, including Wythe, Pulaski, Carroll and Grayson. It was named "New" for the same way that mapmakers once gave the "New World" title to Virginia as a whole. What lay beyond the Blue Ridge became "New Virginia." Ironically, though, some scientists believe the New River is a really *old* river—older, even, than the surrounding Appalachian Mountains.

The tracks ended at Ivanhoe. But the New River Plateau Railway Company had ambitions to keep going. In 1889, this company produced a map proposing where this railroad line should go farther. According to plan, the rail would cut into Carroll County and head to Parsons Gap. It would cross the Blue Ridge, skirt the southern edge of both Sugar Loaf Ridge and Wheeler's Knob and then finally take a dive into North Carolina's Surry County, eventually reaching Mount Airy.

It never got there. The rail line was built beyond Ivanhoe. It crossed the New River and turned to follow the course of Chestnut Creek, where it ended at Chestnut Yard in the early 1890s. But by then, the short-lived New River Plateau Railway Company had been absorbed into the Norfolk and Western Railroad. The company's plan to lay tracks to the south, in turn, had been renamed the North Carolina Branch of the Cripple Creek Extension.

Norfolk and Western Railroad became part of the newly organized Norfolk and Western Railway in 1896. Five years later, a spur of the North Carolina Branch was constructed along the New River to Fries in 1901. At the same time, the main line continued farther along Chestnut Creek, eventually going to what is now Galax in 1904. But there, the North Carolina Branch would stop—still a few miles short of the North Carolina border.

Besides the branch to Fries, this line supported several more spurs. The Reed Island Branch, or "Betty Baker Line," turned at Reed Junction to reach more mines and stops, including Kayoulah and Sylvatus. Farther south, the Speedwell Extension turned west at Ivanhoe and followed the course of Cripple Creek to Speedwell.

Running this railroad wasn't always smooth. The New River froze in 1917 at Fries Junction, and an ice jam pushed up the ironworks at a long bridge on the main line. About a decade later, a fast-moving freight train smashed into a passenger train that was running ahead of schedule and caused a fatal accident on the Fries Spur on November 16, 1928.

Still, the North Carolina Branch prospered for decades, hauling the minerals it had been built to carry: lead, zinc and iron. It shipped factory-made furniture from Galax and textiles from the Washington Mills of Fries.

An ice jam on the New River in 1917 caused damage to the bridge at Fries Junction. *Courtesy Virginia Tech.*

New Jersey Zinc Corporation was a longtime fixture of Austinville. Note the tracks, at right, on what is now the New River Trail State Park. *Courtesy Virginia Tech.*

It also picked up people at places like Allisonia until passenger train service was phased out in the 1950s.

A giant axe fell on the line when the Austinville mines closed in 1981. About four years later, the last train ran on October 15, 1985. Norfolk Southern Corporation abandoned the line.

In 1986, Norfolk Southern donated the railroad grade to the Commonwealth of Virginia. Piece by piece, the line was redeveloped as the New River Trail State Park. The first few miles of the fifty-seven-mile-long trail opened on May 2, 1987, linking the Shot Tower Historical State Park to Austinville.

TRACKING THE TRAIL

New River Trail State Park offers an ever-changing journey from town to town for horseback riders, bicycle riders and hikers. Coupled with a two-and-a-half-mile-long extension called the Dora Trail, this corridor can be used to make a connection for nearly sixty miles to ride or walk across four counties, from U.S. 11 in Pulaski to U.S. 58 ("The Crooked Road: Virginia's Heritage Music Trail") at Galax.

The fifty-seven-mile-long state park measures only about eighty feet wide in many places, or about forty feet from the center of the trail. Yet pocket parks and playgrounds show up every few miles, along with picnic shelters, benches and even places to camp for the night. Railroad markers along the state park corridor start at milepost (MP) 2.0 and measure the distance to Pulaski (marked with a "P").

Expect an elevation climb if you travel north from Hiwassee to Draper. The trail also makes a rise from Fries Junction to either Galax or Fries. Still, the state park appears to be mostly a flat surface—or, as one park manager, the late Mark Hufeisen, put it, "You can hardly tell what's up and down."

Dora Trail

Well groomed and well marked, the Dora Trail follows two and a half miles from the restored train station of downtown Pulaski on South Washington Avenue to meet the Peak Creek Trestle, about a half mile south of the official start of the New River Trail State Park.

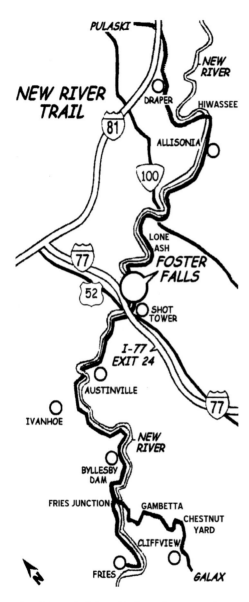

New River Trail State Park can be accessed at Pulaski, Draper, Allisonia, Foster Falls, Shot Tower, Austinville, Ivanhoe, Byllesby Dam, Gambetta, Chestnut Yard, Cliffview, Galax and Fries. *Courtesy Virginia State Parks.*

This connector was built to standards similar to the state park, including a cinder-gravel surface for most of the run; part of the path is paved. While worth exploring, the Dora Trail is not technically a rail trail. But it does partially parallel active railroad tracks, making it practically a rail-with-trail.

The path opened in 2008, just a few weeks before a freak fire at the Pulaski Train Station—actually, the second fire in twenty years. Here, on the morning of November 17, 2008, an electrical short in the ceiling caused flames to shoot high above the stately stone structure. Later rebuilt, the circa-1888 depot has since become half-original, half-replica.

Dora Junction to Draper

Officially, the New River Trail State Park begins a couple miles outside downtown Pulaski near Dora Junction (MP 2.0). This site takes its name from Dora Mills, the daughter of George Mills, a businessman behind the construction of the Dora Furnace, once part of Pulaski's manufacturing industry. From here, the trail spans 4.2 miles to a parking access at Draper that includes a restroom.

Within the first mile, the trail slips between rock cuts, crosses the picturesque Peak Creek Trestle (mile 2.5) and passes a remaining railroad signal (mile 2.6). Continuing through woods as it makes an elevation climb, the trail follows beneath I-81 (mile 3.6). Then it reaches McAdam (mile 3.8), a place where a folk tale says railroad workers were once at wits' end when trying to assign names to different stops along the line. While here, it's told, one man said it doesn't "make a damn" (Mc-A-dam) what this one would be called.

Draper (mile 6.2) takes its name from the family of John Draper, whose wife was captured by Shawnee Indians in 1755 at Draper's Meadows—what is now Blacksburg. Draper later found his wife living with the family of an Indian chief. He paid a ransom for her, and in 1765, the couple moved to a log cabin in what became the Drapers Valley area of central Pulaski County.

The Draper Mercantile stands near the trail along Greenbriar Road. This structure has been a fixture in the community since the railroad era—a time when Draper boasted its own railroad depot. Built in the late 1800s, the Draper Mercantile has served as a barbershop, a dress shop and a post office. In more recent years, it has evolved into a multifaceted store and restaurant.

Draper's long-gone depot was a fixture on the Norfolk and Western Railway's North Carolina Branch, prior to the creation of the New River Trail State Park. *Courtesy Virginia Tech.*

Draper to Allisonia

New River Trail State Park runs 6.4 miles on the southward stretch from Draper to Allisonia. Look for gorgeous scenery and big bridges along Claytor Lake as the path follows mostly downhill.

Almost immediately after easing out of Draper, the trail crosses the long and high Sloan Creek Trestle (mile 6.5), offering great views of nearby peaks and farms. After a mile of moving past rock cuts, the trail crosses the tall Bridge No. 1505 (mile 7.7) and the extraordinarily scenic Bridge No. 1506 (MP 8), a trestle spanning about four hundred feet at the edge of Claytor Lake.

New River Trail borders Claytor Lake for about four miles. Surrounded by forests and private residences, this 4,475-acre reservoir lures anglers in search of smallmouth bass, spotted bass and walleye. The $11 million Claytor Dam in Pulaski County sits a few miles downstream of the trail. Completed in 1939, the dam and lake forever changed the land at the edge of the railroad tracks. The waters of the New River rose and erased the sites of homes and businesses, including the old Clarks Mill that once stood below Bridge No. 1506.

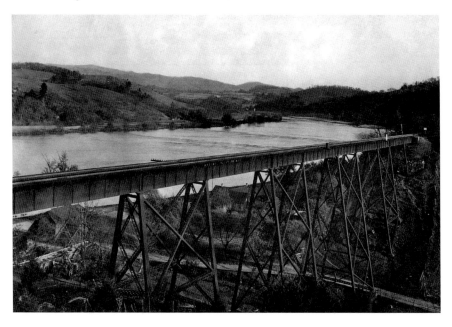

A 1930s-era view of the New River Trail State Park's Bridge No. 1506 shows the New River prior to the creation of Claytor Lake. *Courtesy Virginia Tech.*

The trail passes over a 35-foot-long bridge at Delton (MP 9). Then it crosses Claytor Lake on the 951-foot-long Hiwassee Bridge (mile 10.2), a steel truss structure that offers unparalleled views of mountains and water. The name Hiwassee comes from a Native American Indian word meaning "savannah" or "meadow." Local industries have included Hiwassee's Hoover Color Corporation, which operates at a site where iron oxide pigments have been mined out of the mountains since the 1920s to produce colors in crayons and paint, among other products.

Beyond the big bridge, the trail takes a right and cruises into Allisonia (mile 12.6) in the southwestern corner of Pulaski County. This residential community was once a center for iron ore mining. Standing near the trail, the Allisonia Train Depot was built in 1885 and used until the early 1950s. Decades later, Don and Chipper Holt converted the station into an overnight lodge by turning the telegraph office into a kitchen and making a waiting room into a bedroom.

Virginia Bridge and Iron Company built the Hiwassee Bridge in 1931, prior to the construction of Claytor Lake. *Courtesy Virginia Tech.*

Allisonia Depot has been converted into an overnight lodge near Claytor Lake. *Author photo.*

Look for a trail access in Allisonia just off Julia Simpkins Road (VA-693) near a boat ramp. Such a spot is fitting: New River Trail State Park parallels the New River for thirty-nine miles, providing not only great scenery but also a quick place to cool off. This constant connection between rail trail and river has inspired park officials to promote a blueway that follows the river, with the Allisonia boat ramp on Claytor Lake marking one of the stops along the watercourse.

Allisonia to Foster Falls

Heading south from Allisonia to Foster Falls spans 11.4 miles along the isolated banks of the New River, passing scenes of forests and rock cuts along the way.

About one mile from Allisonia, the trail crosses Big Reed Trestle near the New River. Stand at the center and look upstream. You'll notice Little Reed Island Creek on the right and Big Reed Island Creek on the left.

In a few more miles, the trail arrives at Barren Springs, close to a crossing of VA-100 (mile 17.6). In this vicinity, barricades were once placed across the trail in the 1990s. At what became known as "The Gap," the New River Trail took a detour between Barren Springs and Lone Ash. The reason: a reversion clause in a land deed showed the strip of land where the railroad had passed was returned to the original landowners. who, by then, had turned out to be seventeen heirs of a mining company that no longer existed. To finally connect the park corridor, officials had to contact a lengthy list of people until the trail could be opened—with no gaps—in 1999.

Barren Springs was the site of a busy iron furnace in the late 1800s. Farther along, the trail arrives at the Lone Ash shelter and restroom facility (MP 19) near VA-622. Lone Ash was once called Carter; it took its present name from a large, lone ash tree.

Lone Ash was once a flag stop on the North Carolina Branch of the Norfolk and Western Railway. It is now a rest stop between Foster Falls and Allisonia along the New River Trail State Park. *Author photo.*

Beyond Lone Ash, pass a gated opening, at left, to the Bertha Cave (mile 19.6), a limestone grotto supporting a population of bats. In couple more miles, after passing through the Bertha community (near MP 20), the trail breezes beside Baker Island, a campground for paddlers at the center of the New River, just before entering the Foster Falls recreation area (near MP 23).

Foster Falls

Spacious and green, the state park headquarters at Foster Falls promises a delightful destination, even if you don't get on the New River Trail. This site includes river access points and boat launches for tubing, kayaking and canoeing, plus an amphitheater, the riverside Millrace Campground, a playground, picnic facilities, a restored caboose, Foster Falls Horse Livery, restrooms and the park's Discovery Center. The New River Trail follows through the Foster Falls recreation area for about one mile.

Once called the "Roaring Falls," this area took its name from an early landowner who settled along the New River at a long set of shoals. "Foster Falls" refers to the river's frothy, Class III-IV rapids. Several structures remain from this town's heyday at the turn of the twentieth century, including a general store, corncrib and a barn. The Foster Falls Depot (near MP 24) was constructed sometime after the railroad arrived in 1886. Nearby, the Foster Falls iron furnace was built in 1881 and used until about 1914.

In 1887–88, the Foster Falls Mining and Manufacturing Company built the Foster Falls Hotel, a structure that remains near the park entrance. Within sight of the hotel, about one hundred company homes also once stood near the busy iron furnace and railroad depot. Briefly, Foster Falls Hotel was promoted as a riverside resort. Later, in 1919, the hotel became an industrial school for women and then an orphanage until it was ultimately abandoned. In more recent years, park officials have made plans to renovate the hotel into an overnight lodge.

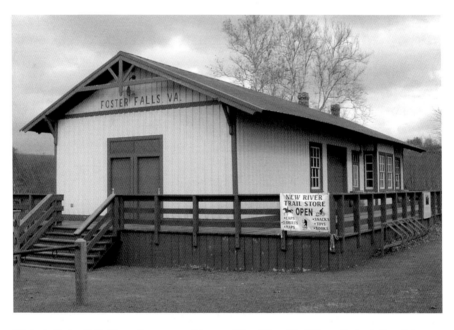

Historic Foster Falls Depot is open to visitors at New River Trail State Park. *Author photo.*

Foster Falls to Austinville

Continuing west from Foster Falls Depot, the New River Trail extends about five miles to Austinville, still closely bordering the New River. Immediately, the trail passes, at right, the site of Hematite, where stone piers remain standing from a washed-out bridge that once connected to a hematite iron ore mine. Further on, the trail slips past the park's Mark E. Hufeisen Horse Complex. Then it crosses Shorts Creek on a bridge near U.S. 52 at Jackson Ferry.

About 1.0 mile from Foster Falls, the Shot Tower Historical State Park (mile 25.2) is reached by a short connector, at left. Ferryboat operator Thomas Jackson built the 75-foot-tall shot tower with limestone in about 1807 to make an early form of bullets called "shot." In the tower's top room, melted lead was poured through various sizes of sieves. That hot lead then fell 150 feet through a shaft to a large kettle of water, which acted as a cushion. Jackson reached his finished shot by an access tunnel near the river. The shot was sold on site to hunters, traders and merchants or sometimes shipped downriver by bateaux.

Railroad tracks near Austinville passed through a tiny tunnel along the New River in the early 1900s at what is now New River Trail State Park. *Courtesy Virginia Tech.*

Just beyond the shot tower, the trail passes beneath I-77 and crosses the Indian Branch on a small bridge. Then, about three miles from the shot tower, the trail runs through the New River Tunnel or "Austinville Tunnel," a rocky bore spanning less than two hundred feet (near MP 28). Yellow straps called "telltales" once hung on either side of this tunnel, giving warnings to railroad men that the tunnel was coming up and that they should duck when the straps touched the top of the train.

The small residential community of Austinville (mile 28.8) took its name from businessman Moses Austin, whose son Stephen Austin was born in the unincorporated town in 1793. Moses Austin ran the lead mines for a few years. Then the family left Virginia for Missouri, later settling in Texas. There, Stephen Austin became a political leader and was beloved as the "Father of Texas." The Lone Star State's large city of Austin was named for him. In Virginia, little Austinville also remembered its native son. Turn right near Austinville's trail access along VA-636, and you'll see a nine-foot-high granite monument at the Stephen F. Austin Memorial Park, a small green space near the New River.

Austinville to Ivanhoe

Linking two historic industrial centers, the New River Trail spans an easy 2.8 miles between Austinville and Ivanhoe. This section makes a great riverside walk or short bike ride, including a big bridge at the center and a restroom near both access areas.

Going south, almost immediately beyond the picnic shelter at Austinville, look to the right. The blank field at the edge of the trail (near MP 29) occupies part of the old industrial area used during Austinville's two-hundred-plus-years of lead mining. Continue past Austinville for about one more mile and

The long-gone Ivanhoe Depot, captured in this 1948 photograph, once stood along what is now New River Trail State Park. *Courtesy Virginia Tech.*

then cross the New River (mile 30.3) on the third-longest bridge of the trail, a scenic span stretching 670 feet.

Little more than a mile beyond, Ivanhoe (mile 31.6) makes a great picnic destination. Look for a picnic shelter along the trail, standing near the site of the old Ivanhoe Depot. Through much of the twentieth century, Ivanhoe was a prosperous center for producing iron ore, carbide and limestone. It had been earlier called Red Bluff, Brown Hill and Van Liew before it became Ivanhoe Furnace and then simply Ivanhoe by 1890. The community took its name from the Sir Walter Scott novel *Ivanhoe*.

Ivanhoe to Fries Junction

Eight miles separate Ivanhoe from Fries Junction on the New River Trail, a popular stretch among horseback riders, where Wythe County merges into Carroll County. The territory bordering this part of the trail is rugged and remote.

From Ivanhoe, the trail moves across a few bridges and borders forests in the 3.0 miles that it takes to reach Buck Dam (mile 34.7). This fifty-foot-tall wall forms a rocky reservoir commonly called Lake Buck. Here, water rises and falls, and fish get trapped in the potholes of river rocks. Next, birds swoop down and eat those trapped fish.

South of Buck Dam, the trail spans nearly another 3.0 miles to Byllesby Dam (mile 37.3), a barrier that makes a lake of 335 acres. Marsh, rock bluffs and tall trees line Byllesby Reservoir, where fishing includes smallmouth bass and walleye. Like Buck, Byllesby stands fifty feet high and was built in 1912–13 by the Appalachian Power Company.

Buck took its name from Harold Winthrop Buck, an engineer who was a partner in the New York City firm that oversaw the dams' construction. Byllesby's name honors Henry Marison Byllesby, the head of the Appalachian Power Company.

Building both Byllesby and Buck destroyed a historic vacation destination, upstream, at Grayson Sulphur Springs (mile 38.6). This resort opened in 1835 when Carroll County was still a part of Grayson County. Visitors came here to drink or bathe in spring water rich in minerals, believing it would cure various ailments. But a flood on the river—and the ensuing Civil War—prompted a shutdown that would span several years. The resort rose again in the 1890s, an era when it could be reached by the railroad. A new, thirty-two-room hotel attracted patrons from as far as Texas. Guests rode

Norfolk and Western Railway tracks (front right) once followed near Buck Dam on the New River at a point now popular among horseback riders on the New River Trail. *Courtesy Virginia Tech.*

horses and flocked to the resort's bowling alley. But it would all ultimately be torn down and swept beneath Byllesby's rising lake waters.

Over the next mile, the trail crosses Brush Creek on a tiny bridge and snakes between strikingly tall walls of rock. Still following the scenic shoreline of Byllesby Reservoir, the trail forks at Fries Junction (mile 39.8), a site with a picnic shelter and restroom.

Fries Junction

Fries Junction makes a great place to either end an excursion or regroup for another adventure. From here, turning right on the Fries Spur travels more than five miles to the Fries Dam at the trail's southwestern-most terminus. Turning left follows the main line to Galax for twelve miles and immediately spans the 1,089-foot-long Fries Junction Bridge. Either way, starting at Fries Junction, you'll be going uphill.

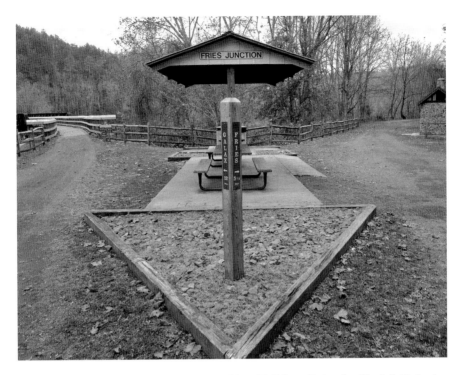

Fries Junction marks the point where the New River Trail State Park splits. The left side leads twelve miles to Galax while the right side goes five and a half miles to Fries. *Author photo.*

Galax to Cliffview

Starting south along U.S. 58, the New River Trail in Galax begins at a caboose at the edge of Chestnut Creek, the main drain for this pretty city. The creek's name comes from chestnut trees that once grew along its banks. From Galax (mile 51.7), the trail immediately borders woods and rolls north across a couple bridges before reaching Cliffview in 2.2 miles.

Earlier called Montplan and Cairo, Galax evolved from a real estate venture by a group of local businessmen. By the end of 1903, this posse had persuaded Norfolk and Western Railway officials to extend the North Carolina Branch to Bonaparte—yet another early name for this settlement straddling the banks of Chestnut Creek.

In 1904, the first train rolled, and the place was renamed for the heart-shaped Galax plant, a mountain evergreen used in floral arrangements. By the time Galax was incorporated as an independent city in 1954, it was well on its way to staking its claim as the "World's Capital of Old-Time Mountain

Music." That comes primarily from the city hosting the Old Fiddlers Convention since 1935. Here, musicians sign up to play in competition on the second week of each August, and some perform "New River Train," a folk tune believed to refer to the rail line that has since become the New River Trail State Park.

Cliffview to Chestnut Yard

New River Trail connects Cliffview to Chestnut Yard in four miles, going from greater Galax to the craggy cliffs of Carroll County, all the while following Chestnut Creek.

Formerly called Blair, Cliffview (mile 49.5) includes a ranger station with restrooms and historical displays. Near the parking area, look for a 1902 mansion called Cliffside. It was built for state senator Thomas Felts, a partner in the Baldwin-Felts Detective Agency, which supplied guards to coal companies during labor disputes in the early 1900s.

In about 1.5 miles from the parking access, the trail reaches the Cliffview Campground and passes a scenic set of rapids (near MP 48). In another 1.5 miles, the watercourse takes a terrific tumble at Chestnut Creek Falls (mile 46.3). This ten-foot-high cascade can be found just 0.8 miles from the parking access at Chestnut Yard (mile 45.5). Overlooked by a bench and a bridge, the waterfall has become quite a popular destination.

Chestnut Yard to Fries Junction

Following the New River Trail north from Chestnut Yard to Fries Junction spans 5.7 miles through some of the state park's most remote country. Gambetta serves as a rest stop along the way.

Immediately beyond Chestnut Yard, the trail passes the site of a turntable (mile 45.1) that was used to turn locomotives during the late 1800s when Chestnut Yard was the terminus of the North Carolina Branch. Continuing north for about three more miles, the trail reaches a trail access at Gambetta (mile 42.3).

How Gambetta took its name may be a mystery. This quiet crossroads could be an honor for Leon Gambetta (1838–82), a French statesman who founded the Third Republic, or "Gambetta" could be derived from an Italian nickname for someone with a peculiarity of the legs.

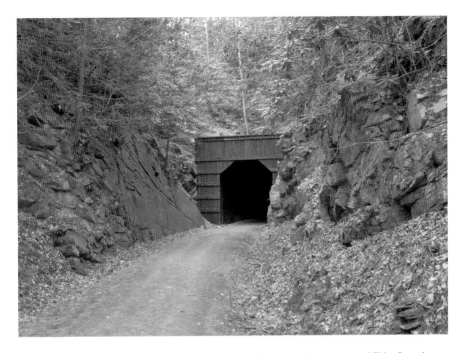

New River Trail State Park passes through a tunnel between Gambetta and Fries Junction. *Author photo.*

In two more wooded miles of following Chestnut Creek, the trail slips through a 193-foot-long tunnel (mile 40.3). Then, in another 0.5 miles, the route reaches Fries Junction, site of the longest bridge on the trail.

Fries Spur

The most logical way to see the Fries Spur is to go south to "Where the Trail Begins," as a sign says in Fries. Simply start at the heart of the Grayson County town: a large parking area for the New River Trail adjoins a Fries community park that features a picnic shelter, a playground, a railroad caboose, a boat launch and fishing access near Fries Dam (mile 45.3).

Colonel Francis Henry Fries used the water power of the thirty-nine-foot-high Fries Dam, constructed in 1902–03. The colonel operated Washington Mills, a textiles factory housed in a large brick building on the riverbank. Washington Mills employed child laborers in its early years and also constructed many buildings in Fries, including rows of

company homes. The mill business survived into the 1980s; the factory was later torn down.

How you say "Fries" has since become a local joke. In the summer, when humidity and heat hangs above the riverside town, people call this place "frys." Come winter, as ice cakes creeks, it's more proper to say "freeze"—just as Colonel Fries would pronounce his name.

Moving north, the New River Trail spans 5.5 miles from Fries to Fries Junction. The path overlooks the backs of buildings in the first mile; it parallels Fries Road/VA-606 over the next. The trail then crosses Fries Road (near MP 43), near a convenience store and heads for the woods.

Between Fries Road and Fries Junction, the trail offers a quiet getaway, highlighted by overlooks of the river's Double Shoals. The path pushes past rock cuts and rhododendron, at left, while the river, at right, becomes so chunky that in times of low water, it simply looks like a rock garden with water running through it.

ACCESS

Pulaski: Dora Trail (a two-and-a-half-mile extension to New River Trail State Park) starts at the Pulaski Train Station, 20 South Washington Avenue, Pulaski, at the Dora Highway Park, which features a railroad caboose, playground, a basketball court and park benches. (From here, the Dora Trail runs two and a half miles to Peak Creek Trestle on the New River Trail State Park.)

Dora Junction: From I-81 Exit 94B, follow VA-99 north for 1.8 miles. Turn right on Xaloy Way to reach the state park trailhead (MP 2.0) near Pulaski.

Draper: From I-81 Exit 92, follow VA-658 southeast for 0.9 miles. The trail access is on the left, near the VA-758 intersection.

Allisonia: From I-81 Exit 89A, follow VA-100 south for 6.5 miles to Barren Springs. Turn left on VA-608 and follow for 2.5 miles. Bear left and follow VA-607 for two miles. Turn left on VA-693 and follow for 1.7 miles to a parking access for the New River at a boat ramp.

Foster Falls: From I-81 Exit 80, follow U.S. 52 south for 7.5 miles. Turn left on VA-608 and follow for 1.8 miles to the park entrance road, at left.

Shot Tower: From I-77 Exit 24, follow VA-69 east for 0.2 miles. Then follow U.S. 52 north for 1.2 miles. Turn left on Shot Tower Road and follow for 0.5 miles to the park entrance.

Austinville: From I-77 Exit 24, follow VA-69 west for 3.9 miles to the trail access on the left.

Ivanhoe: From I-81 Exit 80, follow U.S. 52 south for 1.2 miles. Turn right on VA-94 and go south for 8.0 miles. Turn left on VA-639 and go east for 0.1 miles to the parking access.

Byllesby: From West Main Street in Fries, go north on VA-94 for 6.3 miles. Turn right on Byllesby Road (VA-602) and go east for 3.5 miles to the parking area near Byllesby Dam.

Galax: From I-77 Exit 14 at Hillsville, follow U.S. 58/221 west for ten miles. The Galax trailhead lies on the right where the road crosses Chestnut Creek.

Cliffview: From the Galax trailhead, follow U.S. 58/221 east for 0.4 miles. Turn left on Glendale Road (VA-887) and go 0.6 miles. Turn left on Cliffview Road (VA-721) and follow for 0.5 miles to the parking area and ranger station, at left.

Chestnut Yard: From the Cliffview Ranger Station near Galax, follow Cliffview Road (VA-721) northwest for 1.5 miles. Turn right on VA-607 and go 2.8 miles to the parking access.

Gambetta: From the Cliffview Ranger Station near Galax, follow Cliffview Road (VA-721) northwest for 1.5 miles. Turn right on VA-607 and go 1.2 miles. Turn left on Gambetta Road (VA-793) and go 2.3 miles to the parking access.

Fries: From the Cliffview Ranger Station near Galax, follow Cliffview Road (VA-721) northwest for 1.5 miles. Turn right on VA-607 and go 0.3 miles. Then turn left on VA-721 and go 2.2 miles. Continue on VA-606 at the river crossing and go 2.0 miles (as the road becomes Main Street). Turn left on Fire House Road and follow to the parking access.

RAVEN CLIFF TRAIL

Speedwell

Norfolk and Western Railway's Speedwell Extension could have lived up to another name. It could have been called "Cripple Creek Branch," one of the earliest titles for the line that became the North Carolina Branch of the Norfolk and Western Railway, what is now the New River Trail State Park.

The Speedwell Extension originated at Ivanhoe and was actually a spur of the North Carolina Branch. The railroad reached Wythe County's community called Cripple Creek in 1902 by generally following the cavernous watershed of Cripple Creek.

Legend says hunter James Burk inspired the name Cripple Creek in the 1740s when he chased and crippled an elk on these waters. Later, some believe, this place was immortalized in the folk song "Goin' Up Cripple Creek."

By 1906, the Speedwell Extension spanned more than sixteen miles and was complete. It had reached the iron deposits of Speedwell, a Wythe County community along U.S. 21. Along the way, the line passed Raven Cliff, where an iron furnace has been standing since at least the days of the Civil War—possibly as early as 1810—yet certainly long before the railroad arrived. The Raven Cliff Furnace, made of limestone and sandstone, resembles many of Wythe County's other iron furnaces at Ivanhoe, Speedwell and Foster Falls.

The Speedwell Extension survived only until the late 1930s. The rails were removed, and parts of the railroad grade turned into roads, including a bridge on VA-619 over Cripple Creek. Yet one small section has survived as a trail in the Mount Rogers National Recreation Area.

TRACKING THE TRAIL

Raven Cliff Recreation Area includes the woodsy Raven Cliff Trail (No. 4601). This path follows a cliff-hugging portion of the old railroad grade on the Speedwell Extension of the North Carolina Branch of the Norfolk and Western Railway. The trail spans a bit more than a half mile to Cripple Creek. Look for the trailhead at a small trail sign that is posted between a gravel-topped traffic circle and a sharp right turn on the access road that leads to a parking area.

Immediately, the trail enters a wooded area; the first few yards can be muddy. Bear left at a point where a connector leads back to the right. Then stay straight. For the next half mile, enjoy the rock cuts of the railroad grade as the path grows increasingly more narrow—and scenic. Fallen trees lie crossways above the trail, joining one rock cut to another in a jungle of vines and branches.

Bear left when the trail forks. Go downhill for 0.1 miles to reach the rocky streambed of Cripple Creek. The shallow waters reach only above the ankles. Yet look about fifteen yards immediately upstream, and you'll see concrete piers—on each creek bank—that once held up a long-gone bridge carrying train traffic.

> **Trail tip**
> To see the Raven Cliff Furnace, turn around at the creek and return to the head of the Raven Cliff Trail. Turn left at the access road. Then follow past the gate, where the path to Raven Cliff Furnace begins. Bear right after a few yards. Cross Cripple Creek on a footbridge and continue following a mowed strip through an overgrown meadow. Bear left when the trail intersects a dirt path. Ahead, the thirty-foot-high Raven Cliff Furnace stands at right, about a half mile from the start.

ACCESS

From I-81 Exit 70 in Wytheville, follow U.S. 21 south for 13.8 miles to Speedwell. Turn left on VA-619 (Saint Peters Road, which becomes Gleaves Road) and go east for 6.5 miles. (Note that VA-619, at 5.5 miles from Speedwell, crosses Cripple Creek on a one-lane bridge that was used by the railroad on the Speedwell Extension.) Turn right at Raven Cliff Lane (the campground access road) and go almost 1.0 mile to a gravel turn-around, where the trails begin.

CURRIN VALLEY CIRCUIT

Marion

C hartered in 1891, the Marion and Rye Valley Railroad began operations in 1893 at Marion. It hooked into the main line of the Norfolk and Western Railroad at the site of the stockyards—later, the town pool. From this courthouse town, the track stretched south for about six miles to reach Currin Valley in central Smyth County, where investors thought valuable manganese deposits would provide riches.

Later, the line was extended from Currin Valley to nearby Sugar Grove. There, it met the Virginia Southern Railroad, which stretched a few more miles to Fairwood, the site of extensive lumbering during the early 1900s in Grayson County.

By the 1920s, both lines—the Virginia Southern Railroad and what was later known as the Marion and Rye Valley Railway—came under the same management. Briefly, during this time, the Fairwood section was advertised as the "Switchback Scenic Route" to lure tourists to see sites like the "Scales," a high-altitude point where cattle were once weighed on Grayson County's Pine Mountain. But offering train rides for tourists didn't prove financially viable, and these railroads started shutting sections in the early 1930s. All runs ended by the close of that decade.

Today, a portion of the Marion and Rye Valley Railroad grade can be explored on the remote Currin Valley Circuit of the Mount Rogers National Recreation Area. Named for Virginia's highest mountain, the national recreation area also includes the site of what was once Fairwood and the "Scales," which has since become a popular gathering spot along the Appalachian Trail.

TRACKING THE TRAIL

Currin Valley Circuit spans 5.7 miles in a loop, blazed in orange, that doubles as a gravel-topped forest road. It is open for biking, hiking and horseback riding. Tall trees border the route, which offers sweeping views of nearby mountains, especially in winter when trees are missing leaves.

ACCESS

From I-81 Exit 45 at Marion, follow VA-16 south for 2.8 miles. Turn right on Currin Valley Road (VA-671) and go 1.4 miles until you reach the trail access on Forest Road 243. This route (no. 243) can be walked, or you can simply drive for another 1.3 miles and park at the junction of Forest Road 865. Look for a gate on Forest Road 865 and a parking area to the right. To access the trail, go beyond the gate on this forest road, which partially follows the old railroad grade as it goes uphill. This section makes a pleasant, 2.0-mile up-and-back.

> **Trail tip**
> Maps of the route are available on a brochure at the nearby Mount Rogers National Recreation Area visitor center (3713 Highway 16, Marion). To get there, go 5.8 miles south of I-81 Exit 45 on VA-16 (or 3.0 miles south of the Currin Valley Road intersection).

CABIN CREEK TRAIL

Grayson Highlands State Park

Grayson Highlands State Park stands at the center of Virginia's Big Sky Country. With open vistas and bluffs of boulder, it looks like a little slice of Montana landed among the rocky mountains of Southwest Virginia. Many of the park's trails—including parts of the Appalachian Trail—originated as logging roads or railroad grades in the early 1900s. These trails follow an indefinite number of short-line temporary tracks built to haul timber from the mountaintops.

Here, lumberjacks grabbed the green gold of trees stretching three or four feet in diameter. But they left behind little more than windswept, grassy balds, created by the remnants of grand-scale logging. Park rangers now maintain trails across these oh-so-scenic fields, in part, by allowing wild ponies to roam.

Grayson Highlands Ponies live in both the state park and the adjacent Mount Rogers National Recreation Area. Here, they graze in fields dotted by natural Christmas trees—and they largely fend for themselves, especially in summer. Yet in winter, the Wilburn Ridge Pony Association has sometimes supplemented their diet with bales of hay. The horses nibble at what grows between scattered splinters of residual rhyolite, weathered rocks that mark the remains of an ancient volcanic eruption. These ponies have also been known to sometimes nibble at the heels of hikers—and even swipe backpacks. In turn, park rangers advise visitors not to approach them.

Like the more famous Chincoteague Ponies of Virginia's Eastern Shore, the Grayson Highlands Ponies are not exactly wild. Initially put here in 1974

Cabin Creek Falls can be found by following a footpath on an old railroad grade at Grayson Highlands State Park. *Author photo.*

by the late Bill Pugh of nearby Teas, the ponies have adapted remarkably well to their alpine surroundings, growing long and shaggy manes and tails. Today, about one hundred ponies, more or less, live beside big boulders and bountiful blueberry bushes.

Just beyond the cleared fields, away from where the ponies roam, the state park's Cabin Creek Trail slips beside a forest floor full of ferns. Then the trail

returns to the open meadow of Massie Gap on a clearly detectable railroad grade. Most impressively, this shady path leads to a series of waterfalls on the rippling waters of Cabin Creek, a New River tributary supporting a population of native brook trout.

Cabin Creek takes its name from a small hunting cabin, at the creekside, that once belonged to a man named Livesay. Massie Gap was named for Lee Massey, who, unfortunately, did not get his name spelled correctly by mapmakers. Mr. Massey lived with his family on Cabin Creek and used a pick, shovel and hammer to work on the railroads of this area.

TRACKING THE TRAIL

Blazed in yellow, the Cabin Creek Trail starts at the woods on the left side of the Massie Gap parking area of Grayson Highlands State Park. For the first several yards, the 1.9-mile-long loop roams through a tunnel for trees formed by mountain laurel and rhododendron.

When the trail forks, bear left and continue downhill for about a half mile, following along the creekbed. Then look, at left, for the first of the falls: a twenty-five-foot-high beauty with three prongs that unite as they ripple into the stream. Return to the trail for a few more yards, and look left again: a twelve-foot-high waterfall pours in a consistent cascade. Several yards farther, another waterfall is encountered—a cascade of about fifty feet that is sometimes hard to see due to the overgrowth of vegetation.

Beyond all the falls, the trail makes a sharp right turn and returns to Massie Gap by following an old railroad grade. This flat surface was used between 1910 and 1922 to haul logs for the Fairwood Lumber Company.

ACCESS

From I-81 Exit 45, follow VA-16 south for about twenty-four miles to Volney. Turn right on U.S. 58 and go eight miles to the park entrance on the right. On the park road, continue for about three miles to Massie Gap. The trailhead to Cabin Creek Falls lies to the left of the open field; trail signs are posted.

CHAPTER 36

SALT TRAIL

Saltville

Saltville probably needed a railroad long before 1856. Industrialists in this valley of the North Fork of the Holston River had targeted salt as a resource as early as 1782, when Arthur Campbell began the area's first commercial manufacturing of salt. Commonly at this time, boiling brine became the way to process this natural resource. Brine pumped from wells was cooked in kettles, leaving behind mostly pure salt that could be dipped and dried. Then, prior to the railroad, that salt was transported from Saltville by wagon or by raft, sent downriver to Tennessee by early industrialist William King.

By the time of the Civil War, the Salt Branch railroad had long been part of the landscape. This nine-mile-long branch was built in 1856 as a spur of the Virginia and Tennessee Railroad. It linked the main line at Glade Spring with Saltville.

Twice, during the Civil War, Union troops targeted Saltville in 1864, looking to destroy the saltworks. On the hills surrounding the town, Confederate troops carved out trenches and built forts to defend the salt deposits buried deep beneath the earth's surface. The second battle, in December 1864, partially destroyed the saltworks, though Saltville did ultimately continue to provide the Confederacy with an ingredient needed to preserve food, among other uses.

The train inspired a nickname at "Smoky Row," a line of homes in Saltville where the train's soot would fall. Any white linen would be covered with coal dust—or, as Saltville's longtime tourism director Charlie Bill Totten would say, "You had to be quite selective on the drying-clothes time."

About midway between Saltville and Glade Spring, a rail-side hamlet called Clinchburg emerged as a lumber center during the early 1900s, taking its name from nearby Clinch Mountain. For decades, Clinchburg was the company town of the Holston River Lumber Company and a place where streetlights and a boardwalk lined the road. A railroad spur ran to timber interests on Clinch Mountain, and a giant mill processed lumber. But the operation ended in 1932 when the company "sawed out," as Clinchburg's Ray Wells once remembered, later leading to an auction of the town's company-built homes.

Back in Saltville, the Salt Branch serviced the Mathieson Alkali Works, which eventually became part of the Olin Corporation. This chemical manufacturer made Saltville a company town for decades, beginning in the 1890s. But just like the Holston River Lumber Company ceased operations at Clinchburg in the 1930s, so did Olin at Saltville in the 1970s. It shut down its plant at Saltville in 1972 for failing to meet environmental regulations, among other reasons, and its absence allowed rail traffic on the Salt Branch to become increasingly slow.

By 2006, Saltville had recast itself as a tourist town. Visitors came to fish in the Well Fields, where salt brine was once pumped, and explore the nearby Clinch Mountain Wildlife Management Area, where gravel roads follow old logging lines that were long ago connected to the Salt Branch. At the center of Saltville, the Museum of the Middle Appalachians shined a spotlight on the mountain town's unique history linked by salt, starting with the great woolly mammoths lured by the valley's salt licks thousands of years ago.

The Salt Branch, by then, had long since come to an end, but a new plan arose. The rails of the old railroad were scrapped and sold, giving the Town of Saltville some seed money to plant a new dream called the "Salt Trail." Opened in 2008, it was built quite resourcefully with leftover railroad ties stacked in the shoulders like a fence, providing beautiful barriers.

In all, the Salt Trail runs about nine miles. But it's split apart, with two rail-trail portions joined only by a detour on hill-climbing highways. The reason is for safety. The original rail bed in Washington County ran through the property of U.S. Gypsum, once the site of a company town called Plasterco and earlier called Buena Vista. Those gypsum mines have been prone to cave-ins, forcing the property and its rail bed to be chained-off, like a no-man's-land.

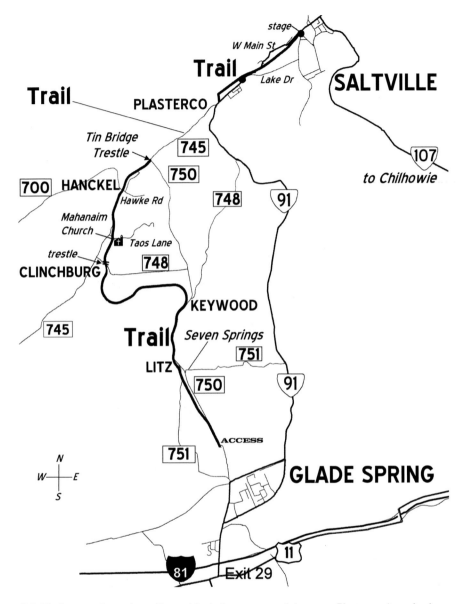

Salt Trail spans about nine miles and includes an on-road detour at Plasterco. An unbroken portion on the old railroad grade runs from Tin Bridge Trestle to an access near Glade Spring. *Courtesy Town of Saltville.*

Tracking the Trail

The Salt Trail surface ranges from asphalt in Saltville's downtown section to crushed stone, dirt, grass and leftover ballast. It's well suited for day hikes. Bicyclists might also note that most of the trail rolls quite consistently downhill from Glade Spring to Saltville.

Glade Spring to Tin Bridge Trestle

The trail starts on the outskirts of Glade Spring. Turning south, or going left, from the parking access on Old Mill Road spans about a third of a mile, passing trees, until the trail reaches an end at a farm.

Going north, by turning right, leads to a variety of farms and forested scenery. The unbroken rail trail spans a bit more than five miles until it meets one of its star attractions: the 210-foot-long Tin Bridge Trestle.

For the first half mile, heading north means a mild uphill climb. The trail crosses Forest Hills Road (VA-751) and a gravel driveway. After that, it's a downhill ride that runs so close to homes that you can smell what's cooking for dinner.

Take note at one mile from the parking area. At a place called Litz, the trail intersects with driveways. Bear left to remain on the trail.

Beyond Litz, the trail enters a charming chasm—the trail's half-mile-long passage through Walker Mountain. Rock walls tower about three stories high. In spring, a burst of green covers everything. Linger in these deep woods long, and it's almost as if you can still hear the ghostly shrill of a steam train.

North of Walker Mountain, expect sunshine when the trail emerges into the agricultural hills of Keywood, a Washington County community that remembers the name of Stephen Cawood (Keywood), an early pioneer of the Methodist Church. The trail crosses a fourteen-foot-long bridge (1.9 miles from the parking area) on a farm where you can hear the cows *moo*. Then, over the next mile, the trail borders a few backyards and runs through a narrow, 0.25-mile-long stretch with rock cuts at both sides.

Still rolling downhill, the passage grows considerably dark as it moves through the moist woods of Kelly Ridge (2.9 miles from the parking area), comes into view of Stone Mill Creek in the small Greenfield community (3.3 miles) and reaches the 110-foot-long trestle over Clinchburg Road (3.5 miles). Beyond that, the trail rolls 0.5 miles more until it reaches the

Salt Trail passes the Mahanaim United Methodist Church, which takes its name from a Hebrew term meaning "two camps." Notice the barrier built with leftover railroad ties, a trademark of this trail. *Author photo.*

Mahanaim United Methodist Church, at right, where a road leads left to Clinchburg. Another 0.5 miles beyond the church, the grassy path passes the homes of Hanckel (also known as "Hankel" or "Hankle"), a hamlet that may owe its name to a lumber company of the same name in the early 1900s.

One mile beyond the church, the trail splits with an on-road detour starting at Santa Cruise Drive (VA-795), veering left toward Old Saltworks Road (VA-745). Or you can continue on the actual rail trail for another third of a mile. You pass over the impressive Tin Bridge Trestle, providing sweeping views of the valley below, just before the trail stops in the woods at a place where two benches have been fashioned from tree stumps.

Tin Bridge Trestle to Saltville

The Salt Trail uses an on-road connector to go from the Tin Bridge Trestle to Saltville because it cannot go through Plasterco, a former industrial site. (This sounds unusual, but it's not in Virginia: both the Tobacco Heritage

Trail at Brodnax and the Chessie Nature Trail at South River must use paved roads to make connections.)

At Santa Cruise Drive (VA-795), proceed north on Old Saltworks Road (VA-745) for 1.2 miles. Turn left on VA-91 and go downhill for 0.3 miles. Then turn left on Buena Vista Drive to find that the pedestrian path begins again. From here, continue for nearly 2.0 miles to the trail's northern trailhead in downtown Saltville.

Saltville

Starting at the northern trailhead and going south is a popular way to tour the in-town portion of the Salt Trail. This 1.8-mile section begins at the Downtown Commons behind a festival stage.

In the first tenth of a mile, look, at left, for a display of antique steam locomotives at what was once the site of a train station. Also, look, at right, to see the Madam Russell Memorial United Methodist Church, built in 1898–1900. This church was named in memory of a sister of Patrick Henry, Elizabeth Henry Campbell Russell, an early leader of local Methodism who

Rail cars on the Salt Branch, circa 1898, stand near the under-construction Madam Russell Memorial United Methodist Church, at right, in Saltville. The train depot, at left, no longer stands. *Courtesy Museum of the Middle Appalachians.*

lived on the property in a cabin in the late 1700s. That cabin, incidentally, was torn down in 1908 when, some say, it was feared to be haunted by unexplained voices.

Continuing another third of a mile, the trail intersects with the Helen Williams Barbrow Interpretive Trail, named for a longtime supporter of all things Saltville, especially the town's must-see Museum of the Middle Appalachians on Palmer Avenue. Turn left off the rail trail to follow this short path to the Well Fields, a labyrinth of little lakes, where salt wells were located to produce brine. For decades, trains slipped past these picturesque pools and puffed smoke clouds that also gave rise to the name of a line of homes called "Smoky Row," in view at left, as the Salt Trail continues south and crosses Main Street (about one mile from the trailhead).

In another third of a mile from Main Street, the trail crosses King Avenue. This lane leads, at left, for a few yards to the Salt Park, where the Washington-Smyth County border was purposely placed in 1832 so that each county could benefit from the bounties of salt revenues. The Salt Park's outdoor exhibits include cast-iron salt kettles, a salt-well pump used to extract brine and a reconstruction of a nineteeth-century salt furnace. The Salt Park also marks the spot where William King dug to extract salt in 1799.

The Salt Trail runs little more than another half mile beyond King Avenue through a tunnel of trees until the route becomes Buena Vista Drive and joins VA-91 at the on-road detour.

ACCESS

Glade Spring: From I-81 Exit 29, follow VA-91 north for 1.0 mile. Continue straight on VA-609 for 0.1 mile. Cross the railroad tracks. Bear right on Old Mill Road (VA-750), which parallels the Salt Branch, and go 1.3 miles to the parking access, on the left.

Clinchburg: Limited parking is sometimes available at the Mahanaim United Methodist Church on Taos Lane (VA-817), just off Old Saltworks Road (VA-745).

Saltville: The northern trailhead is located at the downtown commons, near Main Street's intersection with Palmer Avenue, behind the town stage.

CHAPTER 37

VIRGINIA CREEPER TRAIL

Damascus

Each year, thousands of visitors pass through Green Cove. Few drive cars. Most are on two wheels, riding bikes on the Virginia Creeper Trail. The unincorporated town's tiny train station makes one of the most scenic stops of this thirty-four-mile-long rail trail. It is also famous. Green Cove Depot marks the spot where acclaimed photographer O. Winston Link shot his well-known "Old Maud Bows to the Virginia Creeper" photograph in October 1956, depicting a white horse hanging its head down as a steam locomotive comes in sight.

In those days, clouds consistently rose above Green Cove, a time when train tracks cut across the green fields of Washington County's southeastern corner. Whistles shrilled and echoed, seemingly forever, bouncing off natural walls enclosing the tiny dale. Standing three miles from Green Cove at Whitetop Station in the 1940s, John Sauers could hear the train chugging uphill, heading southeast. "And as I went up to the ridge line," he said, "I could see the serpentine column of smoke as the train approached."

Where Sauers stood became a magical place to witness locomotives puffing like magic dragons, sometimes with such gusts that you could see nothing but the engine's bright headlight shining through black haze. Of course, it did take some *I-think-I-can, I-think-I-can* magic to climb that mountain. Such a struggle might have inspired this train's nickname, the "Virginia Creeper." Some say that moniker comes from early steam locomotives slowly creeping up such steep grades. Others believe it is derived from the Virginia Creeper

vines that grow along the rail bed near the tri-state corner of Virginia, North Carolina and Tennessee.

Contemplate the "Creeper." It's a really foreboding title to be cast on such a pretty place: a rails-to-trails journey of rock-clogged creeks, rolling hills and little depots—one old and two new. This nationally known rail trail wanders out of Abingdon and snakes southeast to a community once called Whitetop City, lying within sight of the misty-topped and oh-so-snowy Whitetop Mountain.

Damascus lies about midway along the trail and has since become the poster child for Virginia's rails-to-trails movement. Once drying up at the crossing of crooked roads, with factories shut down and storefronts empty, this little town at the edge of two national forests badly needed a makeover. Reawakened by the creation of the Creeper, Damascus rose again as an outdoor recreation Mecca in the 1990s. Shops and shuttles sprouted along sidewalks and showed what turning rails to trails can do for a tired town.

The rail line began with a series of false starts after being initially established as the Abingdon Coal and Iron Railroad in 1887. Investors dreamed of shipping large loads of iron from Damascus. But that plan ran out of money in the Panic of 1893. By the late 1890s, however, Wilton Egerton Mingea came on the scene, and he would later recall his involvement in a memoir:

A steam locomotive stops outside the original Whitetop Station at some point after 1912. Notice the horse-drawn carriage, at right. *Courtesy Virginia Tech.*

I knew about the old bankrupt Abingdon Coal and Iron R.R. and talked it over with Mr. F.B. Hurt of Abingdon many times. Finally we made a horseback trip into Shady Valley; down Beaver [sic] Creek to Damascus; along the deserted railroad grade to Abingdon; riding all day in a pouring rain and drinking moonshine. I saw enough prospective traffic for a short railroad and conceived the idea of building this road myself.

A former freight agent for the Norfolk and Western Railway, Mingea headed the Virginia-Carolina Railway, the company that ultimately built the bridges, trestles and track to connect Abingdon to Damascus at the dawn of the twentieth century. Prior to this railroad's arrival, only one general store stood at Damascus. By 1903, two more stores, plus a drugstore and a hotel, had opened.

Damascus would grow. But it would not grow, as some prospectors had figured, into the steel-making "Pittsburgh of the South." This area's iron deposits turned out to be only on the surface. The town's prosperity, instead, came from the railroad and the land. "That's what built this town," remembered the late Louise Fortune Hall, the town historian. "Our mountains were absolutely covered with beautiful hardwoods—a lot of chestnuts."

Branching off the Virginia-Carolina Railway, spurs took turns to Tennessee. South of Damascus, the Beaver Dam Railroad reached the timber of Johnson County, Tennessee, by breaking through Backbone Rock with a twenty-two-foot-long passage—likely the shortest tunnel ever used by a railroad. East of Damascus, the Laurel Railway turned at Laureldale and also followed into Johnson County, going south to Laurel Bloomery.

Continuing east from Laureldale, the main line of the railroad once stopped at Taylors Valley. Starting there, in 1906, the Hassinger Lumber Company financed the construction of a continuation, with a line of tracks spanning about six miles to reach the lumber company's timber town at Konnarock.

The railroad changed considerably in 1912. About four miles northeast of Taylors Valley, construction of a new branch took off on a tall trestle at Creek Junction. This track crossed over the rail route to Konnarock. It also became the new main line, eventually going to Green Cove and Whitetop Station. The section of track that the Hassingers built from Taylors Valley to Creek Junction would remain part of the main line. But the rest of the Hassinger Lumber Company's continuation—from Creek Junction to Konnarock—would then be known as the "Konnarock Branch."

In 1919, the Virginia-Carolina Railway became the Abingdon Branch of the Norfolk and Western Railway. By then, its length had also grown, impressively, to seventy-six miles from Abingdon to a depot at Elkland, North Carolina. Ironically, even as this railroad reached across Ashe County, North Carolina, it was still affectionately called the "Virginia" Creeper in the Tarheel towns of Tuckerdale, Lansing, Warrensville and West Jefferson.

Shouts of "Timber!" could be heard all down the line. Small sawmills and lumber operations popped up in countless hollows as the attached tracks continued to expand through Virginia, North Carolina and Tennessee. Overlooking all three states, the Grayson County community of Whitetop boomed with the logging industry of the 1920s. Rail traffic supported the Whitetop Hotel; Carter's Store sold everything from shoes to caskets.

On an opposite side of Whitetop Mountain, the Hassinger Lumber Company built various spurs to reach deep into forests near its town of Konnarock on the Washington-Smyth County border. But the timber ran out eventually, and the mill at Konnarock closed on December 24, 1928. Train service continued for a couple more years to Konnarock—but not after 1930, when a devastating flood damaged the Konnarock Branch.

Creek Junction's largest trestle crossed the tracks of the Konnarock Branch near the confluence of Green Cove Creek and Whitetop Laurel Creek. This scene looks toward Green Cove on April 17, 1964. *Bob McCracken photo.*

The Abingdon Branch overcame hard times, like that flood of 1930, when bridges had to be rebuilt, and the line was shut down for six months. Another flood in 1940 wiped out more trestles, leaving workers to once again rebuild. Going forward, this railroad had little chance to make a profit. Yet the Creeper continued to cruise casually, year in and year out.

"Unofficially, it will stop anywhere along the line," writer Audrey Bishop noted in a profile of the railroad for the *Baltimore Sun* in 1957. "The engineer doesn't know what it is to watch for signals. There aren't any. The Creeper—daily except Sunday—has the road all to itself except for cows or a stray deer."

Crews would make unscheduled, informal stops, sometimes slowing down to pick up fishermen and dropping them off at what have since become the trophy trout streams of the Mount Rogers National Recreation Area. Hours later, with their trout strings loaded, the anglers would hop on the train again and head for home.

This wasn't completely unusual. Slowing to a standstill could actually impede the train's hill-climbing progression. So often, while creeping along, train crews would not truly halt at a flag stop. Workers would simply reach out to grab a bag and then lend a hand to a passenger climbing aboard while the train continued barely moving.

An old railroad boxcar was set along the tracks at Creek Junction to drop off mail for Konnarock. The flag stop shelter remained standing in the mid-1950s, when this photograph was captured. *Ken Marsh photo.*

In March 1942, the train simply stopped. In the middle of snowy weather, conductor J.F. Anderson waited for nearly three hours at Whitetop Station on an emergency mission. A rescue crew that included a doctor and a nurse had gone five miles into the mountains to the home of Mrs. Wade W. Weaver, who was critically ill and about to give birth. With the help of the surrounding community, a horse-drawn sled was made available, and Mrs. Weaver was bundled in blankets and placed atop a mattress. Pushing through snow drifts, the sled finally reached the train depot, and Mrs. Weaver was rushed down the tracks to the hospital in Abingdon. There, she gave birth to a son, whose middle name, Norwest, paid tribute to the Norfolk and Western Railway.

For the Creeper's crew, caring for children became part of the journey. On Saturday mornings, dozens of children waited beside the tracks for Ralph White. This conductor was best known as the "Candy Man." He tossed lollipops from the train. When White retired, another conductor, J.C. Wohlford, continued the tradition, passing out about two hundred lollipops a week.

As for O. Winston Link, he shot more than that horse named Old Maud—with a camera—outside the Green Cove Depot. For a couple years, this photographer from New York staked out the steam trains of the Abingdon Branch, driving the back roads of both North Carolina and Virginia. Link self-financed a photographic record of the Virginia Creeper from 1955 to 1957, stopping at Watauga, Creek Junction, Whitetop and Damascus. His work, particularly of the Abingdon Branch, would later be displayed at the O. Winston Link Museum on Shenandoah Avenue in downtown Roanoke.

Link had to work fast. This railroad was losing steam—literally. The Norfolk and Western Railway replaced steam locomotives on the Abingdon Branch with diesel engines in 1957. This was a move not taken lightly by the public—including Robert Porterfield, the founder of Abingdon's Barter Theatre. At that time, Porterfield wrote a plea to R.H. Smith, the president of the Norfolk and Western Railway, saying:

> *This letter is to entreat you to do whatsoever you can to perpetuate the steam engine particularly on this line which we call "The Virginia Creeper." It is imperative, it seems to me, for the pursuit of happiness for the youth of tomorrow, that some railways maintain one line under steam locomotion. It has meant a great deal to this area having this little train and it will mean a great deal more in the future.*

The future for the Virginia Creeper, however, did not include steam locomotion. But it did include a few rail excursions using open gondola cars and witnessing what a newspaper writer in 1962 called "breathless beauty with the deeply cut narrow valleys and masses of laurel intermixed with wild flowers."

During the late 1960s, the West Jefferson Woman's Club sponsored the Autumn Leaf Excursion. A round-trip ride on the Abingdon Branch originated in West Jefferson and climbed to Whitetop Station, where the train stopped for a prayer meeting. Next, the train wiggled its way to Abingdon, and, on one Sunday, the passengers met Porterfield, who told of how the Barter Theatre began with food stuffs being traded for tickets to see live shows in 1933.

All of this, of course, sounds like fun. But the Abingdon Branch wasn't making any money. The problem was, on regular runs, the passenger count by 1961 averaged only about five or six people. It was also costing a fortune for the Norfolk and Western Railway to maintain the line's one hundred trestles and bridges.

Regular passenger service ended on the Virginia side in 1962 but continued for another year in North Carolina. By then, the last section of tracks had been removed in North Carolina, and the Abingdon Branch simply stopped at West Jefferson.

Norfolk and Western Railway filed a petition to end all service on the Abingdon Branch in 1972. It also tried to find a new owner for the line, perhaps a buyer who wanted to turn the Virginia Creeper into a tourist train. But no such offers appeared, and all service ended on March 31, 1977.

The last run was an emotional moment—perhaps best signified by the scene of a boy in North Carolina, standing at the side of the tracks with his dog in West Jefferson. The young man waved goodbye, the engineer blew the whistle and the brakeman tossed off one more piece of candy—just like Ralph White or J.C. Wohlford would have done, long before.

By the dawn of the 1980s, tall weeds threatened to suffocate the Green Cove Depot. On down the line, the rest of the tracks stood vacant while a few crazies braved the trestles, driving Jeeps where trains once rolled. Young kids rode bikes over trestles with no railings. Still others talked of turning this rail into a trail. Among them was Tom Taylor, then on the staff of the Mount Rogers Planning Commission. But, Taylor said, some local government leaders issued word that they did not want the trail, nor any application for it, to see the light of day.

Some who owned property adjacent to the rail line were not interested in having trail users walk near their property. Others thought the property

Green Cove Depot stands amid high grass in 1981, about four years after trains stopped running on the Abingdon Branch of the Norfolk and Western Railway. *Bob McCracken photo.*

ought to revert to them when it wasn't used as a railroad. "The landowners were very bitter—some of them were," said Dr. French Moore Jr., an Abingdon town councilmember who became a champion for creating the Virginia Creeper Trail. "I was a dentist, and I lost patients who lived out in that area."

Ultimately, the national forest service acquired the right of way where the train passed from Whitetop to Damascus while the towns of Abingdon and Damascus purchased the railroad grade between the two towns. But the debates didn't die. Initially, investing town funds in the trail was kind of a big gamble, said Al Bradley, a longtime town planner for Abingdon. "We had no assurance at the time that anybody was going to use this."

By the end of the 1980s, the Abingdon Branch became a rail trail, yet only in Virginia. Much of the North Carolina section reverted to adjacent landowners. Still, it is not totally gone. One portion near Todd (formerly called Elkland) became Railroad Grade Road, a favorite among road cyclists for its smooth grade and scenic views, while a tiny stretch of the railroad grade is now part of Backstreet Park in West Jefferson.

Back in Damascus, the town's shuttle-service industry began in 1991. That year, Phoebe Cartwright first took people—and their bikes—on the curvy climbs of U.S. 58 to Whitetop Station. With an old church van, Cartwright

shuttled bicycles to answer an oft-overheard request: "Can somebody drive us to the top of the Virginia Creeper Trail so all we have to do is ride down?"

The Virginia Creeper Trail has since attracted an estimated 150,000 visitors a year. It is jointly maintained by the towns, the U.S. Forest Service and members of the Virginia Creeper Trail Club. It is also a model in the Old Dominion, cited in reports as an inspiration for building new rail trails across Virginia, including the Tobacco Heritage Trail and the Dahlgren Railroad Heritage Trail. It's been a destination for Siberian Husky races in January and guided bird walks in August. It has also been uniquely traversed by the one-wheel wonder of Nate Lancaster, who followed the entire trail on a unicycle in 2009 at age thirteen.

Still, no story of the Virginia Creeper Trail may be more fantastic than that of Lawrence Dye. At age eighty-two, this retired schoolteacher had logged more than 182,000 miles on this trail, cycling as much as 66 miles per day, five days a week. Dye has often left Abingdon as early as 6:00 a.m.

Bicycle rider Lawrence Dye leads the way on the grand opening of the Virginia Creeper Trail's Trestle No. 7 on April 28, 2014. *Author photo.*

and gone against the grain, forsaking the shuttles. For years, Dye rode uphill to Whitetop Station and then turned back to Abingdon. His favorite stretch lies along the little-traveled section between Alvarado and Damascus. Yet he lingers the longest when he comes to Green Cove, stopping at the old depot and shaking hands with all who want to meet "Lawrence the Legend."

TRACKING THE TRAIL

 Few riders trace the Virginia Creeper Trail's thirty-four-mile length up and back. It's more often a trail that is broken in pieces. The crushed-gravel route crosses forty-seven bridges and trestles, all of which are numbered on each end and noted on trail maps posted at access areas. Interpretive signs have been installed at various points of interest by the Virginia Creeper Trail Club. Various maps of the trail are also available and distributed freely from bike shuttle services, the tourism offices of Abingdon and Damascus and the Mount Rogers National Recreation Area.

New, simple mile markers posted on the trail note the distance starting at the Abingdon trailhead and are used to refer to various landmarks, like bridges and trestles. (*Note:* The old, concrete markers topped with an "A" are leftovers from the railroad and refer to the distance to the depot and passenger station in Abingdon. The "A" posts differ by about a half mile from the smaller, concrete trail markers.)

The entire trail is open to hiking, biking, horseback riding and cross-country skiing. The western half—from Abingdon to Damascus—offers easy strolls or mild rides beside rocks and through rolling valleys. The easternmost half—from Damascus to Whitetop—lies largely within the Jefferson National Forest and consistently climbs eastward, making shuttle services popular.

Creeper Trail Extension

West of I-81, the quaint town of Abingdon just can't get enough of the Virginia Creeper Trail. The popular path has been imaginatively extended to run behind buildings for more than a half mile until ending at the town's two train stations, where the mileage count for the original "Virginia Creeper" branch began.

Starting at the Abingdon trailhead of the Virginia Creeper, the extension crosses over the Norfolk Southern railroad tracks and turns left. This rail-with-trail borders, at right, the parking area of Abingdon's Barter Theatre, which offers live performances and was once a destination for train passengers coming to Abingdon. Next, the path goes behind the Martha Washington Inn, a plush hotel that was a women's college from the Civil War to the Great Depression.

The extension slips beneath Cummings Street and passes the site of the popular Abingdon Farmers Market. Continue to follow the wooden boardwalk. The route ends at Depot Square, the site of a restored caboose, a circa-1870 freight station (home to a gallery and workshop called the Arts Depot) and the century-old Abingdon passenger station (a longtime home for the Historical Society of Washington County, Virginia).

Abingdon to Watauga

Many Virginia Creeper Trail visitors start in Abingdon and head east to Watauga for about 4 miles. This portion of the path is popular for walkers and joggers. But going that way by bike also gets the easy part out of the way first. This downhill ride provides such a relaxing run that you hardly have to pedal between miles 2 and 3.

Abingdon's trailhead (mile 0.0) stands at the site of Black's Fort, a Revolutionary War–era site that predates the town of Abingdon by a few years. Also here is Norfolk and Western Railway Engine No. 433, a preserved steam locomotive called a "Mollie." The engine once served as a backup on the Abingdon Branch of the Norfolk and Western Railway.

Within a few feet, the trail crosses Bridge No. 1 over Town Creek and reaches restrooms. Then, within a quarter mile, the trail passes a small park, built on the wye where trains would turn around; the park includes a picnic shelter with a tribute to an early supporter, the late Dr. David Brillhart. The trail's shady setting passes an original ("A-1") railroad marker, at right, marking the distance to the branch's origin at Abingdon ("A"). Then it slips beneath I-81—still within the first mile.

Continuing east, the path grows more wooded and scenic. It cuts through the Great Knobs (near mile 2), where rock walls stand high as trickling waters of Berry Creek ripple far below steep banks. The trail crosses the curved Bridge No. 2 (near mile 3)—a beauty above Dry Branch—about 0.25 miles before reaching Bridge No. 3. About 0.5 miles beyond, after making

The western half of the Virginia Creeper Trail gently eases downhill from Abingdon to Alvarado. It also borders U.S. 58, the road to Damascus. *Courtesy Virginia Creeper Trail Club.*

a bend, the trail crosses the majestic Bridge No. 4 over Fifteen Mile Creek before reaching the Watauga access (near mile 4).

A railroad stop in the early 1900s, Watauga takes its name from the Creek Indian *wetoga*, a word meaning "broken waters." It remained primarily a farming community until the development of the Virginia Creeper Trail spawned residential developments along Watauga Road (VA-677) in the 1990s.

Watauga to Alvarado

Going east from the Watauga access to the Alvarado Train Station follows almost five miles and includes passing cattle guards in scenic pastures. It also goes downhill.

Within a short walking distance of Watauga, the trail slips over a couple high trestles with expansive views of trees and fields (between miles 4 and 5). The larger of the two is Bridge No. 6, a span that was targeted by arsonists but rebuilt in the 1980s prior to the trail's dedication in 1987. Continuing east, the route rams through the rocky River Knobs (near mile 5) and grows considerably cool and shady.

Over the next mile, the view opens on the Smith Farm, where Bridge No. 7 (near mile 6) spans a ravine. The original trestle at this site was built in the late 1890s for train traffic and later converted to pedestrian use. But it was smashed to smithereens when a series of tornados spun into Washington County on April 27–28, 2011. The trail was then rerouted on a gravel path for more than two years until a replacement bridge, at 454 feet in length, was officially dedicated on April 28, 2014.

The trail passes over more bridges in the next one and a half miles with the Middle Fork of the Holston River in view at left. On occasion, you can see fishermen in boats as the river yields to the headwaters of the 7,580-acre South Holston Lake.

Up next, this section reaches a major landmark as it passes over the heavy stone pillars and breathtaking wooden supports of Bridge No. 12 (mile 7.2), a trestle spanning more than five hundred feet where the Middle Fork unites with the South Fork of the Holston River. Stand at the center of this curved trestle and look north. The land on the opposite riverbank was once the site of Carrickfergus, a planned port in 1801. Named for a town in Ireland, Carrickfergus was set up to ship wares west on the South Fork of the Holston River through Sullivan County, Tennessee, just below the Virginia border. Town streets were called Liberty, Independence, Freedom and Republic. But not all of the lots were sold, and the town faded into oblivion.

On the eastern side of the big bridge, the trail passes between fields and shaded riverbanks, where tiny treks lead to fishing spots perfect for snagging bass or bluegill. About a mile beyond the bridge, the trail enters Alvarado: a pretty pit stop where the South Fork of the Holston River winds down on the lake's headwaters, much like applying brakes on a bicycle, wheezing to a whisper its whitewater run in Washington County.

Alvarado was called Barron on timetables of the Virginia-Carolina Railway in the early 1900s. The unincorporated town's current name comes from the Alvarado of Texas, which, in turn, took its name from Alvarado at Veracruz, Mexico. In Texas, Alvarado's first sheriff, A.H. Onstoott, supplied the "Alvarado" name because he had fought at the "Alvarado" of Veracruz

during the Mexican War. In Virginia, it's believed, some wandering boys made their way to Texas. Then, coming home, these boys convinced local folks to rename this place for where they had been.

A trail access area lies just outside the replica of the Alvarado Train Station (mile 8.5). Built in 2011, the faux depot includes restrooms and stands at the approximate site of the original Barron Depot, a wooden building with a telegraph office. The old depot eventually took the name Alvarado and was painted the customary green-and-white décor commonly associated with Norfolk and Western Railway stations. Like the trail's Green Cove Depot on the east, the Alvarado Train Station was photographed by O. Winston Link in the late 1950s.

Alvarado to Damascus

For about 8 miles, the Virginia Creeper Trail passes farms and homes between Alvarado and Damascus. It borders the South Fork of the Holston River (miles 8–13) and Laurel Creek (miles 13–16). The path also stays largely within sight of U.S. 58 for about half the run (miles 12–16).

Compared to other parts of the Creeper, this section remains quiet and is a favorite for horseback riders. It is also about as flat as the Virginia Creeper Trail gets, making a climb of only about 150 feet from the Alvarado Train Station replica until reaching the Damascus Town Park.

Expect an alternation between shade and sun, gravel and grassy. Highlights include rock cliffs among the river, three more bridges (near miles 9 and 10), cattle gates and mostly forgotten rail stops called Delmar (near mile 10.5) and Drowning Ford (near mile 12).

Just after passing behind the parking lot of a shopping center (near mile 15), the trail cuts over driveways. It crosses U.S. 58 and then comes into the Damascus Town Park (near mile 16), which includes a restored caboose, restrooms, gazebo and a playground.

Damascus

An out-of-the-way crossroads, Damascus took its present name from the ancient capital of Syria. Previously, it had been called Mock's Mill in honor of a gristmill owned by early settler Henry Mock, a man who fathered thirty children by three successive wives.

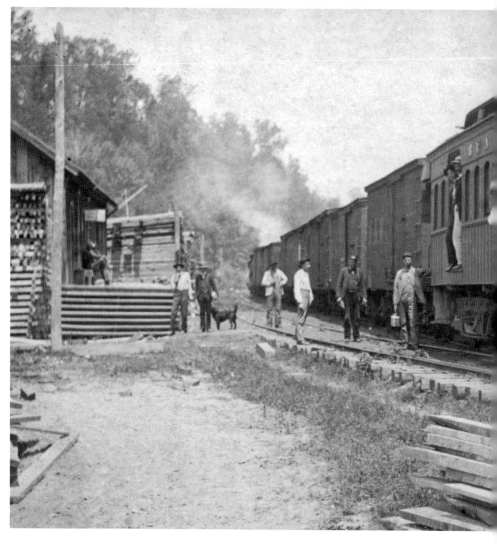

A rail car belonging to the Beaver Dam Railroad stops at the Barron Depot, circa 1904, prior to the stop being known as Alvarado. *Courtesy Hugh Belcher.*

This mountain town supported factories and train traffic for more than half of the twentieth century at the confluence of Beaverdam and Laurel Creeks. Yet it nearly died in the 1980s—with buildings shuttered and empty—in the years following the demise of Abingdon Branch of the Norfolk and Western Railway. Fortunately, the path of that train became the Virginia Creeper Trail, which brought new life to this town of about one thousand people.

Various bike shuttles can take you to the "Top"—*Whitetop* Station, that is. Then it's your job to find your way back to Damascus. Brace yourself: it's a long ride—seventeen miles, to be exact. But that's seventeen, wind-in-your-face miles of snaking between mountains on the big bridges and tall trestles of the "Creeper"—crossing ravines and rocky creeks—as the path loses about 1,500 feet in elevation from Whitetop Station to Damascus. What's unique: because so many bicyclists use shuttles, a one-way ride on this section appears to both begin and end in Damascus.

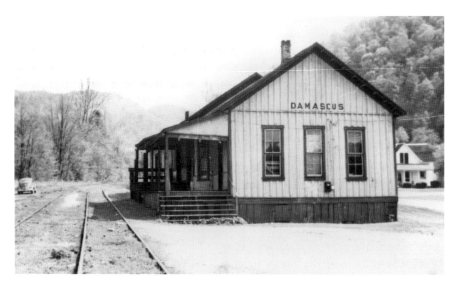

The Damascus Train Depot remained standing when this photograph was made in 1972 at what is now the Damascus Town Park, a popular green space crossed by the Appalachian Trail. *Bob McCracken photo.*

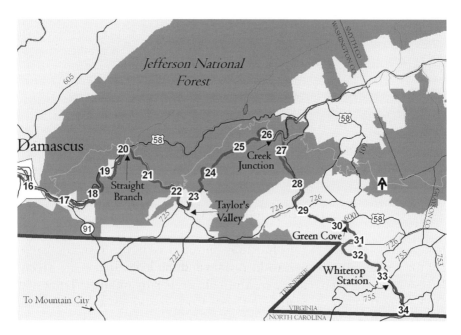

Most of the eastern portion of the Virginia Creeper Trail lies in the Jefferson National Forest of the Mount Rogers National Recreation Area. Notice how the trail's horseshoe bend between miles 31 and 32 comes within a tenth of a mile of touching the easternmost tip of Tennessee. *Courtesy Virginia Creeper Trail Club.*

206

Consider this more than just a rail-trail town. Damascus has also been dubbed the "Friendliest Town" on the Appalachian Trail and attracts about twenty thousand people a year to mid-May's Trail Days celebration. The Appalachian Trail crosses the Virginia Creeper Trail at the Damascus Town Park and then heads south along or near what was once a spur that led to the long-gone Damascus Depot.

Whitetop Station to North Carolina

One of the least-seen stretches of the Virginia Creeper Trail lies in Grayson County. It's gorgeous and green and, geologically, the only part of the trail with waters flowing to the New River. This section rolls downhill from Whitetop Station to the trail's terminus at the Tarheel State. Thousands come close to this point each year when shuttles drop them off at Whitetop. Yet they turn the other way, heading west to Damascus.

Take a few minutes and go the extra mile. Turn right at the Whitetop access and head east. This section immediately offers grand views, at left, of mile-high Whitetop Mountain's natural bald. Much closer to the trail, see a picturesque pond plus rows of evergreens, staked like statues at a Christmas tree farm. Sweet-smelling Fraser firs are grown at Whitetop and then shipped to distant markets a few weeks before Christmas.

Pass over Bridge No. 47 and slip through a thicket of rhododendron amid rock cuts. Also look, at right, for the railroad's original "A-34" marker, noting a distance of thirty-four miles from this point to Abingdon. The trail overlooks the rippling waters of Big Horse Creek as it crosses VA-753. Then it shares the path with a driveway, briefly, before ending at the state line.

Whitetop Station to Green Cove

It just cannot get any better than this—if you're coasting downhill, that is. For three miles, you roll past rocky ravines and rhododendron in the Mount Rogers National Recreation Area. You look between trees and see Tennessee. Cycling from Whitetop Station to Green Cove, the Virginia Creeper Trail simply remains completely pedal-free on what may be the most priceless portion of any rail trail in Virginia.

With an elevation loss of about four hundred feet, this is either the trail's easiest three miles—or the toughest, if you chose to make the climb. The

Whitetop to Green Cove section also marks the beginning of what most riders encounter after being dropped off by bike shuttles near the Whitetop parking lot.

At the start, explore the replica of the Whitetop Station, constructed in 2000 as a visitor center. Usually open on summer weekends, the Whitetop Station (near mile 33) sells souvenirs and supplies. It also features historical displays, restrooms and an inviting front porch.

The original Whitetop Station boasted an elevation of 3,576 feet and was once claimed to be the highest point reached by a common-carrier passenger service east of the Mississippi River. It was torn down prior to early 1962 and replaced by a tiny passenger shelter.

Like its predecessor, the new station offers a splendid view of Whitetop Mountain, the second-highest point in Virginia. Standing north of the trail, this peak tops out at an elevation of 5,520 feet and boasts air so pure, so fresh, that you can still taste heaven, and not the pollution in between, when snowflakes fall to Earth. Plenty of snow does fall here regularly, from Halloween to Easter. But that's not why it's called "Whitetop." The mountain actually took its name from a field of white grass at its top, which makes it look white at a distance.

Now, it won't take much effort to ride this section. Just ease past Whitetop Station and let it roll. Soon, you'll be rushing like a rollercoaster on a 3 percent grade. Cruising the "Creeper" is cool even on a warm day in July. The downhill slide continually keeps a breeze blowing.

Remember, this run is remote. Your cellphone won't work, and you won't cross any roads for nearly three miles. Even so, with about a dozen shuttles providing access to such easy freewheeling, these deep woods have become akin to a theme park, with kids rolling wildly past their parents, who may still be trying to get their bikes in gear at Whitetop Station and yelling for their children to "stop racing."

What happens if you stop racing? Well, be sure to exercise caution when you start again, just like you would in merging a car back on a road. Other joy riders on two wheels will likely be coming at you, at speeds of fifteen miles per hour, on what appears to be mainly a one-lane route—but just remember that it's not. Stay to the right, and be aware that a rare few actually do cycle their way up the steep grade, huffing and puffing like an old steam locomotive.

About a mile into the run, the curved Bridge No. 46 provides a scenic highlight, standing high (near mile 32). Almost 2 miles beyond, the trail crosses a gravel road with a red barn in sight, at right. Then you'll see the

Left: Shuttles drop off riders near the replica of the Whitetop Station so they can coast downhill to Damascus for a seventeen-mile-long journey on the Virginia Creeper Trail. *Author photo.*

Below: Whitetop Mountain looms large in the background of this 1920s-era scene, near Green Cove, on what is now the Virginia Creeper Trail. *Courtesy Virginia Tech.*

Green Cove Depot, where a granite marker notes the intricate nature of how O. Winston Link photographed a steam locomotive and a horse named Old Maud in 1956.

Built in 1914 for $2,600, the station at Green Cove housed a post office until 1958. For years, this was also a general store. In 1991, the family of a former station manager, William M. Buchanan, donated the depot to the U.S. Forest Service. Much of the old store's merchandise remains intact, still on the same shelves since the 1940s. The depot now serves as a visitor center in the Mount Rogers National Recreation Area. Inside, the depot sells snacks, books and T-shirts. Outside are restrooms and picnic tables.

Green Cove to Straight Branch

Passing across tall trestles, the Virginia Creeper Trail offers only beautiful scenery between the Green Cove Depot and Straight Branch. Most of this ten-mile-long section lies within the boundaries of the Mount Rogers National Recreation Area.

The trail spans about 3.5 miles from Green Cove to a parking access at Creek Junction, 4.0 miles from Creek Junction to Taylors Valley and 2.5 miles from Taylors Valley to Straight Branch. Going east to west, it's all downhill. It's also a continuation of what's traced by bike riders using shuttles. So that means it can get busy. Any weekend from April to October should be considered prime time for crowded conditions.

Pedaling west of the Green Cove Depot (near mile 30), you'll pass beside rocks, at right, and Green Cove Creek, at left. You'll cross a couple bridges—and some say you might even spot the ghostly "Creekfield Woman," a figure in white, looking for her lost child. Folktales of this woman date to the early 1900s, about the time trains first came to this remote region.

Beyond a road crossing at VA-726, the trail enters a small, grassy valley dotted by barns. Here, at midday, it would not be unusual to see a deer jump across the trail (near mile 29). Pause at the short Bridge No. 43, and enjoy the view of scenic farmland. The route then passes through a shady stretch and meets VA-859 at the site of an old railroad junction called Callahan's Crossing (near mile 28).

Next, get ready for the gorge. The route reaches deep into a moist forest where Green Cove Creek cuts between Chestnut Mountain, at left, and Lost Mountain, at right. The view shed narrows. Rock cuts grow bigger. The volume of the creek intensifies.

Go through a curve with rock cuts towering as much as four stories high (mile 27). Arrive at Bridge No. 39, the first of two trestles at Creek Junction. Far below, waterfalls flow. Immediately cross Bridge No. 38, spanning more than five hundred feet. Then look, at left, for a bench, a bicycle rack and a swimming hole, all within a few hundred yards.

Here, at Creek Junction, another rail trail makes a hard left and spans a half mile on the old Konnarock Branch, a rail line that once passed beneath towering Bridge No. 38. Today, what's left of the Konnarock Branch, as a trail, leads to universally accessible fishing piers in the Mount Rogers National Recreation Area, at right, plus a parking area with a restroom, the last one on this section of the trail before reaching Straight Branch.

Continuing west from Creek Junction, the Virginia Creeper Trail enters a nationally noted fly-fishing area on Whitetop Laurel Creek. This trout

Whitetop Laurel Creek, at right, flows alongside the tracks of the Konnarock Branch in this 1920s-era scene showing the branch leading under what is now called the Virginia Creeper Trail's Bridge No. 38 at Creek Junction. *Courtesy Virginia Tech.*

stream runs clear and cold; it was called "Big Laurel Creek" on maps of the 1930s. To best witness its beauty, cross Bridge No. 37 (near mile 26) and then look right. Steps lead to small falls at the trail's edge.

For the next couple miles, the trail passes over several bridges, all quite similar, while staying beneath a canopy of trees. It leaves the national forest for 1.5 miles just before crossing Bridge No. 29 (near the old "A-24" railroad marker). The trail flies by a few homes as it borders VA-728 (near mile 23) and zips through the center of a shaggy meadow with high grass. Then it arrives at Taylors Valley, an isolated community that can only be reached on paved roads from the rest of Virginia by crossing through Tennessee.

The two-story train depot at Taylors Valley has long since been torn down; a railroad camp car now stands in its place at the Virginia Creeper Trail's parking access. Railroad workers once lived in this camp car while in the area to repair bridges and trestles. The car (commonly called a "caboose") also served as a lodge for railroad officials while on trout fishing trips. After the abandonment of the railroad in 1977, the camp car was given to retired Norfolk and Western Railway employee Morgan Parker, whose family later donated it to the Taylors Valley Community Club.

The two-story Taylors Valley Depot, shown here in about 1920, stood along what is now the Virginia Creeper Trail. *Courtesy Virginia Tech.*

Beyond the camp car, the trail reenters the national forest at a gate, where a sign announces the distance to Damascus: six miles. Look on the opposite side of that same sign for what all the downhill bike riders would never turn to see: going east, it is four miles to Creek Junction and eight miles to Green Cove.

Going northwest, the trail continues along the course of Whitetop Laurel Creek. It crosses three more bridges in less than two miles. About forty yards beyond Bridge No. 23, look left to see a side trail leading to the Creeper Pool, a natural swimming hole with a sandy beach. This pool is just a quarter mile from the Straight Branch parking access, a site along U.S. 58 that includes a restroom (near mile 20).

Straight Branch to Damascus

Just four miles lie between Straight Branch and Damascus Town Park, rolling downhill from east to west. These are the final miles traced by shuttle users on the eastern half of the Virginia Creeper Trail.

Less than a mile west of the Straight Branch access, the trail passes over Bridge No. 21, a prefabricated replacement for an old trestle that was washed out by high water in 2001. Immediately beyond, look behind to see the frothy Whitetop Laurel Falls, a ten-foot-high drop (between miles 19 and 20).

Within 0.5 miles of the falls, you'll see U.S. 58. This curvaceous road will remain a companion all the way to Damascus. The path crosses Bridge No. 20, at the edge of the highway, and Bridge No. 19, with rushing rapids (mile 18). Next, go across the steel truss Bridge No. 18 and look about thirty yards below to see a trail leading to a natural swimming pool/fishing hole with a sandy beach.

In another mile, exercise caution where the trail crosses VA-91 (mile 17). West of this intersection, the trail overlooks the tidy homes, shops and eateries of Damascus as it rides at the median of U.S. 58. Inside the town limits, the trail crosses over Bridge No. 17 (near mile 16) and then passes the municipal swimming pool, at left. Finally, within a quarter mile, the trail reaches the long and winding Bridge No. 16, a steel truss structure providing a gateway to the Damascus Town Park and its landmark red caboose—a great place to take a portrait at the end of a joyous journey.

The Abingdon Branch in Damascus crossed the old VA-91 (now Orchard Hill Road/Town Route 1212) in this 1949 scene. Note the distance to nearby towns, including Boone, North Carolina (thirty-eight miles). *Courtesy Virginia Department of Transportation.*

ACCESS

Abingdon: From I-81 Exit 17, follow Cummings Street north for 0.2 miles. Turn right on Green Spring Road and go 0.3 miles to the trailhead parking.

Watauga: From I-81 Exit 17, follow VA-75 south for 2.5 miles. Turn left on Watauga Road (VA-677) and go east for 2.0 miles to the parking access, on the left.

Alvarado: From I-81 Exit 19, follow U.S. 58 east for five miles. Turn right on VA-722 and go three miles (continuing straight as the road becomes VA-710/Alvarado Road). Parking is available at the Alvarado depot replica.

Damascus: From I-81 Exit 19, follow U.S. 58 east for ten miles. The Damascus Town Park lies at the intersection of West Laurel Avenue and South Beaverdam Avenue, where the Virginia Creeper Trail crosses U.S. 58, near the red caboose.

Straight Branch: From the Damascus Town Park, go 4.6 miles east on U.S. 58 to the access, on the right.

Taylors Valley: From the Damascus Town Park, follow U.S. 58 in Damascus east for one and a half miles. Turn right on VA-91 and go south for three miles (following into Tennessee on TN-91). Turn left on a road with

sign pointing to Taylors Valley. Continue to follow for about two and a half miles to the trail, near the intersection of VA-725 and VA-726.

Creek Junction: From the Damascus Town Park, go ten and a half miles east on U.S. 58. Turn right on VA-728 and go a half mile (on the rail bed of the old Konnarock Branch). From the parking access, the Virginia Creeper Trail is reached by walking a half mile (on the old Konnarock Branch), crossing beneath the large bridge and passing the universally accessible fishing piers.

Green Cove: From the Damascus Town Park, follow U.S. 58 east for about fifteen miles. Turn right on VA-600 and go almost a half mile. The depot is on the right.

Whitetop: From the Damascus Town Park, follow U.S. 58 east for seventeen miles. Turn right on VA-726 and follow south for one and a half miles to the Virginia Creeper Trail crossing at Whitetop Station.

HIDDEN VALLEY WILDLIFE MANAGEMENT AREA

Abingdon

Hidden Valley Wildlife Management Area certainly fits its name—
hidden. Simply getting here, at an elevation of 3,600 feet, requires
driving practically straight up Brumley Mountain, a rounded and rocky
peak where the Holston River Lumber Company operated narrow-gauge
lines in the early 1900s. By the 1930s, topographic maps showed a trail
in the path of where a railroad once chugged across the mountain on the
outskirts of Abingdon.

What was once a trout stream on Big Brumley Creek was dammed in
the 1960s to form the 61-acre Hidden Valley Lake, the centerpiece of the
6,400-acre Hidden Valley Wildlife Management Area. Thick marsh lines
a portion of Hidden Valley Lake, known for its population of bluegill and
catfish swimming above a bed of stringy vegetation. Interesting, too: you can
hear everything people say on the shore. The forested Brumley Mountain
holds sounds like an amphitheater as comments cruise swiftly across the
rippling lake waters.

TRACKING THE TRAIL

Beyond the dam on Hidden Valley Lake, a trail whisks into the woods at
the Hidden Valley Wildlife Management Area. What was once the path of
a railroad used to extract timber starts just beyond a gate beside the lake's
dam. This trail finds its way for one mile or more and crosses a few railroad
ties, still embedded in the loamy soil near the banks of Big Brumley Creek.

Consider this a rail-trail challenge for any hiker who wants to get back to nature. Prepare, too, to bushwhack your way through the rhododendron and mountain laurel, and remember to wear blaze orange clothing during hunting season. Yet what does remain of the rail bed provides a glimpse into yesteryear as you traverse atop ties that once bound this mountain to massive lumber harvests.

ACCESS

From U.S. 11 in Abingdon, follow U.S. 19 northwest for 10.0 miles. Turn right on Hidden Valley Road (VA-690) and follow for 4.0 miles to the gravel entrance to Hidden Valley Wildlife Management Area. Continue straight to the dam for about 1.2 miles, where the trail begins beyond a yellow gate.

CHAPTER 39

BULL CREEK PEDESTRIAN & BIKE TRAIL

Maxie

Just above an old schoolyard, where loud locomotives once hauled loads of coal, you may now detect the quiet whir of a chain and sprocket. Or maybe you'll notice the shuffling of feet in Buchanan County, banked on the border of both Kentucky and West Virginia.

Bull Creek Pedestrian & Bike Trail lies just a few miles west of Grundy, Buchanan County's courthouse town. Opened in 2013, this rail trail's crushed-stone surface provides easy hiking and biking while overlooking rugged mountains, deep within Virginia's coal-mining country on the Appalachian Plateau.

Just about all of Buchanan County, including Bull Creek, feels like you're passing through a canyon. The mountains are so steep that, by midafternoon, you run out of direct sunshine. The sky stays lit, but much of the landscape appears in shadows, which is why it's so neat and unique—and necessary—to have lights on this trail.

The eastern end runs through an area once called Mudlick but later renamed "Convict Hollow" when a convict escaped. The western side sweeps into Belcher Fork on what used to be the Bull Creek Spur of the Norfolk and Western Railway. Along the way, the trail skirts the edge of Harman, named for the H.E. Harman Mining Company, which established a coal camp at Bull Creek in the early 1930s.

Bull Creek Pedestrian & Bike Trail passes rock cliffs as it follows the path of an old coal train in Buchanan County. *Author photo.*

TRACKING THE TRAIL

Riding a bike along Bull Creek feels much like charging uphill. Simply start at Maxie and go up, slight but steady, on an estimated 0.75 percent grade. The one-and-a-half-mile-long trail passes the old Harman Elementary School ("Home of the Tigers"), with a trail spur leading downhill, about a quarter mile from the trailhead.

For most of its length, the trail parallels VA-609. It also stays close enough to keep in sight the big boulders of Bull Creek, a watercourse named for a bull elk killed on the creek sometime in the early 1800s.

Look for trail maps posted at signs along the route. Rocks and forest border the southern side of the trail, at left. The northern side, at right, lies along the backyards of residences. Reaching Belcher Fork Branch, turn back to Maxie and follow the easy ride back to the trailhead.

ACCESS

Convict Hollow: From the Buchanan County Courthouse (near Walmart) in Grundy, follow U.S. 460 west for 6.0 miles. Turn left on VA-609 and go 0.9 miles, passing the Maxie Post Office. Then turn left on VA-601 to find the trail almost immediately on the right, just beyond Bull Creek.

Belcher Fork: From the Convict Hollow Access on VA-601 near Maxie, follow VA-609 west for 1.7 miles, passing the Bull Creek Old Regular Baptist Church of Jesus Christ of the Union Association. Then turn left to reach the parking access road.

CHAPTER 40

GUEST RIVER GORGE TRAIL

Coeburn

Consider the contents: a waterfall and a tunnel, plus a bridge over a rocky river. It all waits near Coeburn, where Wise County's waters bash big boulders, all within the first half mile of the Guest River Gorge Trail. This seldom-crowded site sits on a shelf overlooking the Guest River's splashy show.

Here, you might spy a salamander in the middle of the trail or look for warblers throughout the summer in leafy ravines. All along are informal paths leading to fishing holes, where anglers cast for smallmouth bass.

Guest River Gorge shares an early name for Coeburn—"Guest's Station" or "Guesses Station," which pays reference to the adventures of Christoper Gist, an explorer in Virginia's mountains during the mid-1700s. The Guest River, named for Gist, originates in Wise County near Dixiana, a few miles north of Norton.

Coeburn took its present name from Teddy Roosevelt's brother Elliott, who put the "Coe" with the "Burn" when combining the names of W.W. Coe and Judge William E. Burns, partners in the Coeburn Land and Improvement Company. At that time, in the 1890s, Elliott Roosevelt lived at Abingdon and explored nearby coal and timber interests while on leave from New York.

The Interstate Railroad built what was called the Guest River Extension in the 1920s, thereby creating a shortcut. This line linked the Coeburn area to the mouth of the Guest River at a place called Bangor, where Wise County meets Russell and Scott Counties along the Clinch

Looming cliffs border the Guest River Gorge Trail in the Jefferson National Forest near Coeburn. *Author photo.*

River. From here, the track connected to the Carolina, Clinchfield and Ohio Railway.

It wasn't easy blasting the Pennsylvania sandstone in the four-hundred-foot-deep gorge—a remote region once crawling with copperheads. About halfway down what is now the Guest River Gorge Trail, one section came to be called "Big Shot" because it took so many explosives to crack the craggy cliffs during construction.

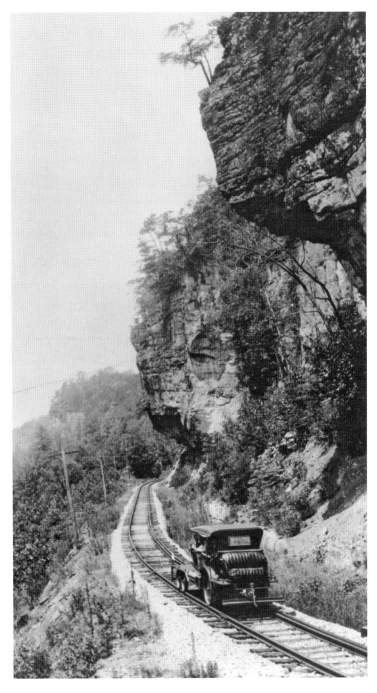

In this 1920s-era scene, an Interstate Railroad motorcar journeys uphill alongside the big cliffs of the Guest River Gorge. *Courtesy Kenny Fannon.*

Heavy loads of coal started rolling by the mid-1920s. Sometimes, too, excursion trains followed the path—including a 1920s venture by members of the Andover Sunday School Club.

Trains continued to run long after these tracks eventually became part of the Norfolk Southern system. But the line was abandoned by the late 1980s, and the land was donated to the Jefferson National Forest. The railroad was turned into a trail in 1994 with help from student laborers at the nearby Flatwoods Job Corps.

TRACKING THE TRAIL

The Guest River Gorge Trail gradually drops in elevation from the parking area near Flatwoods to the Guest River's confluence with the Clinch River at Bangor. That means walking the dirt-and-gravel path may appear mostly flat, but following the entire, 5.8-mile-long trail by bike will definitely mean an uphill climb that you can feel—on return.

For much of the journey, the U.S. Forest Service property boundary measures about one hundred feet wide, or fifty feet from either side of the trail's center. Hiking and biking are allowed, but don't pack your saddle: horseback riding is prohibited.

The Swede Tunnel, constructed in 1922, took its name for its Swedish builders. *Author photo.*

Turn right at the parking area. Only a few steps into the journey, the Falls at Swede Tunnel cascade about fifteen feet, rushing down a slippery slope, at right. Then, within a few hundred yards, the trail passes through the always-damp Swede Tunnel (mile 0.3). Spanning about two hundred feet, the Swede Tunnel was built in 1922 and took its present name for its Swedish builders. It was originally known as the Beverly Tunnel for the Beverly family that owned land in the area. Bring a hat when you hike: water constantly drips from the ceiling of the dark passage and collects in small, muddy pools.

A waterfall drops about fifteen feet near the Swede Tunnel on the Guest River Gorge Trail. *Author photo.*

The trail crosses the Guest River on a scenic bridge (mile 0.4), providing a snapshot opportunity of the river's rumbling rapids. Next, at left, see the first of many rugged rock walls, standing stories high above the trail. These chiseled surfaces remain stained with coal dust and soot from steam engines.

About a mile beyond the tunnel, a walking path breaks away from the railroad bed, at left. This old road works its way to the top of the Crab Orchard Branch Falls, about thirty yards before the Guest River Gorge crosses the Crab Orchard Branch (mile 1.4).

The waterfalls on Crab Orchard Branch can be heard from the main trail and are worth exploring, but be forewarned: these cascades cannot be reached without scrambling down the hillside. The branch drops about twenty-two feet on a twenty-foot-wide cascade, forever wetting a wall of black rock, about one hundred yards upstream of the rail trail, yet still within the boundaries of the national forest.

Opposite the Crab Orchard Branch, a spur track once ran to a sawmill at Crab Orchard, along the Guest River. The mill closed in the 1930s.

Benches line the rail trail as it continues between towering rock walls and the woodsy riverbanks. The Guest River's rampaging run of Class III-IV rapids attracts adventurous kayakers from as far away as Canada.

About 2.0 miles beyond Crab Orchard, the forty-foot-high waterfall of Lick Log Branch (mile 3.5) lies about ten yards off the trail's left side, near a wooden bench. Yet it is impossible to view the entire falls at once because a culvert at the side of the trail blocks part of the view.

The Guest River Gorge Trail begins to flatten out on its last couple miles. The path dead-ends at a bridge (mile 5.8) near the confluence on the Clinch

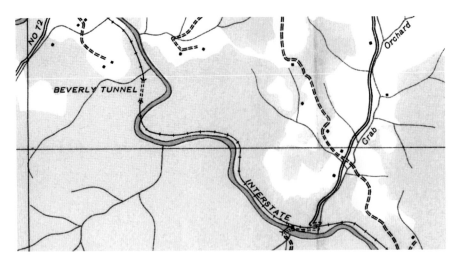

A 1935 topographic map shows the railroad line that is now the Guest River Gorge Trail. Notice the name "Beverly Tunnel" used in place of what is now called the Swede Tunnel. *U.S. Geological Survey map.*

River, a waterway known for its vast range of fish species as it passes through towns like Dungannon and St. Paul.

ACCESS

From U.S. 58A in Coeburn, follow VA-72 south for 2.0 miles. The Guest River Gorge entrance road, on the left, runs 1.2 miles to a large parking area at the trailhead.

LITTLE STONY NATIONAL RECREATION TRAIL

Coeburn

Stocked trout in Little Stony Creek might lure fishermen to Virginia's Scott County. But what really hooks hikers to follow the 2.8-mile-long Little Stony National Recreation Trail is the creek's tendency to fall.

Splashing and spitting, Little Stony plunders in pools at the gut of its gorge in the Jefferson National Forest. At its most dramatic drop, the creek flies below a bridge and drops two dozen feet in midair, providing a natural swimming hole.

The yellow-blazed Little Stony National Recreation Trail never strays far from such aqua action. Nearly always shaded by a canopy of trees, the trail traces a forest floor full of ferns and narrowly hugs banks of coal-black soil.

Embedded railroad ties provide evidence of the trail's former life. Here, during the early 1900s, as lumber crews sought logs across the northern reaches of Scott County, a narrow-gauge railroad chugged through the creek's 1,700-foot-wide and 400-foot-deep gorge. The timber train hauled wood to a sawmill in nearby Dungannon, a sleepy town on the Clinch River. By 1936, after most trees had been harvested along Little Stony, the U.S. Forest Service acquired the area.

Today, cove hardwood and hemlock lushly line roaming rhododendron and masses of mountain laurel. Opposite the upper falls, the southern trailhead starts at the Hanging Rock Picnic Area, a fee area offering fishing in the trout-stocked creek, plus picnic units with tables and grills.

TRACKING THE TRAIL

Hiking along the 2.8-mile-long Little Stony National Recreation Trail ranks easy to moderate. From the upper falls, the trail descends on a moderate grade as it goes south toward Hanging Rock, following a path that is sometimes narrow and often balanced on rocks and roots.

At the start, a universally accessible portion of the Little Stony National Recreation Trail leaves the national forest's gravel parking lot and reaches a scenic footbridge atop the upper falls in less than a quarter mile. The trail then winds along the walls of a naturally chiseled stone amphitheater that frames the falls at center stage. Stone steps descend from the main trail to an overlook, at left, where hikers can soak in misty air and watch the waters flow.

Continue a quarter mile beyond. Cross a footbridge and look, at right, for a drop of about a dozen feet. One side of the creek flumes through a narrow rock chute while the other fans into a wispy, watery umbrella. Following downstream another quarter mile, the creek careens over a black rock wall at a thirty-foot-high cascade at the Lower Falls of Little Stony, overlooked by a wooden platform.

Little Stony National Recreation Trail has become a popular point to easily access the Upper Falls of Little Stony in the Jefferson National Forest. *Author photo.*

Beyond all the waterfalls, the trail almost immediately reaches a long and narrow footbridge as it continues to parallel the creek (mile 0.8). For the adventurous, a left turn beyond that bridge on an informal path follows a small branch upstream. Here, in times of wet weather, you can find more falls, about seventy-five yards into the woods, at the eighteen-foot-high Laurel Branch Cascades.

> **Trail Tip**
> Hike both ways. This trail's intricate scenery makes retracing the route like a nearly new hiking experience.

Go about 0.3 miles beyond that bridge as the trail slips past a scenic fishing hole, just below a wide but short cascade. Continuing another 0.5 miles, the trail crosses another footbridge, where you should look left, especially if the weather is wet. A thin stream of water makes a drop of fifty feet with a cliff-top jump that smashes on rocks like a sweet song. It's as if the feeder stream merrily shouts that it wants to join nature's party of tumbling water, too.

Continuing south along the joyously noisy creek, you can soon reach Hanging Rock Picnic Area at the southern trailhead (mile 2.8). This point takes its name from a cliff that hangs high above Little Stony Creek. A small coal mine operated at Hanging Rock in the 1920s.

ACCESS

Upper Falls: From U.S. 58A at Coeburn, follow VA-72 south for three miles. Turn right on VA-664 and go one mile. Turn left at USFS-700 and go two miles. Turn left on USFS-701 and go almost one mile to the parking area, on the left.

Hanging Rock Picnic Area: From VA-65 in Dungannon, follow VA-72 north for 2.5 miles to the entrance, at left.

CHAPTER 42

DEVILS FORK TRAIL

Fort Blackmore

Surely, it takes the devil to get to the Devil's Bathtub—why, even just finding the trailhead in the Jefferson National Forest can be bedevilling. Next, consider the challenge of following the Devils Fork Trail. This path devilishly zigzags across a stony stream about ten times—maybe more, depending on how Mother Nature has reworked her running waters. Certainly, jumping over rocks helps to stay dry, but you should certainly expect to get your feet wet if you search for this natural wonder near Fort Blackmore.

Devils Fork is far from the only place in Virginia named for the devil. Maps list both a "Devil Branch" and a "Devils Branch" in nearby Buchanan County. Rockbridge County boasts the "Devils Marbleyard," an area strewn with boulders, just off the Appalachian Trail. A swampy bend of the Nottoway River near Courtland is called "Devils Elbow." A stream feeding into Virginia Beach's Back Bay goes by the name "Devil Creek."

You'll find one "Devil's Den" near Christiansburg and another near Fancy Gap. A third "Devil's Den" straddles the Grayson-Wythe County border, along the Iron Mountain Trail and is characterized by a hellish blend of steep inclines and rocky terrain—about as rough a country as you can see a trail go through.

Anything that is real rough—or real dangerous—got to be called the "Devil." The rugged mountains surrounding the Devils Fork certainly qualifies. However, that rule does not apply to the naming of the Devil's Bathtub. Here, the rippling Devils Fork of Big Stony Creek has carved a hole in the creek bed nearly twenty feet long and perhaps a dozen feet deep. This

depression is known as the Devil's Bathtub. And the name fits: legend says this bathtub for Beelzebub was named because its icy water is "cold as hell."

The western portion of the Devils Fork Trail—the route leading to the Devil's Bathtub—was once a rail line, hauling timber and coal. It passes through a cove forest with rich soil and high plant diversity. Much of the path along the creek was built on the old railroad grade. Along the way, about a half mile from the trailhead, are the remains of a rusted railroad car.

TRACKING THE TRAIL

Not exactly an easy walk in the woods, the moderate-to-difficult Devils Fork Trail requires a true hike. Tracking this trail means scrambling over rocks and sloshing through water. Moving gradually uphill, it's an outing not recommended for anything other than foot traffic—and yes, your feet will get wet. But, in less than two miles from the start, hikers can discover a wild run of watery features.

The Devils Fork Trail begins at the gated road above the parking area. Go beyond the gate and cross the Straight Fork (mile 0.2). About fifty yards farther, at a sharp curve, bear left (do not turn right on the forest service road) and follow the trail for twenty yards. Then bear right at a curve and continue to follow the yellow-blazed trail as it goes up the creek.

Unfortunately, the yellow blaze may not always be apparent. Fallen trees sometimes block the path. Stream crossings can vary, as well, and at times, this will mean walking through the creek.

Perhaps the most difficult crossing comes early on, when the trail jumps into the fork's overflow and hops through a small field of rocks. After this point, regain the railroad grade on the creek's right bank and pass a small flatcar, once used on the railroad, at right (mile 0.7). Then, in about one more mile, come into a narrow section. Carefully scale a small slippery cliff, at the creek's left bank, several feet above the ruffling waters.

In a few more steps, take a break and take a dip in the gorgeous swimming hole (mile 1.7), where a narrow flume spits into a ten-foot-deep pool of blue-green water. This is often mistaken for this trail's Devil's Bathtub. But for many, this marks the main destination. The swimming hole is popular among kids of all ages.

Continue on the trail for several more yards. Then look left for a side path (mile 1.8) that leads into the creek to the Devil's Bathtub, a plunge

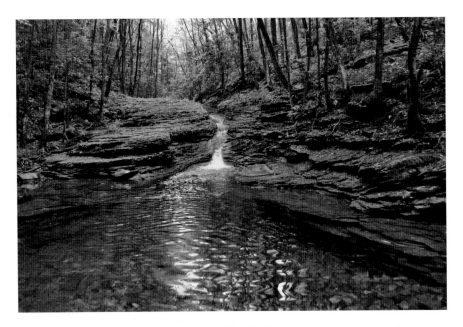

Scott County's swimming hole on the Devils Fork Trail is a popular summertime destination in the Jefferson National Forest. *Author photo.*

pool fed by a small waterfall. At the base of this basin, drift your eyes to the dreamy downstream, toward the swimming hole, where the creek has carved a mossy maze of unforgettable grooves in the rock walls of the Devils Fork.

Rejoin the trail on the rail bed. For one more treat, continue about a half mile farther. Pass two large rock walls, at left. Then look to the right to see a waterfall in the distance, skimming down a rock wall, several yards off the trail. At this point, most trail users turn back.

ACCESS

From VA-65/72 at Fort Blackmore, follow VA-619 north for five miles, bearing to the right at the Glen Carter Memorial Bridge. At the crossroads of VA-619 and VA-657, turn left onto a one-lane bridge to follow VA-619 for a quarter mile. Then turn left on a rough and muddy gravel lane, next to a white house, and follow for about a half mile. The parking access makes a loop; bear right to enter the area. Do not drive on the forest road above the parking lot—that's the beginning of the trail.

PHILLIPS CREEK LOOP TRAIL

Pound

Come winter, long before trees sprout leaves in the spring, waters flow in the Jefferson National Forest. Gushing like a shower, the Phillips Creek Falls courses its way into the eternal beauty of a rhododendron thicket.

Come summer, when the sandy beach at Phillips Creek Recreation Area smells of suntan lotion and hot dogs, this waterfall may be gone. Sometimes, it has even been known to reduce itself to no more than a trickle, barely seeping down that same rock wall and looking like the well-worn crevices are only leaking.

Phillips Creek is no wet-weather stream, but it may seem that way as it disappears, yielding to summer drought. Even so, a sign posted at the head of the Phillips Creek Loop Trail boasts a painting of a crashing cataract pouring out of Pine Mountain. This waterfall, at its best flow, drops about fifteen feet, cascading over a small cliff. Yet something happened: some believe a rock froze and broke off, slowing what used to include a midair drop of about eight feet.

Commonly called "Phillips Creek Loop Trail," this footpath has also been dubbed the "Pine Mountain Trail." But do not confuse it with the much-longer Pine Mountain Trail that traces the Kentucky-Virginia border atop the spine of Pine Mountain from Pound to Breaks Interstate Park.

This rail trail can be found just outside Pound, a coal-mining town that has given the world a remarkable trio of famous faces. This is the hometown of Napoleon Hill, the author of 1937's self-help book *Think and Grow Rich*, which has sold more than seventy million copies; Francis Gary Powers,

whose U-2 spy plane was shot down over the airspace of Russia in 1960; and Glen Roberts, who helped originate the jump shot while playing basketball for Emory & Henry College in the 1930s.

Managed as part of the Clinch Ranger District of the Jefferson National Forest, Phillips Creek Loop Trail chugs down a former railroad grade, used when this area was logged in the early 1900s—several decades before the U.S. Army Corps of Engineers built the skinny, winding Pound Reservoir in 1966. Flanked by banks of earth, this rails-to-trails conversion clearly retains the look and texture of a railroad grade. The loop trail also passes the remnants of an old homestead, where fruit trees continue to grow, providing food for deer and wild turkey.

Tracking the Trail

Phillips Creek Loop Trail begins about 0.5 miles from the beach on the North Fork of the Pound Reservoir. Clearly marked, most of the 1.3-mile-long hike strolls atop rocks and beside fallen logs. The shady path requires minimal elevation climbs and makes a great family outing.

Cross a footbridge at the trailhead and continue following yellow blazes. Within the first quarter mile are remnants of a homestead. Bear left when the trail forks. Cross two tiny bridges and continue following along Phillips Creek for nearly a half mile until the trail splits at a large tree.

At left, stone stairs lead down to the creek and the Phillips Creek Falls. Turning right and climbing an embankment for a few yards, the trail makes a loop and follows the former railroad grade for about a quarter mile. The trail then bends and returns, looping back to the start.

Access

From U.S. 23 at Pound, turn west on North Fork Road (VA-671) and follow for 5.4 miles to Phillips Creek Recreation Area, on the right. Follow the forest service road to the far end of the picnic area, where the trail begins, about a mile from the entrance.

BEE ROCK TUNNEL

Appalachia

To say the Bee Rock Tunnel is short might be an understatement. "The Bee" measures a wee forty-seven feet and seven inches long. For years, town brochures at Appalachia boosted its fame, saying the Wise County landmark "gained notoriety in 'Ripley's Believe It Or Not' as the 'Shortest Railroad Tunnel in the World' and held that title until 1963."

Local legend says the Bee Rock Tunnel derived its name from both a buzz and a blast. While the tunnel was under construction by the Louisville and Nashville Railroad in the early 1890s, dynamite explosions dislodged honeybees from their home along the Powell River.

But the Bee Rock took a sting when it dropped from the top of the short list. As it turned out, a tinier tunnel on the Scottsville Branch of the Louisville and Nashville Railroad, near Gallatin, Tennessee, was found to measure about one foot less in length. Even so, either of these tunnels stretches nearly twice what might have been the real "Shortest Railroad Tunnel in the World"—Tennessee's Backbone Rock Tunnel, a twenty-two-foot-long passage built just three miles south of Damascus, Virginia, in 1901 as part of the Beaver Dam Railroad, a line that hooked into the rail that is now the Virginia Creeper Trail.

Visible from U.S. 23 Business, the Bee Rock Tunnel can be found about a quarter mile from the south entrance to Appalachia, a town that sprang up at the junction of several rail lines. This town took its name from the Appalachian Mountains, which, in turn, were named by the Spanish for a Native American tribe called the Appalachee. Still, a local story says

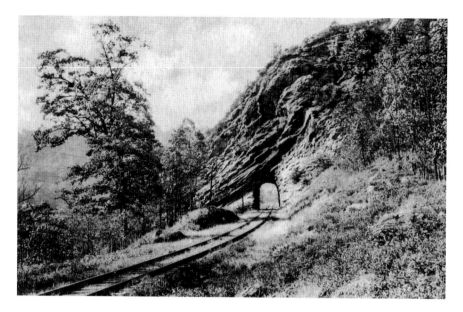

Bee Rock Tunnel in Wise County spans only forty-seven feet, seven inches. *Courtesy Frank Kilgore.*

"Appalachia" was actually derived from a marital squabble, in which a wife looked at her husband and said, "You better watch out, and I'm gonna throw an *apple at-cha!*"

In 2009, the Bee Rock Tunnel lay abandoned on the railroad line—not used since the mid-1980s. At that time, though, plans had developed for a rails-to-trails project linking Appalachia to Big Stone Gap. This long-awaited rail trail is slated to pass through both Bee Rock Tunnel and the 135-foot-long Callahan's Nose Tunnel near Big Stone Gap.

Heralded as the "Little Town with a Big Story," Big Stone Gap boasts both the Southwest Virginia Museum Historical State Park and the Trail of the Lonesome Pine outdoor drama. The town also stars in a string of novels by bestselling author Adriana Trigiani, who returned to town in 2013 to film a movie adaptation of her first "Big Stone Gap" novel.

By 2014, construction continued at the rail-trail site, paralleling both U.S. 23 Business and the Powell River, a watercourse that memorializes early explorer Ambrose Powell. Stories say Powell carved his name on so many trees in the mid-1700s that the Powell River, Powell Mountain and Powell Valley were named for him.

WILDERNESS ROAD TRAIL

Ewing

J ust take the name of this train—the Louisville and Nashville Railroad—and you'll get a good idea of how far Lee County sits toward the setting sun. Virginians here in the westernmost tip of the Old Dominion are actually closer to the capitals of at least five other states than their own. Wander west of Wheeler and whistle "Williamsburg" or refer to "Richmond," and you might include what commonwealth you're referencing, since towns use those same names in Kentucky.

Louisville refers to Louisville, Kentucky, and Nashville refers to Nashville, Tennessee. The L&N, as this railroad was commonly called, arrived in western Lee County in 1890, connecting towns called Ewing, Rose Hill and Hagan. The Wilderness Road Trail follows a portion of the iron road that once trolled this terrain.

This trail spans eight and a half miles along U.S. 58, connecting the Wilderness Road State Park to the Cumberland Gap National Historical Park. This path also lies along the Warriors Path—a battle zone for the Cherokee and Shawnee, prior to the arrival of European explorers in the mid-1700s. The rail trail slips behind homes and between farms and walks, quite literally, in the footsteps of Daniel Boone.

A famed frontiersman, Boone came to the Cumberland Gap, at what is now the western tip of Virginia, in 1775 with a group of thirty men and helped blaze the road to Kentucky's bluegrass. Boone's route became known by many names, including "Wilderness Road," "Wilderness Trail," "Boone's Trail" and "Boone's Trace."

Martin's Station stood along Boone's route, as early as 1769, in the vicinity of what became known as Rose Hill. But the fort's founder, Joseph Martin, was soon run off by Native Americans. Undaunted, Martin returned in 1775 and built a new Martin's Station—until the Indians came charging again. Moving closer to Cumberland Gap, Martin stuck his poles in the ground for a third Martin's Station in 1783. There, in the shadow of what became the westernmost tip of Virginia, Martin's Station provided protection plus a place to shop for supplies. Ultimately, in 1788, Martin was able to sell his lands in Powell Valley and retire to the foothills of the Blue Ridge Mountains, where he lived in a community named in his honor: Martinsville.

Even so, Lee County wasn't through with Joseph Martin yet.

What must be called a "fourth" Martin's Station rose from the ground centuries later at Wilderness Road State Park and was claimed to be "the most authentically reconstructed frontier fort in the United States." Builders of the hand-hewn log replica, constructed in 2002, used only the kind of tools that Martin would have had on the wild frontier in the late 1700s. Workers carted logs into the construction site with oxen and then used ropes and horses to set those logs in place. At times, reenactors came on the scene and made the construction difficult yet authentic by staging spontaneous Indian attacks.

Today, along the Wilderness Road Trail, the Wilderness Road State Park celebrates Martin's Station and the times of the early American frontier. But it wasn't always this way.

In 1993, about a year before the planned Wilderness Road Trail won $354,000 in federal grant money, this was known as Karlan State Park and took its name from a *Gone with the Wind*–style mansion that forms the park's original centerpiece. State officials acquired the twelve-room mansion under a strict stipulation: that its name should remain "Karlan" for past owners Karl and Ann Harris. Still, locals more commonly called it "Elydale," the name given by Robert McPherson Ely, who named the house when it was built in 1878.

Mr. Ely did not live long. He died in 1880—about two years after the house was built and ten years prior to the train's arrival. At age twenty-four, he went for a swim in a creek and became ill with typhoid fever while his wife, Susan, was out of town, visiting family in Missouri.

Susan Ely remained in the Elydale home with the couple's three daughters. She married Thomas A. Taylor in 1885. Then, in about 1890, the Taylors either sold or gave land to build a depot along the Louisville and Nashville Railroad, a couple miles east of the Elydale mansion. But a mistake was made, and soon the stop that should have been "Taylor" became known as "Caylor" on maps.

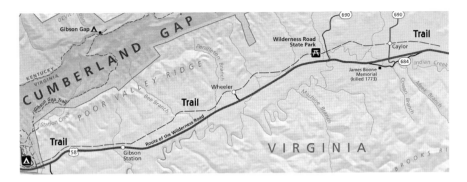

Wilderness Road Trail parallels U.S. 58 in western Lee County, linking a campground at Cumberland Gap to Wilderness Road State Park. *Courtesy Cumberland Gap National Historical Park.*

Still, the train remained a part of the family's life. The train ran just behind the Elydale mansion, and it made a stop in 1899 so guests could attend the wedding of Mary, the second Ely daughter. Then, the newlyweds left on the L&N, following the same path that is now the trail.

West of Wilderness Road State Park, the tracks ran through Gibson Station, a stop that took its name from George Gibson, a Revolutionary War hero who owned four hundred acres on both sides of Indian Creek in the late 1700s and built a fort for the protection of his family. Beyond this point, in the 1930s, the train crossed U.S. 411/VA-10, a forerunner to U.S. 58, and headed southwest to Shawanee, Tennessee.

For decades, the L&N provided a lifeline in Lee County, long before U.S. 58 became a four-lane freeway. It was a place where wild strawberries grew profusely along the train tracks as cars carried coal.

"I remember hearing the whistle a lot," said Carl Cheek, who grew up along the line, near Wheeler. "It echoed up and down that valley; and the sound, depending on what mood one was in, could be blue and lonesome—or very musical and soothing."

TRACKING THE TRAIL

Wilderness Road Trail provides a mild ride with occasional climbs on a crushed-gravel surface. Partially lined with split-rail fencing, the east–west passage is open for hiking, biking and horseback riding.

The path begins about ten miles east of Cumberland Gap or about three miles west of Ewing, a community named for Lee County's first

sheriff, Samuel Ewing. Look above the northern side of the trail, at right, to see the White Rocks of Cumberland Mountain. Early travelers saw these unchanging cliffs like a promise: "Walk one more day, and you'll pass through the Cumberland Gap."

From the Ewing-area access, the trail stretches past farms for nearly one mile to Caylor, alongside VA-690, where an old brick store stands. From Caylor, the trail goes about one mile to another crossing of VA-690 at Wilderness Road State Park.

For about a half mile, the trail runs through the state park property. Notice the back of the Karlan Mansion ("Elydale"), at left. Just beyond, at left, stands the park's visitor center. Cross over the main park road (VA-923) and look, at right, for a trail leading in a field to the park's reconstruction of Martin's Station.

Next, the trail runs about four miles from the state park to another access point at Gibson Station, along U.S. 58. Expect some wilderness on this part of the trail, bordered by a tangle of trees and a few embankments but also a few rural road crossings. This portion passes over feeder streams of Indian Creek—the Pendleton Branch and the Bee Branch—and winds through Wheeler, a place named for a local family.

Heading toward the setting sun, the final two miles adjoin the median of U.S. 58 on what is also the westernmost reach of Virginia's Beaches to Bluegrass Trail. Little of this section follows a railroad grade, however, as it lies within only a few feet of the highway margin. This up-and-down stretch—going from Gibson Station to the Cumberland Gap National Historical Park—ends at a gate. But here, taking a right turn at the national park, a new journey can begin on the clearly marked footpaths of the forest.

ACCESS

Ewing: The parking lot for the eastern trailhead lies 3.3 miles west of Ewing's intersection with VA-724, along U.S. 58.

Wilderness Road State Park: To reach the state park, follow the entrance road (VA-923) from U.S. 58, about 2.3 miles west of the Ewing rail-trail access on U.S. 58.

Gibson Station: A parking area lies along U.S. 58—about four miles west of Wilderness Road State Park.

Cumberland Gap: The trail ends, with limited parking, at the easternmost entrance to the Cumberland Gap National Historical Park, along U.S. 58, about 6.2 miles west of Wilderness Road State Park.

RESOURCES

Appalachian Trail: www.appalachiantrail.org
Ashland Trolley Line: www.hanovercounty.gov
Blue Ridge Parkway: www.blueridgeparkway.org
Chessie Nature Trail: www.vmi.edu/chessie
Chester Linear Park: www.chesterfield.gov
Dahlgren Railroad Heritage Trail: www.friendsdrht.org
Dick & Willie Passage Rail Trail: www.visitmartinsville.com
Elizabeth River Trail: www.norfolk.gov
Grayson Highlands State Park: www.dcr.virginia.gov/state-parks/grayson-highlands.shtml
Hanging Rock Battlefield Trail: www.roanokecountyva.gov
High Bridge Trail State Park: www.dcr.virginia.gov/state-parks/high-bridge-trail.shtml
Huckleberry Trail: www.huckleberrytrail.org
Jackson River Scenic Trail: www.jacksonrivertrail.com
James River Heritage Trail: www.lynchburgva.gov
Jefferson National Forest: www.fs.usda.gov/gwj/
Lake Accotink Park: www.fairfaxcounty.gov/parks/lake-accotink/
Lake Anna State Park: www.dcr.virginia.gov/state-parks/lake-anna.shtml
Mayo River Trail: www.patrickchamber.com
New River Trail State Park: www.dcr.virginia.gov/state-parks/new-river-trail.shtml
Norfolk Avenue Trail: www.vbgov.com
Patrick County Historical Museum: www.patcovahistory.org
Rails to Trails Conservancy: www.railstotrails.org
Riverwalk Trail: www.playdanvilleva.com
Salt Trail: www.saltvilleva.com

Resources

South Boston-Halifax County Museum: www.sbhcmuseum.org
Southern Tip Bike & Hike Trail: www.fws.gov/refuge/eastern_shore_of_virginia/
South Hill Tourist Information Center: www.southhillchamber.com
Staunton River Battlefield State Park: www.dcr.virginia.gov/state-parks/staunton-river-battlefield.shtml
Suffolk Seaboard Station Railroad Museum: www.suffolktrainstation.org
Tobacco Heritage Trail: tobaccoheritagetrail.org
Virginia Blue Ridge Railway Trail: www.blueridge-railtrail.org
Virginia Capital Trail: virginiacapitaltrail.org
Virginia Central Railway Trail: www.fredericksburgva.gov
Virginia Creeper Trail: www.vacreepertrail.org
Warrenton Branch Greenway: www.facquiercounty.gov
Washington and Old Dominion Trail: www.wodfriends.org
Wilderness Road State Park: www.dcr.virginia.gov/state-parks/wilderness-road.shtml

BIBLIOGRAPHY

Books

Adkins, Leonard M. *50 Hikes in Southern Virginia*. Woodstock, VT: Countryman Press, 2002.

Ashe County Heritage Book Committee. *The Heritage of Ashe County, North Carolina*. Vol. 1. Winston-Salem, NC: History Division of Hunter Publishing Company, 1984.

Ashe County Historical Society. *The Virginia Creeper in Ashe County (Images of Rail)*. Charleston, SC: Arcadia Publishing, 2011.

Blevins, Thomas H. *A Brief History of the Virginia Creeper*. N.p.: self-published, 2003.

Bracey, Susan. *Life by the Roaring Roanoke: A History of Mecklenburg County, Virginia*. Mecklenburg County, VA: Mecklenburg County Bicentennial Commission, 1977.

Brubaker, John H., III. *The Last Capitol: Danville, Virginia and the Final Days of the Confederacy*. Danville, VA: Danville Museum of Fine Arts and History, 1979.

Cohen, Stan. *Historic Springs of the Virginias: A Pictorial History*. Charleston, WV: Pictorial Histories Publishing Co., 1981.

Davis, Edward H., and Edward B. Morgan. *The Virginia Creeper Trail Companion*. Johnson City, TN: Overmountain Press, 1997.

DeHart, Allen. *The Trails of Virginia: Hiking the Old Dominion*. 3rd ed. Chapel Hill: University of North Carolina Press, 2003.

Dixon, Thomas, Jr. *Chesapeake & Ohio Alleghany Subdivision*. Alderson, WV: Chesapeake and Ohio Historical Society, Inc., 1985.

Dunn, Joseph W., Jr., and Barbara S. Lyle. *Virginia Beach: Wish You Were Here*. Norfolk, VA: Donning Company/Publishers, 1983.

Fauquier Historical Society. *250 Years in Fauquier County: A Virginia Story*. Fairfax, VA: GMU Press, 2008.

Finley, Lori, and Thomas Horsch. *Mountain Biking the Appalachians*. 2nd ed. Winston-Salem, NC: John F. Blair, Publisher, 1998.

BIBLIOGRAPHY

Griffin, William E., Jr. *The Atlantic and Danville Railway Company: The Railroad of Southside Virginia, Revised and Expanded Second Edition*. N.p.: TLC Publishing, Inc., 2006.

Guillaudea, David A. *Washington & Old Dominion Railroad (Images of Rail)*. Charleston, SC: Arcadia Publishing, 2013.

Hagemann, James A. *The Heritage of Virginia*. Norfolk, VA: Donning Co. Publishers, 1986.

Hall, Louise Fortune. *A History of Damascus: 1793–1950*. Abingdon, VA: John Anderson Press, 1950.

Hall, Randal L. *Mountains on the Market: Industry, the Environment, and the South*. Lexington: University Press of Kentucky, 2012.

Hanson, Raus McDill. *Virginia Place Names*. Verona, VA: McClure Press, 1969.

Harwood, Herbert H. *Rails to the Blue Ridge: The Washington and Old Dominion Railroad, 1847–1968*. 4th ed. Fairfax Station: Northern Virginia Regional Park Authority, 2009.

Hatfield, Sharon. *Never Seen the Moon: The Trials of Edith Maxwell*. Chicago: University of Illinois Press, 2005.

Jordan, James M., IV, and Frederick S. Jordan. *Virginia Beach: A Pictorial History*. Np: Thomas F. Hale, n.d.

Kegley, Mary B. *Glimpses of Wythe County, Va*. Wytheville, VA: Kegley Books, 1986.

Kent, William. *A History of Saltville*. Saltville, VA: self-published, 1955.

King, Nanci C. *Places in Time Volume III: South from Abingdon to the Holston*. Marion, VA: Tucker Printing, 1994.

Lathrop, Carl M. *Sentimental Journey*. Lancaster, PA: Brookshire Printing, 1979.

Lord, William G. *Blue Ridge Parkway Guide: Rockfish Gap to Grandfather Mountain*. Birmingham, AL: Menasha Ridge Press, 1998.

Loth, Calder, ed. *The Virginia Landmarks Register*. 4th ed. Charlottesville: University Press of Virginia, 1999.

Lyons, Mary E. *The Blue Ridge Tunnel: A Remarkable Engineering Feat in Antebellum Virginia*. Charleston, SC: The History Press, 2014.

Manfield, Stephen S. *Princess Anne County and Virginia Beach: A Pictorial History*. Norfolk, VA: Donning Company Publishers, 1989.

McGuinn, Doug. *The "Virginia Creeper": Remembering the Virginia-Carolina Railway*. Boone, NC: Bamboo Books, 1998.

Molloy, Johnny. *Mount Rogers Outdoor Recreation Handbook*. Birmingham, AL: Menasha Ridge Press, 2001.

Nanney, Frank L., Jr. *South Hill, Virginia: A Chronicle of the First 100 Years*. South Hill, VA: self-published, 2001.

Neal, J. Allen. *Bicentennial History of Washington County, Virginia, 1776–1976*. Dallas: Taylor Publishing Co., 1977.

Noe, Barbara A. *Rails-to-Trails: Maryland, Delaware, Virginia, West Virginia*. Guilford, CT: Globe Pequot Press, 2000.

Ogle, D.W. *Salt Trail Guide*. Saltville, VA: self-published, 2009.

Patrick County Historical Society. *History of Patrick County, Virginia*. Stuart, VA: Patrick County Historical Society, 1999

Porter, Randy. *Mountain Bike! Virginia*. Birmingham, AL: Menasha Ridge Press, 1998.

Rails to Trails Conservancy. *Rail-Trails Mid Atlantic*. Berkeley, CA: Wilderness Press, 2007.

Ramage, James A. *Gray Ghost: The Life of Col. John Singleton Mosby.* Lexington: University Press of Kentucky, 1999.

Reid, H. *Extra South.* Morristown, NJ: Compton Press, 1964.

Rockbridge Area Conservation Council. *Field Guide to the Chessie Nature Trail: A Path for All Seasons.* Buena Vista, VA: Mariner Publishing, 2009.

Speidell, Phyllis, and Karla Smith. *Peninsula in Passage: Driver—Bennett's Creek—Harbour View.* Virginia Beach, VA: Donning Company, Publishers, 2012.

St. John, Jeffrey, and Kathryn St. John. *Landmarks 1765–1990: A Brief History of Mecklenburg County, Virginia.* Boydton, VA: Mecklenburg County Board of Supervisors, 1990.

Talley, Dale Paige. *Ashland (Images of America).* Charleston, SC: Arcadia Publishing, 2005.

Tucker, George Holbert. *Norfolk Highlights: 1584–1881.* Norfolk, VA: Norfolk Historical Society, 1972.

Virginia Beach Public Library. *The Beach: A History of Virginia Beach, Va.* Rev. ed. Virginia Beach: Virginia Beach Public Library, 1996.

Walker, Carroll. *Norfolk: A Tricentennial Pictorial History.* Norfolk, VA: Donning Company/Publishers, 1981.

Webb, Munsey W. *Norfolk and Western Railway Company: North Carolina Branch.* Pulaski, VA: Edmonds Printing, Inc., 1995.

Wolfe, Ed. *The Interstate Railroad: History of an Appalachian Coal Road.* Silver Spring, MD: Old Line Graphics, 1994.

———. *The Life and Times of Miller Yard in Scott County, Virginia.* Pittsburgh, PA: HEW Enterprises, 2002.

Yarsinke, Amy Waters. *The Elizabeth River.* Charleston, SC: The History Press, 2007.

Newspapers and Magazines

Alexander, Robert. "Carrickfergus, Virginia: The Town That Never Was." *Bristol (VA) Herald Courier,* March 28, 1978.

Aronhime, Gordon. "Carrickfergus? Area Ghost Town." *Bristol (VA) Herald Courier,* November 12, 1964.

Bishop, Audrey. "Virginia Creeper: Mountain Railroad That Time Forgot." *Baltimore Sun,* October 13, 1957.

Bristol (VA) Herald Courier. "Mountain Empire Crossroads." February 27, 1994.

Capps, Emily Murden. "Rural Princess Anne County Bustled with Activity." *Virginian-Pilot,* August 24, 2006.

Carpenter, Brown. "Dead Beach Rail Links Recalled." *Norfolk (VA) Ledger-Star,* January 25, 1974.

Clarke, Jessica. "Divided Blacksburg Town Council Decides Against Lighting Trail." *Roanoke Times,* October 28, 1987.

Clifton Forge (VA) Daily Review. "Scenic Railroad to Start Runs from Intervale Beginning in May." February 20, 1975.

Coleman, Ron. "Blacksburg Railroad Story Comes to Final Chapter." *Roanoke Times,* July 22, 1966.

BIBLIOGRAPHY

Conley, Jay. "Footbridge Will Help Keep Hikers Safe." *Roanoke Times*, October 6, 2000.

Cox, Janet D. "Trail Will Remain in the Dark." *Montgomery County (VA) News Messenger*, October 28, 1987.

Delawyer, Mark W. "Replacement of the Snowden Bridge." *Chesapeake and Ohio Historical Magazine*, September 1987.

Dixon, Thomas, Jr. "The Chesapeake & Ohio Railway in Covington, Virginia." *Chesapeake and Ohio Historical Magazine*, September 2007.

Faulconer, Justin. "Development Continues for Blue Ridge Railway Trail." *Lynchburg (VA) News & Advance*, July 10, 2008.

Freis, Robert. "Rails-to-Trails Journey Will Be Complete This Year." *Roanoke Times*, January 11, 1998.

Galax (VA) Gazette. "Sulphur Springs Voting Precinct and District, and the Name's Origin." June 11, 1964.

Garrett, J.C. "Huckleberry Bed Has Potential for Use as Local Nature Trail." *Montgomery County (VA) News Messenger*, November 17, 1966.

Garrett, Kelly. "The Huckleberry Line: Historic Railroad to Live Again as Walking Path." *Virginia Tech Magazine*, Spring 1992.

Gordon, Marty. "Tunnels and Bridges, Everywhere." *Blacksburg (VA) Sentinel*, November 4, 1998.

Grant, Elizabeth Baker. "History of the Abingdon Branch Line." *Plow*, February 1977.

Hamilton, Gordon. "Nuggets from the Archives/The N&W Lifeline: A Winter Drama." *Arrow*, March/April 2005.

Hanes, Cary Lee. "'Huckleberry' Has a Juicy History." *Montgomery County (VA) News Messenger*, February 23, 1992.

Huso, Deborah R. "The Night the Mountains Fell." *Blue Ridge Country*, July/August 2007.

Jones, Matthew. "Walking the Line." *Virginian-Pilot*, January 9, 2005.

Kirkman, Kenney. "Patrick County Tracks. " *Quarterly Publication of the Patrick County Genealogy Society*, no. 18 (May 2004).

———. "Railroad Once Town's Main Attraction." *Patrick County (VA) Enterprise*, June 20, 1984.

———. "Remembering Heyday of Railroads in Henry County." *Martinsville (VA) Bulletin*, June 15, 1997.

Kraft, Carl, and Neal Kraft. "When Trains Made Tracks for the Beach." *Virginian-Pilot*, July 27, 1975.

Lewis, Lloyd D. "An Abingdon Branch Accolade." *Trains: The Magazine of Railroading*, June 1984.

Lightfoot, Regina. "Suffolk Explores Development of Bike Trail: Nearby Cities Plan to Offer Assistance in 28-mile Project." *Newport News (VA) Daily Press*, December 2, 2000.

Link, O. Winston. "The Mixed Train." *Trains: The Magazine of Railroading*, July 1957.

Martinsville (VA) Bulletin, July 4, 1976. Bicennential Edition.

McCown, Debra. "'Good to Go': After Bitter Land Dispute, State Supreme Court Rules in Favor of Salt Trail Proponents." *Bristol (VA) Herald Courier*, May 16, 2010.

Medeiros, Bunny. "Shuttle Launching." *Damascus (VA) Times*, April 16, 2012.

Montgomery County (VA) News Messenger. "'Huckleberry' Gets Big B'bg Reception Monday as it Brings 400 Visitors." September 5, 1957.

Parker, Stacy. "Norfolk Avenue Trail Project is Nearly Complete." *Virginia Beach Beacon*, September 7, 2003.

Patterson, Steve. "Riding Through the Downhome Life in Lofty Heights." *Vintage Rails*, Winter 1997.

Price, Gary P. "The Switchback Scenic Route: A History of the Marion and Rye Valley Railway Company." *Whistle Stop*, April 2012.

Roanoke Times. "New Path in the Woods." November 19, 2010.

———. "N&W's 'Virginia Creeper' to Cut Passenger Service." March 16, 1962.

———. "Train Passengers Get Tops in Scenic Rides." January 22, 1962.

Robertson, Gary. "He Wanted to Grow Up to Be an Engineer…" *Richmond Times-Dispatch*, July 19, 1981.

Sarvis, Will. "Green Cove Station: An Appalachian Train Depot and Its Community." *Virginia Cavalcade*, Autumn 1992.

Sheppard, Susan Bracey. "Oh! For a Railroad. Oh! For Power." *Virginia Cavalcade* 33, no. 4 (Spring 1984).

Sunderland, Kim. "Huckleberry Planners Discuss Barriers to Trail." *Roanoke Times*, April 27, 1991.

———. "Huckleberry Trail Proposed as First County Bike Path." *Roanoke Times*, February 6, 1990.

Tennis, Joe. "Bike Shuttles Make Cycling Creeper Trail a Downhill Breeze." *Bristol (VA) Herald Courier*, September 21, 2003.

———. "Huckleberry Trail Forges Tech-Christiansburg Link." *Roanoke Times*, April 1, 1992.

———. "Rail to Trail: Hiking and Biking the Southern Tip of the Eastern Shore." *Hampton Roads Magazine*, July 2013.

———. "Sweet Virginia Breezes." *Blue Ridge Country*, May/June 1997.

———. "What's in a Name?" *Bristol (VA) Herald Courier*, October 20, 1994.

———. "Williamsburg of the West." *Bristol (VA) Herald Courier*, May 8, 2003.

Virginia Beach Beacon. "Entrepreneurs Decided Sea Air Was Good." June 29, 2003.

———. "Train Whistles Echo in Present-Day Park." June 29, 2003.

Waite, Jim. "The Hike: Chessie Nature Trail." *Blue Ridge Country*, March/April 2001.

Walsh, Jim. "Foster Falls: Least Known Spot in Southwest Virginia." *Roanoke Times*, September 3, 1963.

Warden, William E., Jr. "Steam Success Story." *Trains: The Magazine of Railroading*, October 1962.

Watson, Sarah. "Huckleberry Trail to Get Face-lift." *Collegiate Times*, June 17, 2010.

Wessol, Shay. "Vandals Hit Huckleberry Trail." *Roanoke Times*, September 17, 2002.

Williams, Ames W. "The Virginia Central Railway." *National Railway Bulletin* 50, no. 1 (1985).

Wilson, Goodridge. "When a Roosevelt Found Health in Virginia Hills." *Richmond Times-Dispatch*, February 24, 1935.

Reports, Brochures and Booklets

Alleghany County, Virginia. "Jackson River Trail Master Plan." November 2006.

"Alum Spring Park: Historical & Recreational Information." Fredericksburg, VA: Department of Parks, Recreation and Public Facilities, March 2004.

Bowman, Emily, Susan Sherwood and Michelle Swagler. "The History of Dahlgren Railroad." Independent Study, Department of Geography, University of Mary Washington, April 30, 2007.

Chen, Kimberly M. "Richmond and Chesapeake Bay Railway Car Barn: National Register of Historic Places Registration Form." United States Department of the Interior, National Park Service, January 17, 2006.

Consroe, Anne. "The Dahlgren Railroad Heritage Trail: An Assessment of Trail Benefits for Users and Neighboring Residents." Written for the Friends of the Dahlgren Railroad Heritage Trail.

"Damascus Virginia: The Town of Natural Resources." Promotional booklet, circa 1914.

"Fort Norfolk," undated brochure, presented by the Norfolk Historical Society and the U.S. Army Corps of Engineers, Norfolk District.

"Joshua Falls Bridge." Historic American Engineering Record. Philadelphia, PA: National Park Service, September 1993.

Mingea, W.E. "How I Built Three Railroads Without Money." Abingdon, VA. November 14, 1930.

"Phoenix Bridge." Historic American Engineering Record. Philadelphia, PA: National Park Service, n.d.

Pulice, Michael J. "Foster Falls Historic District: National Register of Historic Places Registration Form." United States Department of the Interior, National Park Service, May 2009.

Southside Richmond Rail-Trail Project Team and James River Branch Rail-Trail Citizens Advisory Committee. "James River Branch Rail-Trail Concept Plan: A Vision for Southside Richmond," March 9, 2010.

Temple, Harry D. "Genesis of the Huckleberry Railroad," October 1990. File at Virginia Tech Library, Blacksburg, VA.

"The Trails of Grayson Highlands State Park." Richmond, VA: Department of Conservation and Recreation, October 1991.

Vanasse Hanger Brustlin, Inc. "Suffolk Seaboard Coastline Trail: Master Plan." Suffolk, VA: Department of Parks and Recreation, August 2006.

"Washington & Old Dominion Railroad Regional Park: Trail Guide—Sixth Edition." Ashburn, VA: Northern Virginia Regional Park Authority, 2004.

Online References

"Virginia Blue Ridge Railway." www.whippanyrailwaymuseum.net (accessed October 9, 2012).

"Virginia Creeper," Louise Fortune Hall Collection. http://www.archives-wcpl. net/Archive7_Hall/project/items/show/17 (accessed August 16, 2014).

INDEX

ABOUT THE AUTHOR

Photo by John Patrick Tennis.

Joe Tennis has written about rail trails across Virginia since 1992 for newspapers and magazines, including *Blue Ridge Country,* *Bristol Herald Courier,* the *Roanoke Times,* *Virginia Living, Appalachian Voice* and *Hampton Roads Magazine.* He has also written for the *Virginian-Pilot* and *Kingsport Times-News.* The Virginia Beach, Virginia native is a graduate of both Radford University and Tidewater Community College.

The author's third book, *Beach to Bluegrass,* inspired the name of Virginia's Beaches to Bluegrass Trail, linking rail trails and other paths along U.S. 58. The author's other books include *Southwest Virginia Crossroads*; *Washington County, Virginia (Then & Now)*; *Sullivan County, Tennessee (Images of America)*; *Haunts of Virginia's Blue Ridge Highlands*; *The Marble and Other Ghost Tales of Tennessee and Virginia*; and *Finding Franklin: Mystery of the Lost State Capitol.*